WISCONSIN

POST OFFICE MURALS

DAVID W. GATES JR.

Post Office Fans
PO Box 11
Crystal Lake, IL 60039
Phone: 815-206-8405
Web: www.postofficefans.com • Email: info@postofficefans.com

Publisher's Cataloging-in-Publication Data
Names: Gates, David W., Jr., author.
Title: Wisconsin post office murals / David W. Gates Jr.
Description: Crystal Lake, IL : Post Office Fans, [2019] | Includes bibliographical references and index.
Identifiers: ISBN 9781970088007 (softcover) | ISBN 9781970088014 (ebook) | ISBN 9781970088021 (PDF)
Subjects: LCSH: Mural painting and decoration, American—Wisconsin—20th century. | Post office
 buildings—Decoration—Wisconsin—History—20th century. | Public art—Wisconsin—History—
 20th century. | Government aid to the arts—Wisconsin—History—20th century.
Classification: LCC ND2635.W6 G38 2019 (print) | LCC ND2635.W6 (ebook) |
DDC 751.7309775—dc23

ISBN (Softcover): 978-1-970088-00-7
ISBN (eBook): 978-1-970088-01-4
ISBN (PDF): 978-1-970088-02-1

Cover and interior designed by John Reinhardt Book Design
Front cover mural: *Threshing Barley*, by Charles W. Thwaites, Chilton, Wisconsin Post Office, Chilton, Wisconsin

Printed in the United States of America

DEDICATION

This book is dedicated my parents, Dave and Mary Anne Gates, who instilled in me a sense of travel and adventure at an early age. Your unconditional love, inspiration, and support are appreciated every day. I love you both more than words can express; however, now I have a book to put it into writing and let the world know. I love you.

ACKNOWLEDGMENTS

I've visited hundreds of post offices and spoken to a lot of people during the creation of this book. I'm inspired by all the interesting people and stories I hear across Wisconsin and other states. I can't thank you enough for sharing your time discussing the buildings or art and, most importantly, your stories. I don't always remember your names, and since all my visits seem to blend together, I don't always remember where we met, but rest assured you have had a huge influence in the creation of this book.

Thanks to my mother and father: This book would not be possible without your love and support.

Thanks to my wife and son for putting up with me during our family vacations where I just needed one more photo.

No book of this magnitude is written in a vacuum and brought to fruition without the help of skilled professionals. There are several individuals who have been instrumental in the influence of this book. I wish to celebrate them here.

Howard Hull—the author of *Tennessee Post Office Murals*, whose wisdom and knowledge has been a huge influence, inspiration, and source for this book—is one of the trailblazers for visiting and writing about post offices with murals. I've kept your book on my desk as a constant reminder of what is possible. I'm delighted to have been in contact with you during the creation of this book and cherish our long-distance friendship. Thank you.

I have learned a great deal from Robert Mis's comments on www.postofficefans.com. You've also answered an unending number of questions via email, and for this I can't thank you enough. You know more about post office buildings than anyone I've met, and I've enjoyed our shared interest in these magnificent structures.

Toby McIntosh, author of *Apple Picking, Tobacco Harvesting and General Lee*: Thanks for answering my numerous questions and for your very insightful book. It's been a pleasure connecting with you. You've inspired me to plan a future trip to Arlington, Virginia.

Michael Schragg: The amount of history you have housed in your museum is incredible. The personal escort through your world of the post office left a lasting impression and is something I will always remember.

Jeff Karon who took this project to a whole new level way above what I would have ever been able to do on my own: Your knowledge and skill are appreciated and valued. What is most impressive to me is our shared vision of getting the story out for others to enjoy these wonderful works of art. You got it right from the start and completely understood the goals and objective of this project. Not only did you "get it," but your enthusiasm to see it through made it a joy to work with you. Writing a book is a lot of work, and when your editor can connect with the material the way you did makes the project a delight. You have my full admiration and respect for working this project perfectly.

Kathleen Strattan, editing and proofreading and numerous suggestions which have improved this work immensely: At first I had no idea how many little things were missing. Your attention to the details have improved this book and made it much more valuable than I thought possible. I have also learned a great deal from you, and for a new author, that means a lot.

John Reinhardt, thanks for designing such a beautiful cover and book. I'm delighted we connected and worked on this book together. It has been a pleasure working with you and learning all about book design. I also appreciate the time and effort you put into answering all my unending questions. It means a lot to me, and I wanted you to know.

Thanks to the following individuals who have helped along the way: Susan I., Jay M., Angela E., Mike C., Jane F., Joel F., John R., L. Robert Puschendorf, and David B.

There were several people early on who helped with various parts of this project, including research, writing, photo editing, designing, and so on. In this modern age of the internet, I've utilized several platforms for various pieces of this book. For this reason, I may only know you by your screen name. While I may not have utilized all work you performed, you have made this book a reality. I've learned a ton working with you, and for that I'm grateful.

If I've missed thanking anyone, it is my own fault and I should be publicly tarred and feathered. Do they still do that?

Thank you.

David W. Gates Jr.

CONTENTS

POST OFFICE LOCATION MAP . ix

INTRODUCTION . 1

BERLIN . 3

BLACK RIVER FALLS . 7

CHILTON . 13

COLUMBUS . 17

DE PERE . 21

EDGERTON . 27

ELKHORN . 31

FOND DU LAC . 35

HARTFORD . 43

HAYWARD . 47

HUDSON . 51

JANESVILLE . 55

KAUKAUNA . 61

KEWAUNEE . 65

LADYSMITH . 69

LAKE GENEVA . 73

LANCASTER . 79

MAYVILLE . 83

MILWAUKEE (WEST ALLIS) . 87

NEILLSVILLE . 93

OCONOMOWOC . 97

PARK FALLS . 101

PLYMOUTH . 105

PRAIRIE DU CHIEN . 109

REEDSBURG . 113

RICE LAKE . 117

RICHLAND CENTER . 121

SHAWANO . 125

SHEBOYGAN . 129

STOUGHTON . 135

STURGEON BAY . 139

VIROQUA . 143

WAUPACA . 147

WAUSAU . 151

WEST BEND . 155

WISCONSIN POST OFFICE MURAL LIST 159

NOTES . 161

BIBLIOGRAPHY . 163

ABOUT THE AUTHOR . 165

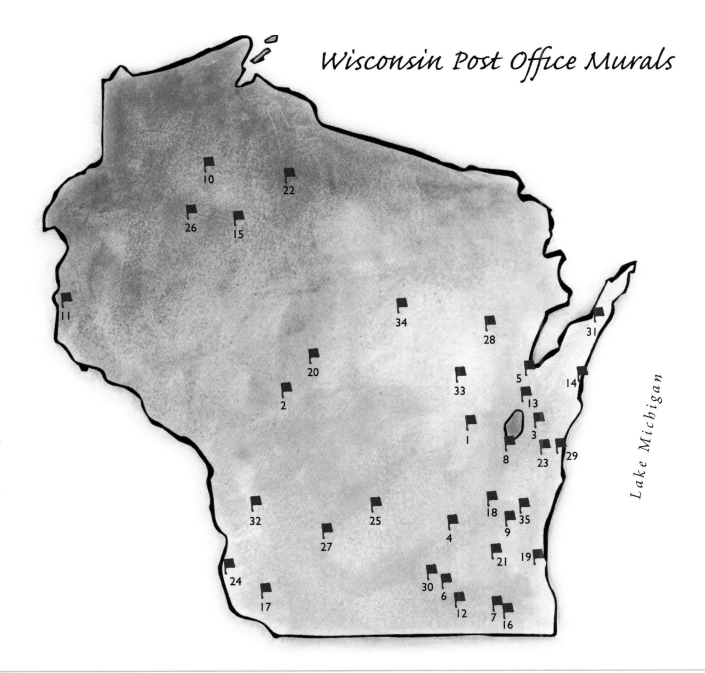

Wisconsin Post Office Murals

1. Berlin
2. Black River Falls
3. Chilton
4. Columbus
5. De Pere
6. Edgerton
7. Elkhorn
8. Fond du Lac
9. Hartford
10. Hayward
11. Hudson
12. Janesville
13. Kaukauna
14. Kewaunee
15. Ladysmith
16. Lake Geneva
17. Lancaster
18. Mayville
19. Milwaukee
20. Neillsville
21. Oconomowoc
22. Park Falls
23. Plymouth
24. Prairie du Chien
25. Reedsburg
26. Rice Lake
27. Richland Center
28. Shawano
29. Sheboygan
30. Stoughton
31. Sturgeon Bay
32. Viroqua
33. Waupaca
34. Wausau
35. West Bend

Lake Michigan

INTRODUCTION

In 1933, America was in the grip of the Great Depression and a quarter of her people were out of work. In response to this financial crisis, President Franklin Delano Roosevelt initiated the New Deal to help a struggling populace. One New Deal program, the Public Works of Art Project (PWAP), dedicated one percent of funding for new federal construction to commission works of art to decorate public buildings.

Though many Americans didn't know it, the government had a history of supporting the arts long before the Great Depression and Roosevelt's New Deal. While commissioning artists to create murals to hang in post offices wasn't a stretch considering this history, the PWAP was directly related to the Depression. In 1935, PWAP broke into three separate entities, with the Treasury Department's Section of Painting and Sculpture (later called the Section of Fine Arts) overseeing the post office mural project. The other two programs were the Treasury Relief Art Project (TRAP) and the Federal Art Project (FAP). All three programs continued through 1943.

With the Treasury Department assuming control in 1935, the intention of the program changed. From providing employment to artists, the goal was now improving morale in these Depression-era communities. Artists who won these commissions were expected to consult with prominent members of the community, as well as with regular folk, to create works meaningful to that region.

For example, in the words of Edward B. Rowan, Superintendent of Section of Painting and Sculpture,

My suggestion is that you take in one of the phases which interest you in the history of Berlin, either past or present, and develop it into a composition. What we most want is a simple and vital design. If you feel that the river is the most important natural feature about the town I would suggest that you do something with that theme.

It is suggested that you use a subject matter which embodies some idea appropriate to a Post Office or to the particular locale of Berlin.

Artists were encouraged to visit the local post office and consult with the postmaster and locals to discuss appropriate subject matter for the town in question. This is indicated in various letters from Rowan to the artists.

If it is convenient for you to make a visit to this post office, the Section considers it advisable for you to call on the Postmaster and at the same time determine the exact dimensions and most suitable character for the decoration. We shall be very glad to inform the Postmaster of your intended visit.

What began for me as an interest in a photographic subject soon became a deep fascination with the history and presence of a unique moment in American culture and art. Before documenting the murals in this book, I visited hundreds of post offices and spoke to dozens of people across the U.S. We were united in our enthusiasm for keeping the stories of this art alive and available for the American public.

I eventually became an active contributor to The Living New Deal Project, which aims to inventory, map, and publicize the achievements of the New Deal and its public works across all fifty states. The present book, which is a tour guide to all 35 of Wisconsin's New Deal post office murals, is a contribution to my larger project of visiting and documenting all the murals in each state. I encourage you to visit one of these post offices in Wisconsin or seek out one in your own state if you aren't personally traveling through Wisconsin. To learn about this special art is to learn about the continuing American journey.

Thank you for traveling with me.

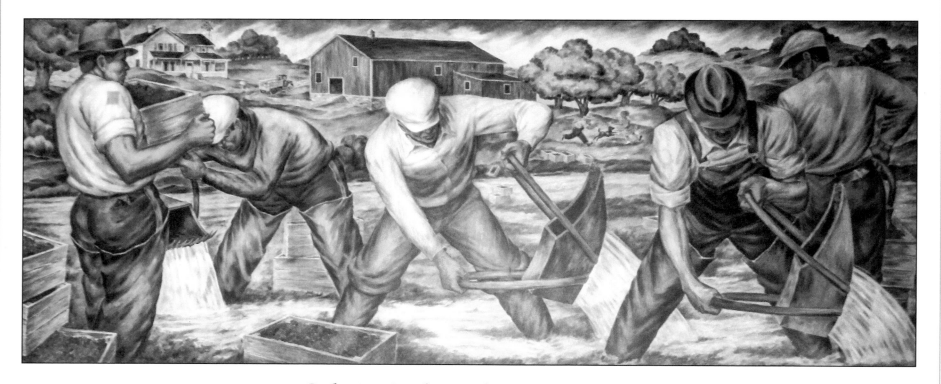

Gathering Cranberries, by Raymond Redell

The mural *Gathering Cranberries* is oil on canvas, measures 13 feet by 5 feet, and was installed on Saturday, June 18, 1938. The mural depicts five men gathering cranberries from the flooded marshes with their rakes. By the left-hand side and almost out of the panel are a couple of crates in which the cranberries are deposited, and in the background, there is a house and a building that is apparently a storehouse for gathered cranberries.

BERLIN

History of the Mural

The commission of $630 went to Raymond Redell of Milwaukee, Wisconsin. Redell first sent a two-inch, black-and-white sketch of what he had in mind for the Berlin mural decoration. But the Section of Fine Arts felt that (1) too much of Berlin's history was included in the one panel, and (2) the artist had made the design too complex. Instead, he was advised to choose from among the many phases of Berlin's history the one that he found most interesting and to develop that particular phase into "a simple and vital composition." The Section of Fine Arts also suggested that Redell should submit a couple of black-and-white pencil sketches, rather than just one, from which the committee would make their choice.

Redell went to work and created two more sketches. The subject of one of the sketches was cranberry growing. He chose this because Berlin had once been the national center of cranberry growing as well as a principal shipping point of that particular industry, which at one point employed nearly 1,800 pickers.

The second subject he sketched was dairying, since Berlin was also known for condensed milk which was made by the Carnation Company. But after reviewing the sketches, the Section decided that the theme of the cranberry pickers was the more interesting of the two for the citizens of Berlin, though the theme of condensed milk was better executed. Redell was asked to create another design which had cranberry picking as its subject matter but on a scale similar to that of the condensed milk/dairying design, so that more details could be worked into the landscape. Redell's final sketch satisfied the members of the Section of Fine Arts and their Supervising Architect.

Cranberries are grown in marshes which become flooded when it is time to pick. The flooding of the marshes floats the plants, which makes it easier for the berries to be scooped. Redell showed a marsh's edge to get more landscape into the panel and thus better illustrate the whole process of cranberry cultivation and picking.

The mural was well received by the public, many of whom went to the post office just to see it.

MORE ABOUT THE ARTIST AND THE MURAL

Raymond Redell was born in 1913 in Delafield, Wisconsin, the same town of his death in 1978. Redell was a resident of Milwaukee when he was commissioned to paint the Berlin mural. He graduated from the Layton School of Art in Milwaukee, Wisconsin. On the basis of a work he had created for a Treasury Department Art Project competition, Redell was the only artist sent a letter of invitation by the Section of Painting and Sculpture to submit designs for the Berlin mural.

In Redell's sketch, he ran the Fox River through the entire panel since the river was central to the life of the town. He also included Jesuits and explorers in the mural, figures who represented the earliest history of Berlin.

Until a couple of years before the mural painting, Berlin was a national center of granite quarrying and raising of cranberries. But at the time the mural painting was commissioned, there were two significant industries in Berlin: the trading of goods by farmers once every month at the market square in front of the city hall and the manufacturing of condensed milk by the Carnation Company.

Redell initially had sketched a train surrounded by people, but he proposed to remove this so that there would be more space for the cranberry pickers. He also proposed to divide the mural design into three different parts with the same historical subjects contained in each. The largest panel would be in the middle with the other two panels on either side.

After Redell's initial sketch was approved, he created a two-inch-scale color sketch and also forwarded information on the dimension

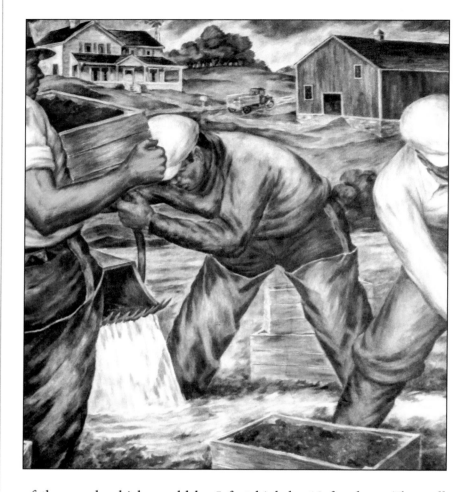

of the panel, which would be 5 feet high by 13 feet long. The wall on which the mural was to be painted was 14 feet wide; this meant that there would have been a space of about 6 inches on each side of the mural after its installation. Redell thought that a space of about 6 inches should be left at the bottom of the panel. He was, however, willing to make any changes directed by the Section of Fine Arts. He intended to complete the work by May 31.

The Section responded with a suggestion that in the oil painting version a little more intense red be added to the boxes of cranberries in the corner of the painting. After finishing the cartoon for the Berlin building, Redell forwarded another sketch.

During his technical outline, Redell had designated Musini colors for the mural painting, but during the course of his work, he asked the Section of Fine Arts to permit him to use Rembrandt oil colors instead. The reason for this change was the fact that Rembrandt oils were readily available and accessible where he worked. He also proposed that he add Burnt Sienna to the colors on his palette.

Redell, apart from the Berlin mural, was also commissioned to paint murals in Waupaca, Wisconsin, and Middlebury, Indiana.

History of Berlin

Nathan H. Strong was the first resident of Berlin in 1845. After Strong settled there, Hugh G. Martin, Hiram Barnes, and William Dickey followed and together formed a settlement called Strong's Landing. The first post office was built in 1848, and the town was given the name Berlin after the German capital city.[1]

By 1850, there were over 250 residents living in the town, especially from New England states. The population was increasing rapidly, the town favored for its location and natural resources. For all these years, it was only the east side of the river that was available for settlement as the west was part of "Indian country." However, in 1850, the Indians surrendered and the west side was opened for settlement. The first school and church were established in 1850 and 1851 respectively. In 1857, the first railroad was established, inviting more settlement in the area. The town was incorporated in the same year.[2]

Berlin's location and the goods and services that its businesses provided helped fuel its expansion. The cranberry industry and the stone

quarries became the main sources of employment, as well as providing a good reputation for the town. Immigrants from Scotland, Italy, Poland, and Wales came to look for employment in the quarries. By the mid-1860s to the 1890s, many businesses had cropped up, and, as a result of these businesses, the city was nicknamed "the fur and leather city." In the early 20th century, the Carnation Company built the first milk condenser factory, opening up opportunities for further expansion.[3, 4]

Today, Berlin stands on an area of 6.36 square miles (5.78 square miles of land and 0.58 square miles of water) and has become the home of many people and factories. According to the 2010 Census, its population was 5,524.

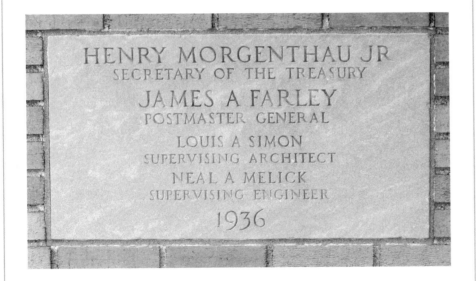

The Berlin Post Office

122 S. Pearl St., Berlin, Wisconsin 54923

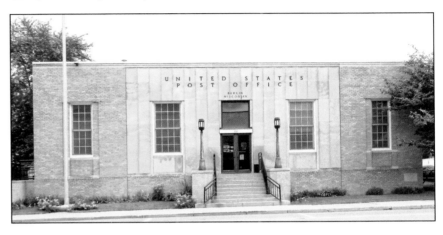

The Berlin, Wisconsin post office was constructed by Bracker Construction Company of Minneapolis, Minnesota. The cost of the building when new was about $49,315.

The Berlin Post Office was completed in 1936 as indicated on the cornerstone on the lower right corner of the building, which reads, *Henry Morgenthau Jr—Secretary of the Treasury. James A. Farley—Postmaster General. Louis A Simon—Supervising Architect. Neal A Melick—Supervising Engineer.*

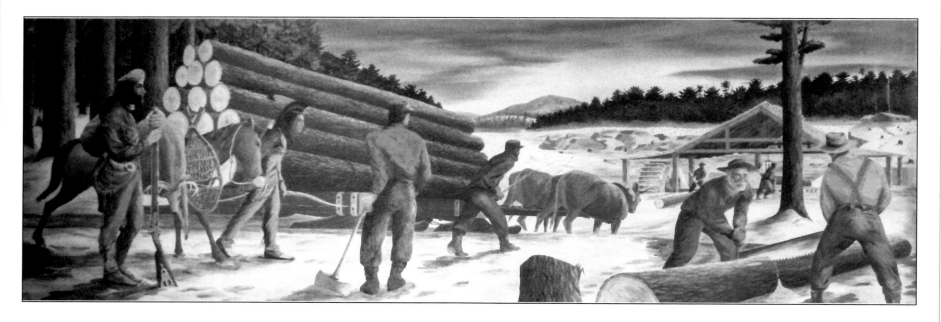

Lumbering—Black River Mill by Frank E. Buffmire

The mural *Lumbering—Black River Mill* is oil on canvas, measures 14 feet by 5 feet, and was installed on November 23, 1939. The mural depicts a hill in the background a mile or two upriver; the hill was known as Iron Mound (as well as Wheaton Mound to older citizens of Black River Falls). Also depicted in the mural is a water wheel which was the source of power used to operate the saw attached to a shaft on the wheel's hub.

BLACK RIVER FALLS

History of the Mural

The only suggestion made by the Section to Buffmire's initial design was that Buffmire improve on the treatment of the ends of the logs depicted in the painting since they appeared out of proportion with their sides.

Buffmire made necessary adjustments based on information provided by the then-postmaster, also giving more importance to the rocky formation of the far river bank than he did in his original design sketch. The postmaster helped him find photographs and dates necessary for the authentication of the painting's elements.

Postmaster Dickey wrote to the Section that he was satisfied with the installation and that the painting was a worthy addition to the building. The Section agreed based on photographs of the mural. In his report following the installation of the panel, Buffmire wrote,

The mural depicts a scene of winter activity in the Black River Falls lumbering camp of one hundred years ago. At that time, the state boasted the finest stand of white pine to be found in Wisconsin.

The figure of the pioneer helps to date the picture as does that of the Indian hunter returning from a successful hunt. His kill will augment the loggers' menu. The Winnebago Indians played a prominent role in the life of Black River Falls and are still quite numerous there.

The sled of loaded logs illustrates the method of hauling logs into the mill for sawing in the cold months. The oxen were, of course, the traction power then.

Sawmills of that era were rather roughly built. The one I've shown is typical—a peaked roof supported by corner timbers. The water wheel was the source of power operating the saw which was attached to a shaft on the hub of the wheel.

The bunkhouses to the right represent the usual sleeping quarters of the lumberjacks. The men in the right foreground show the use of the crosscut saw. After trimming, the logs were thus reduced to convenient handling lengths.

The town's story is a saga of rugged men in rugged country. I think the mural expresses something of that feeling.

Buffmire's work received attention from the press upon installation in 1940, a result of Buffmire's articles which appeared in several papers and journals such as *The Milwaukee Journal*, *The Black River Falls Paper*, *The Oconomowoc Enterprise*, *The Watertown Gazette*, and *The Milwaukee Sentinel*.

More about the Artist and the Mural

Frank E. Buffmire, the artist responsible for the Black River Falls mural decoration, was born in Oconomowoc, Wisconsin. He was also a resident of the same town at the time he was commissioned to paint the Black River Falls mural.

Buffmire was offered the commission of the Black River Falls mural because of a design that he submitted in the Wausau Post Office mural competition. Upon receiving the invitation letter from the Section, Buffmire wrote to Postmaster Dickey of Black River Falls notifying him of his intention to visit the building a couple of days later in order to see the building, acquaint himself with the town, and discuss and line up a suitable subject matter for the mural painting. Upon his visit, Buffmire examined the space allocated for the mural painting and found out that the actual dimensions were different from the ones he was sent in the blueprints in a letter from the Section. The lobby wall was actually 14 feet as opposed to the 13 feet in the blueprint, and the depth of useful space over the postmaster's door was in reality 4 feet 8 inches as opposed to the 5 feet 5 inches he was told. This meant that the real dimensions he had for the mural painting were in actuality 14 feet by 4 feet 8 inches instead of 13 feet by 5 feet 5 inches.

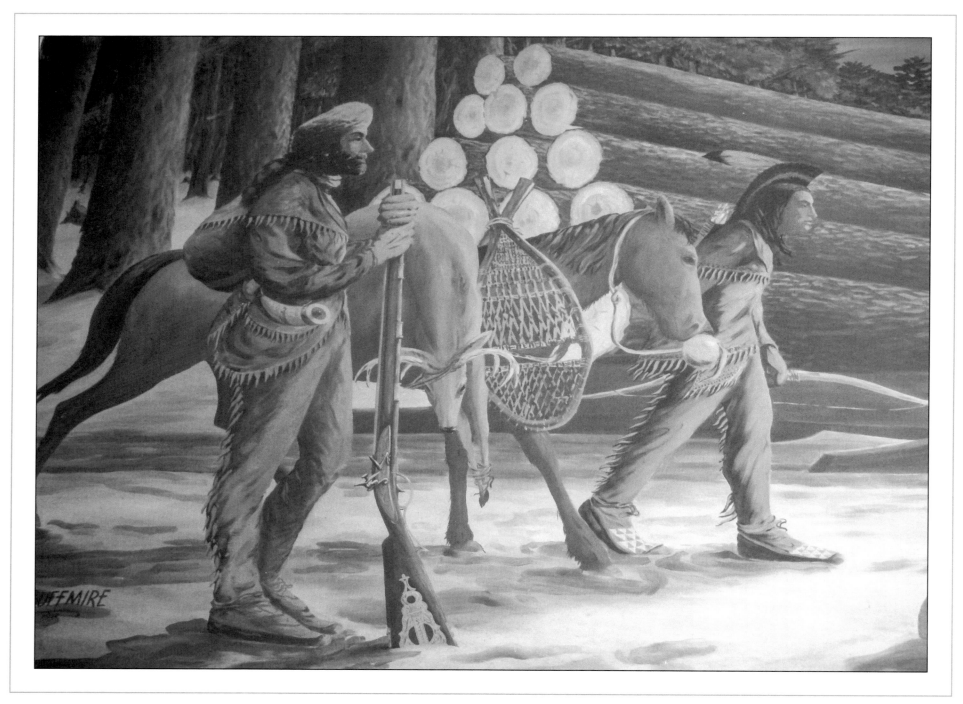

Frank E. Buffmire, *Lumbering—Black River Mill*

In his correspondence, he stated his concern that painting the mural around the office door of the postmaster to accommodate a depth of 5 feet 5 inches would not be advisable due to a light fixture occupying a position to the left of that door. That light fixture served to illuminate a lobby writing desk. He suggested that a similar light could be placed on the opposite side of that door in the future should it be needed.

He and the postmaster thought it would be best that the painting fit flush against the door and straight across. The extra foot in length, he thought, would closely balance the needed depth.

He proceeded to make two black-and-white designs: The postmaster had suggested a painting relating to a winter scene, which was his second choice. His first choice was his own preferred subject of the beginning of the lumbering trade around 1839. He sketched a summer scene of a water-powered saw, an open-sided sawmill, and Indian and frontiersmen figures. Buffmire was given one design suggestion: Authenticate the figure of the Indian in the sketch in future developments.

During the painting of the Black River Falls mural, Buffmire used as his temporary studio a space above the Nelson Grocery Store located at N. Main St., Oconomowoc, Wisconsin.

Buffmire was an accomplished artist, one of the recipients of awards at the Wisconsin Painters and Sculptors show that took place in 1940. Buffmire underwent three years of study at the Layton School of Art in Milwaukee, Wisconsin, after his elementary education. After his training at this school, he worked as a commercial illustrator for a number of advertising firms after which he served as a documentary painter for the Resettlement Administration.

Buffmire also spent some time in Detroit working for an advertising agency where he did layout and design work. He had his paintings exhibited far and wide, including solo shows at the Layton Galleries.

History of Black River Falls

Black River Falls is located in Jackson County in Wisconsin. According to the 2010 Census, the city's population stood at 3,622.

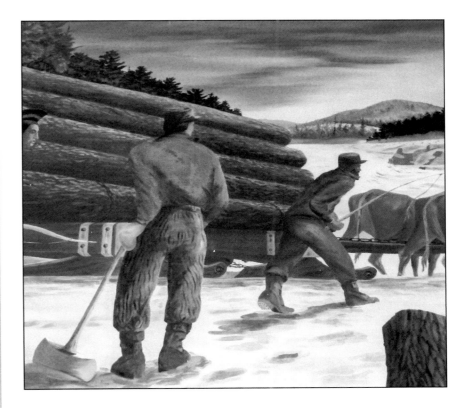

There are two different stories told of how Black River Falls came to be. During the winter of 1818–19, a sawmill was opened in the area, and some people attribute this mill to the growth of the town. Jacob Spaulding is commonly identified as the founder of the town later in 1839, attracting settlers to set up sawmills in the area and powering the growth of Black River Falls.[5]

The main inhabitants were the Ho-Chunk Indians, but other immigrants also came into the city. The Mormons settled in the town in 1842 but left after the death of the founder of their church, Joseph Smith. In 1847 and 1848, the first church and school respectively were opened, and the town was made the seat of Jackson County in 1853. The town faced a setback when it burned down in 1860 but was rebuilt

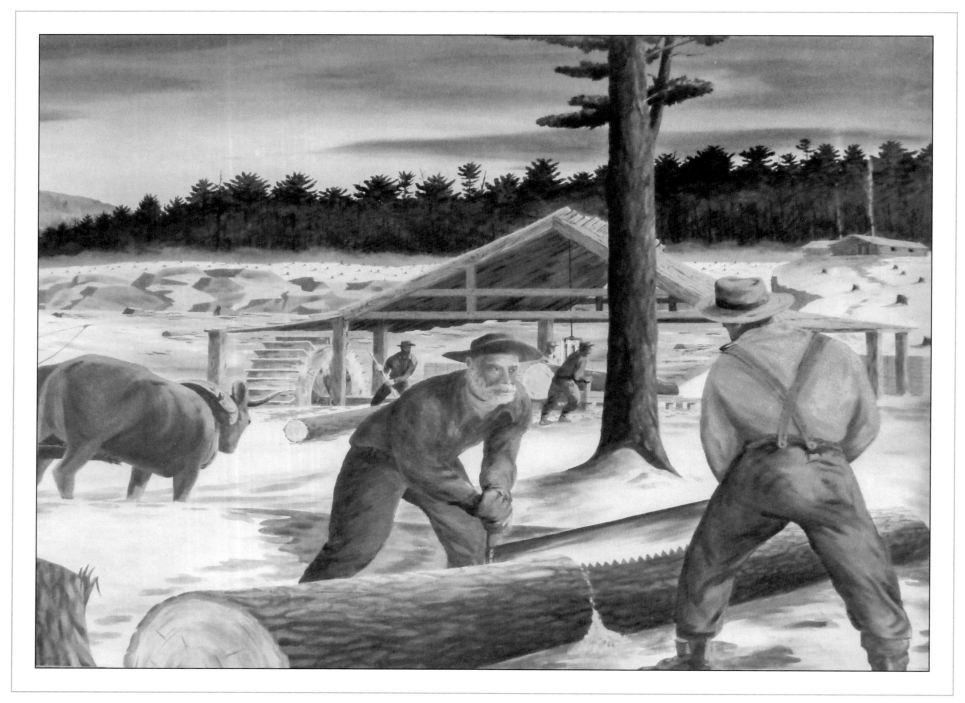

Frank E. Buffmire, *Lumbering—Black River Mill*

in 1861.[6] In 1872, the town became the first one in the state to construct a free city library that was located at 222 Fillmore Street.[7]

The city's growth was mainly pioneered by Ho-Chunk Indians who were living off the land surrounding the city. They were forced to relocate to Nebraska between 1873 and 1874.[8] The predominant forests were the major source of economy, and Black River Falls was used to produce waterpower for running the sawmills.

The Black River Falls Post Office

108 Fillmore St., Black River Falls, Wisconsin 54615

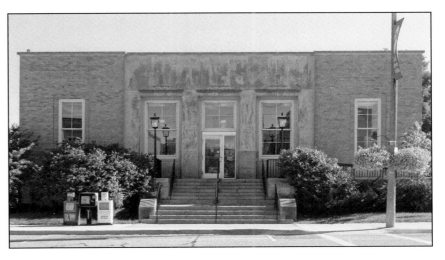

The Black River Falls, Wisconsin, post office was constructed by J. S. Sweitzer & Son Inc., of St. Paul, Minnesota. The cost of the building when new was about $48,958.

The Black River Falls Post Office was completed in 1938 as indicated on the cornerstone on the lower left corner of the building. It reads, *Henry Morgenthau Jr—Secretary of the Treasury. James A. Farley—Postmaster General. Louis A Simon—Supervising Architect. Neal A Melick—Supervising Engineer.*

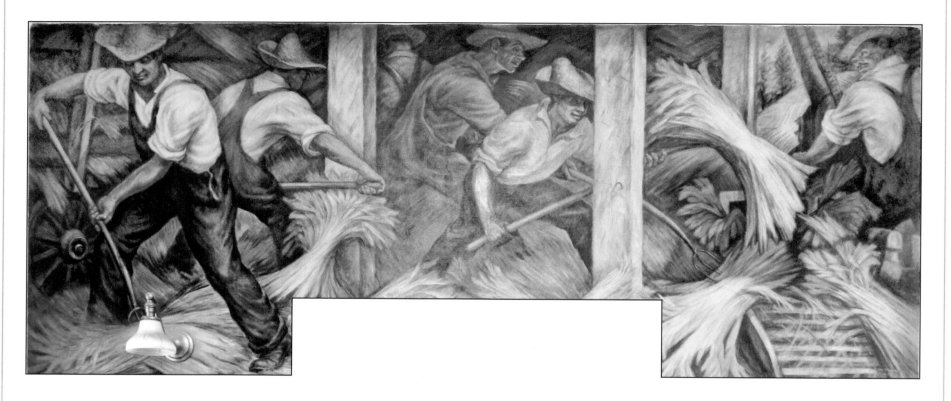

Threshing Barley, by Charles W. Thwaites

The mural *Threshing Barley* is tempera on canvas and measures 12 feet by 4 feet 10 inches. The commission was awarded on November 1, 1939; the mural was completed and subsequently installed around the month of November, 1940.

CHILTON

History of the Mural

The contract for the mural was awarded for $790. The jury (which was composed of Maurice Sterns, Olin Dows, Edgar Miller, and Henry Barnum Poor) selected Thwaites's design for Chilton as a result of the Forty-Eight States Mural Competition in which he participated.

MORE ABOUT THE ARTIST AND THE MURAL

Charles W. Thwaites was born on March 4, 1904 and died on November 21, 2002, in La Restencia, New Mexico. At the time he was commissioned for the Chilton post office building mural, he was a resident of Milwaukee, Wisconsin.

After having been sent an invitation to submit designs for the Chilton mural, Thwaites first forwarded a photograph of his design sketch which he executed in charcoal and chalk on brown wrapping paper. Later, when the Section received his letter along with the photograph of his full-size cartoon that he proposed for the mural decoration of Chilton, they directed that he proceed with the actual painting as they felt that the photograph indicated satisfactory progress on the work.

Thwaites wrote back to the Section, informing them that the work on the Chilton mural was almost completed and that by mid-July he would send photographs for their approval. They replied that press releases for the installation of the mural had been prepared and would be made available to him upon receipt of the completed mural's photograph and negative. He could then release them to the press after the installation had been made as had been done for the Greenville, Michigan, post office mural.

Thwaites started his painting and printmaking career by making self-portraits. He first studied engineering after which he enrolled in the Layton School of Art in Milwaukee, Wisconsin. Between 1933 and 1934, Thwaites worked for the Works Progress Administration where he created four mural paintings. Two of those murals were in Wisconsin (Chilton and Plymouth), one was in Michigan, and one was in Minnesota. In 1962, Thwaites and his wife relocated to New Mexico where they lived for the rest of their lives.

History of Chilton

Chilton is the seat of Calumet County in Wisconsin. The town is located along the southern branch of the Manitowoc River.[9] It had a population of 3,933 according to the 2010 U.S Census. The main nationality is German, and the main industries are trade and manufacturing.[10]

The founders of the town were Moses Stanton, an African-American, and his Native-American wife, Catherine, who came to the area in January 1845. They constructed a gristmill and sawmill, and the city grew around these mills some years later. Initially, it was referred to as

Charles W. Thwaites, *Threshing Barley*

Stantonville until 1852 when it was purchased by John Marygold, who renamed it "Chilington" after the Chillington Hall in England. When he sent Patrick Donahoe with a message to Stockbridge to register the town, the "ing" was accidentally omitted, and the town was mistakenly registered as Chilton. The city was made the seat of the county in December 1853, and the first courthouse was established the same year.[11]

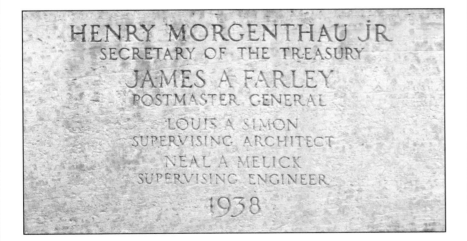

The Chilton Post Office

57 E. Main St., Chilton, Wisconsin 53014

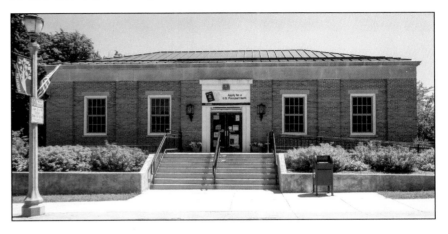

The Chilton, Wisconsin, post office was constructed by Carl Wesberg & Company Inc., of Chicago, Illinois. The cost of the building when new was about $49,577.

The Chilton Post Office was completed in 1938 as indicated on the cornerstone on the lower left corner of the building. It reads, *Henry Morgenthau Jr—Secretary of the Treasury. James A. Farley—Postmaster General. Louis A Simon—Supervising Architect. Neal A Melick—Supervising Engineer.*

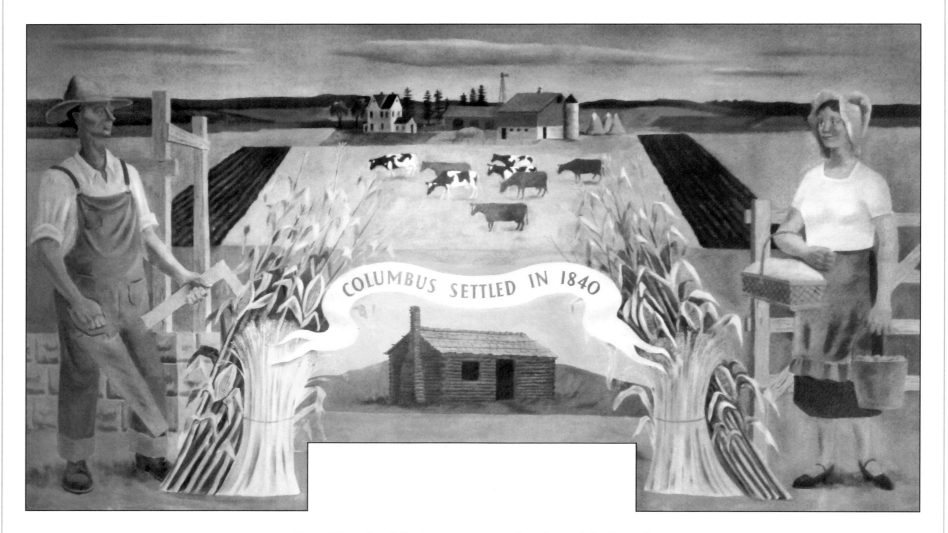

One Hundredth Anniversary, by Arnold Blanch

The mural *One Hundredth Anniversary* is oil on canvas, measures 12 feet by 6 feet, and was installed in June 1940.

COLUMBUS

History of the Mural

Blanch was chosen on the basis of designs he had previously submitted in the post office competition in Poughkeepsie, New York. A commission of $1,000 was awarded.

Blanch made two initial designs for Columbus: a landscape sketch and the Centennial celebration theme which was considered more appropriate for Columbus by the Section, since the town wanted the mural completed in time for its Centennial celebration in July 1940. In one of his final letters to Blanch, the postmaster mentioned that he felt the mural's edges were unfinished. He asked that Blanch stop by the post office and finish up the edges.

MORE ABOUT THE ARTIST AND THE MURAL

Arnold Blanch was born on June 4, 1896, in Mantorville, Minnesota. He died in Woodstock, New York, in 1968.

At the time Blanch was awarded the commission to paint the Columbus mural, he lived in Colorado Springs, Colorado. Upon being awarded the commission, he headed out to Columbus where he examined the post office and spoke with the postmaster.

He ended up sending two designs a little later than he had promised. One was from material suggested by some of the people he had met on his visit to Columbus, based on the Centennial celebration that was in progress. The other landscape design was not based on any location in particular but rather on the character of that part of Wisconsin. In his letter, Blanch also informed the Section that he would be going on a trip to Mexico at the end of that week before returning to find a suitable place to work. He asked that they hold onto the sketches until then.

They sent a reply to him confirming their receipt of his two design sketches, and though they thought the designs were beautiful, one stood above the other in quality and unusual arrangement of subject matter. The Section approved the design with figures on both sides and asked that Blanch proceed with the full-size cartoon on completion of which he was to forward a negative to their office for further deliberation.

While communicating and working with the Section of Fine Arts, Blanch apparently also traveled a bit as several letters were addressed to St. Simons, Georgia, where he seems to have worked for several months in 1939. Upon his eventual return to the States, Blanch found a place where he planned to stay and work for three months. He then forwarded a technical outline to the Section informing them of his wish that they send to him the Columbus designs so he could start work. The Section asked Blanch to forward for approval a sample of pure linen canvas which he intended to use for the mural painting.

Blanch's mural designs were well received and favorably commented on by many people, so much so that offers were made to buy the landscape design privately. Blanch appeared quite pleased at the attention and admiration his design was receiving and was open to the idea of selling the landscape for a price of $75 to whoever cared to have it.

History of Columbus

Nicknamed the "Redbud City" due to its small, rounded, canopy-shaped Redbud trees that beautify the city's landscape, the bigger part of Columbus is located in Columbia County and the other part in Dodge County in Wisconsin.[12] According to the 2010 U.S. Census, the city had a population of 4,991, with all this population residing in the part of the city located in the Columbia County portion.

The first person to move into the area was H. A. Whitney from Vermont, a Yankee peddler.[13] When he came, he erected a wood frame store where the present-day Whitney Hotel stands. The building was multipurpose, serving as a store, post office, rooming house, and tavern. The building was destroyed by fire in 1857, and the Whitney Hotel

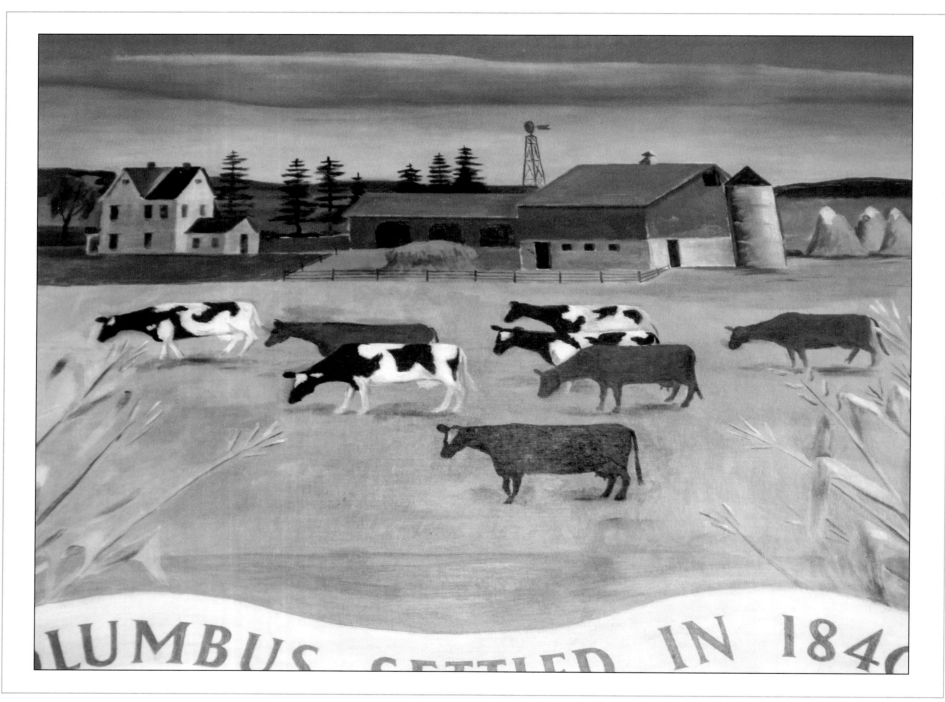

Arnold Blanch, *One Hundredth Anniversary*

that currently stands on the lot was constructed in 1858. However, in an article titled "Columbus Pioneer" that was published in the *Columbus Democrat* in 1908, Harvey McCafferty claimed that the Dickenson and Taylor families were the first settlers of the area at the time he arrived there as a young boy in 1843.[14]

The major source of employment for the early people of Columbus was agriculture. They mainly grew wheat, barley, and corn. This was evident by the nature of investments made by the settlers. In 1859, the first brewery was opened by Henry Kuth; another was erected in the mid-1960s.[15] Transportation was mainly by the railroad, especially to transport tobacco, a main cash crop.

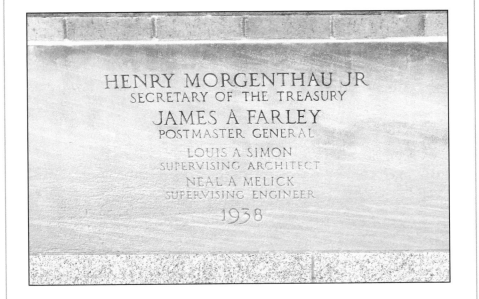

The Columbus Post Office

211 Dickason Blvd., Columbus, Wisconsin 53925

The Columbus, Wisconsin, post office was constructed by Maas Brothers of Watertown, Wisconsin. The cost of the building when new was about $41,362.

The Columbus Post Office was completed in 1938 as indicated on the cornerstone on the lower left corner of the building. It reads, *Henry Morgenthau Jr—Secretary of the Treasury. James A. Farley—Postmaster General. Louis A Simon—Supervising Architect. Neal A Melick—Supervising Engineer.*

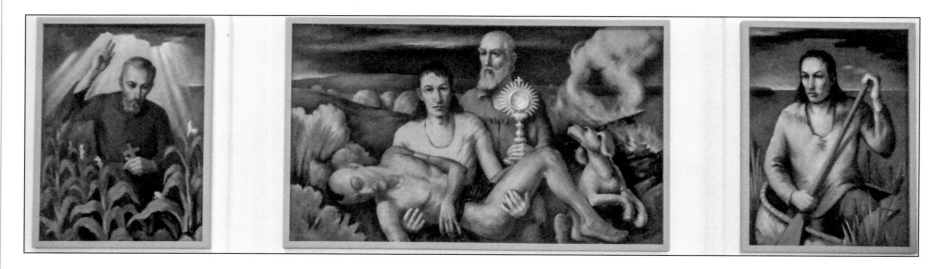

Give Us This Day, The Red Pieta, and Nicholas Perrot, by Lester W. Bentley

Of the three mural panels, one (the largest) measured 11 feet by 10 feet while the other two each measured 3 feet by 6 feet. The murals are egg, tempera, and oil on canvas, and were installed on August 19, 1942.

DE PERE

History of the Mural

The decision by Bentley to create three murals instead of the traditional one mural painted in the other post office buildings was based on the space allowed. A commission of $750 was awarded.

A letter written by Bentley tells of how he had a meeting with a committee of De Pere citizens about the murals he was to paint for the post office building. He had done preliminary research about the town's history and had concluded that De Pere was a town rich in history with an enormous amount of material from which to choose a theme.

Bentley wrote to the Section of Fine Arts,

De Pere is one of the most art minded communities in Wisconsin and the committee, which has been of great help, are giving me a free hand in this individual treatment.

The committee was, however, disappointed as was I regarding the limitations of this size mural. The entire wall space is 5' 3" x 13' 10". The one eighth inch insert mural space is 3' 4½" x 11' 10" which leaves an extremely large border measuring one foot and a half at the bottom.

The committee and myself feel that a more impressive mural could be made by considering the entire panel. The committee chairman is writing you shortly, and in the meantime, I shall continue with my research and preliminary drawings.

The Section of Fine Arts gave their consent to Bentley's using a larger space for the murals so long as it was at no extra cost to the government.

According to the correspondence, it can be inferred that the space allocated for the mural painting was too long which would have led to the mural's figures looking dwarfed. Planning and designing would have had to be done in an extremely narrow and long space. Bentley opted to divide the panel into three spaces instead. He felt this would be more convenient and feasible for the subject matter he was to cover.

Since the county of De Pere was the location of one of the earliest paper-making companies that still existed at the time of the mural painting, this was the preferred subject.

Despite the delay encountered as a result of the size issue, Bentley expressed confidence in the murals being installed in the time given him to complete the commission.

He also wrote,

I would appreciate a short note from you if you have any suggestions. From past experience, I find my most difficult job is what I am doing now the planning or composition and I can assure you I am giving my whole time to this job. I hope to have the completed sketches ready by the beginning of March.

To Bentley's question of how they would feel about his using a small scale for the figures in the mural, the Section's representative replied that it might look appropriate depending on the size of the lobby; he also expressed the belief that the figures are never dwarfed in great mural paintings. They suggested that Bentley keep the design very simple and that he not necessarily take into account the "encyclopedic" suggestion of the local committee of De Pere.

De Pere had two major characters in its history: one was Nicholas Perrot, a French trader and acclaimed "Commandant of the West," and the other was Father Allouez, who was a Jesuit missionary. The town also had one significant relic which was a silver ostensorium given to Father Allouez by Nicholas Perrot on his mission. There is a story about how the ostensorium was saved from Father Allouez's burning church by a converted Indian who lost his life in the act. This legend is a central part of De Pere's history: Bentley depicted these two characters in the central and principal mural which he titled *Red Pieta*.

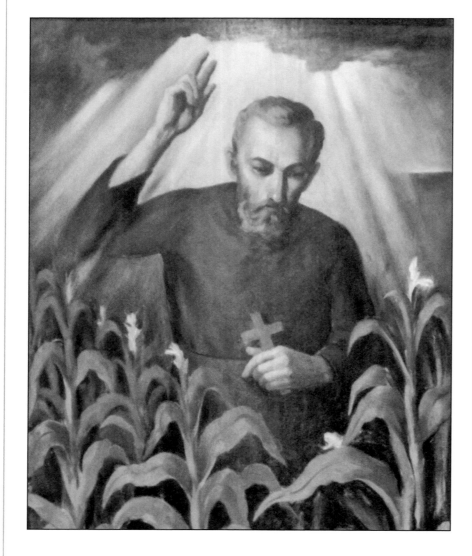

Upon review, members of the Section of Fine Arts expressed pleasure at what they termed "the intense spiritual quality" of the work as well as "the able design." They thereupon approved the work and asked that Bentley proceed with the full-size mural. They also requested that he forward the photographs and negatives as he progressed with the work.

They made one final request that Bentley send a one-inch color scale architectural rendition of *Red Pieta*'s proposed placement on the wall in relation to where the other two pictures would be.

The artist then proceeded to complete the cartoons, after which he was sent a check for $150. He had some difficulties finding a photographer to handle the fifteen-foot space of the mural, which hindered his sending pictures of the completed cartoon to the Section.

Bentley, at the time of the commission, was 34 years old; he had hoped to enlist in the Navy after the job was done, and as fate would have it, his Selective Service number came up earlier than he expected. This necessitated that he work faster as he was left with less than a month in which to finish the murals, install them (along with whatever changes were required to the plaster wall), and close up the studio where he worked. He decided to ask for a short deferment from his local board at Two Rivers, Wisconsin.

The Section advised Bentley to inform his local draft board about his commitment with the government involving the mural, since some draft boards were extremely considerate when it came to commitments of artists with the government. They also assured Bentley of their cooperation in the matter.

Bentley finished the murals for the post office with little time to spare. He wrote back informing them of his readiness to install the murals. The only thing left was to clarify some standing issues concerning the installation procedure. Prior to writing a letter, he had hired a mason based on the De Pere postmaster's recommendation to install the dividing panels for the murals.

The construction engineer for the post office building in De Pere described and praised the mural painting and the artist commissioned to do the job. He wrote,

There are three panels comprising this mural; the saintly figure of the missionary "Father Claude Allouez" is the subject of the left panel, with his right hand raised in the motion of blessing the standing crop of maize; in the background rays of sunlight are piercing through the clouds as if the Creator is already listening to his prayers.

History indicates that Father Allouez was a frail man, privations and hardships have been his lot in the mission field, the coloring of the cassock seems to show that it was worn for many years, it is a faded black to a brownish tint, even has shrunk from exposure to the weather. The hands and fingers which are always a difficult part to represent correctly indicate age and probably have toiled and tilled the land with the red men. The features are of a saintly man, of prayer, sacrifice, and devotion. The artist is also familiar with his botany as the form and color of flowers and blades, their texture, and sway, are so vivid and natural. The title given by the artist for this panel is "Give Us This Day."

The center mural, the "pièce de résistance," is the main feature of this work of art. It represents the devotion of the red man, a new convert to Christianity, in entering the burning mission house to save from destruction the ostensorium (this to this date has been kept and is an item of prominence in the Museum at Green Bay) and giving his life for recovering of this Catholic Church treasure. The anatomy of this red warrior is splendid; an inert figure is always more difficult to represent and depict, the coloring of the partially scorched and suffocated body is astonishing in reality. The artist we must say has a fine mastering of the blending of his colors, the tone is so mellow it is difficult for a layman to realize what coloring and assembly can do to a painting and not to be overdone or heavy. The artist has successfully rendered the hands, limbs and feet; all so perfectly arranged and disposed, everything inspires admiration for the work, and you naturally feel satisfaction to view some genuine art.

The appearance of the youth supporting the Indian shows fatigue, his face is pale and somewhat strain and anxiety for the exciting moments of the firing by the Iroquois of the mission chapel. From the depicting of several personages in the murals the artist has shown great imagination in the featuring, that is, they are the true French type, the writer being of French Canadian descent can appreciate that the artist has made a thorough study of this type.

The older coureur des bois or settler has a more quiet and serene significance, has had the experience of hardships, has been through

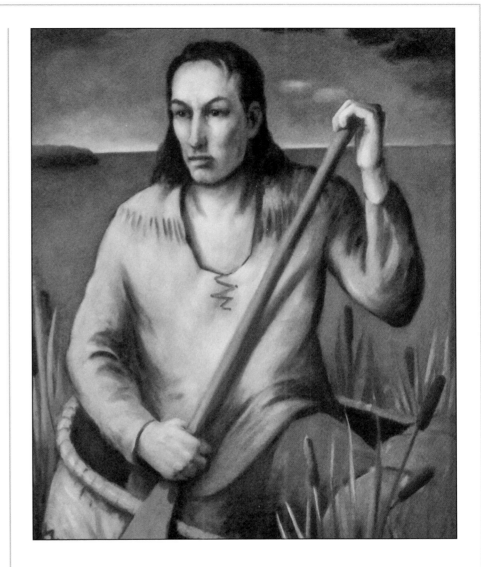

many battles with lurking enemy Indian tribes, this sorrow leans for the dead Indian comrade but amidst this all there is shown some satisfaction that the period treasure of the mission has been saved.

The grouping of the personages is outstanding and well-spaced and in pleasing relief, the perspective of the rugged background where the

huts are easily seen and giving atmosphere to the scene, the smoke from the burning chapel which is vivid and of true coloring and the hanging clouds darken but not so to reveal the outline of the horizon which gives a definite depth to the mural.

The dog, generally excitable, has become quieted though in an attitude of feeling towards the red man, its instinct seems to realize the sad happening to his companion of the hunt, the dead Indian.

Giving these murals close review one can only imagine that they really belong to the period of the occurrence though they were painted in our modern era.

The artist has so well-toned his coloring that they are in perfect harmony with the general scheme of the lobby, walls, woodwork. They are well suited for the location.

Under both natural and artificial light, it is easy and requires no effort to perceive every detail, no glaring, and the lighting seems to have been designed for the purpose of showing to advantage this mural.

The right panel is the French trader "Nicholas Perrot." He is a true historical figure, he is seen here paddling a bark canoe, his features are those of vision, of perspicacity and alertness, seeming to be on the constant qui vive and lookout for an incoming enemy or of friends with their pelts for an offer of trade, along the shores of the river seemingly realizing that something is happening in the distance that is attracting his attention, warring Indians or the fire itself. He is a Frenchman, whom his contact and living amongst Indians has somewhat changed his mode of living and appearance, he is wearing buckskin unique; the fur trader has to be shrewd but yet remain friendly with the Indians who are hunting the forest for pelts.

Perrot's influence contributed largely towards the King of France the priceless gift and treasure of the chapel, the "ostensorium." Here also the artist has created a fine personage with typical features of the period, the man from France.

The mural reportedly had a good reception by the De Pere public. The post office was reportedly filled during the mural's dedication, with many people still outside and unable to enter. The principal address was delivered by Reverend Hamilton who was the Dean of Marquette University and a missionary belonging to the same order as Father Allouez.

More about the Artist and the Mural

Lester W. Bentley was born in 1908 in Two Rivers, Wisconsin. He died in 1972 at the age of 64 in Madison, Wisconsin. At the time he was commissioned to paint the De Pere Post Office mural in 1942, he was 34 years old.

He was invited to submit designs for De Pere by the Section on the basis of sketches he had submitted in the West Allis Branch mural competition in Milwaukee, Wisconsin. Bentley studied at the Art Institute of Chicago on a four-year scholarship where he was trained by famous artists. Before being awarded the scholarship, he worked in a commercial studio.

Upon receiving the invitation, Bentley sent in a couple of designs, one of which was found unacceptable. The jury then recommended that he be given another post office under the program.

During the war, Bentley (who was a petty officer) produced other works of art which were just as acclaimed. He particularly specialized in portraits for public and private commissions, the most notable of which is a portrait he made of Dwight D. Eisenhower. His work can be found in many permanent collections. He met and married his wife, Constance, in New York where he stayed after the war.

History of De Pere

De Pere is located in Brown County in Wisconsin. The 2010 Census estimated the city's population as 23,800.[16]

By the time the first European, Jean Nicolet, came to the area between 1634 and 1635, there were already thousands of people living in polyglot settlements. Their primary livelihood was fishing at the Fox River. In 1671, Father Claude Jean Allouez, a Jesuit missionary and an explorer,

came to the area and formed the St. Francis Xavier Mission at the last rapids of the river. The mission was known as Rapides Des Peres (in French) or the Rapids of the Fathers.[17] The mission's aim was to convert the Potawatomi and Ho-Chunk tribes who were the original residents of the area.

After the invasion by the French, they started the fur trade. The French controlled this trade until 1763 when they were overthrown by the British. Twenty years later in 1783, the British were defeated by the Americans who took over the trade.[18] In 1821, the Oneida Indians from New York came to the area, but were forced to go west in 1827 by the white settlement. By 1850, the settlers had constructed a power generating plant along the Fox River that powered one flour mill, two lathe mills and three sawmills.[19]

The main economic activity was agriculture. People grew wheat, potatoes, barley, corn, rye, and oats. The widespread forests of pine, oak, maple, ash, and hickory provided raw materials for lumber and paper, which were exported using Lake Michigan steamers and railroads.

The Former De Pere Post Office

416 George St., De Pere, Wisconsin 54115

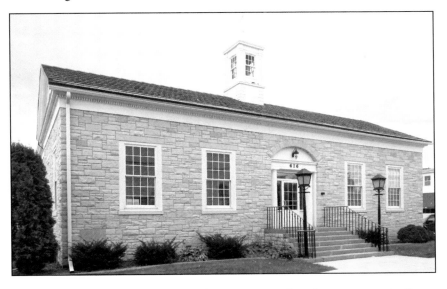

The former De Pere Post Office was completed in 1940 as indicated on the cornerstone on the lower left corner of the building. It reads, *Frank C Walker—Postmaster General. John M Carmody—Federal Works Administrator. W Englebert Reynolds—Commissioner of Public Buildings. Louis A Simon—Supervising Architect. Neal A Melick—Supervising Engineer.*

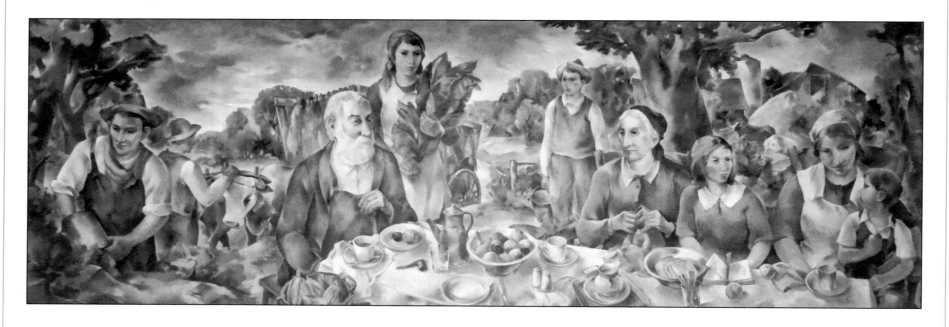

Tobacco Harvest, by Vladimir Rousseff

The mural _Tobacco Harvest_ is oil on canvas, measures 13 feet 4 inches by 4 feet 8 inches, and was installed on May 29, 1941.

EDGERTON

History of the Mural

The commission of $850 was awarded to Vladimir Rousseff of Green Bay, Wisconsin. During the time of painting and preparing the job, Rousseff visited the town of Edgerton and met with the postmaster, where he learned that the primary industry of Edgerton was tobacco farming.

Rousseff wrote,

The theme "Tobacco Harvest" appealed to me as being most romantic and preserving the spirit of the pioneers of the settlement which goes back 60 to 80 years to the days when the tobacco industry in Wisconsin was first begun. A time of peace and rest at the end of the day when the entire family gathered in the open to partake of a meal in the enjoyment of the lovely country and the rich harvest.

Rousseff designed three sketches for the Section to review. Of the three designs that were sent, the Section chose one that depicted a tobacco farmers' family on the basis of its probable public appeal.

Upon receipt of a photograph and negative sent by Rousseff, the Section directed him to proceed with the installation of the mural. They, however, called his attention to the fact that the negative he submitted to them was smaller than was specified in the contract terms he signed. The terms stated he would forward an 8 x 10 negative for their records, but he had instead sent something smaller.

Rousseff next wrote to inform the Section of the mural's installation, sending along a negative (taken of the mural on the wall) of the proper size stated in his contract. He also informed them of his plan to visit Edgerton about a month after his letter in order to put a final coat of varnish on the mural.

The postmaster expressed his (and post office customers') contentment with the mural. The customers felt the artist had rendered a work of the highest quality and that he had also shown great judgment on the subject chosen.

MORE ABOUT THE ARTIST AND THE MURAL

Vladimir Rousseff, the artist who painted the Edgerton mural decoration *Tobacco Harvest*, was born in Sillistria, Bulgaria, on May 24, 1890, and died in Boston, Massachusetts, in 1988 at the age of 98. At the time he was awarded the Edgerton post office mural commission, he was a resident of Green Bay County. He studied at the Art Institute of Chicago along with Albert H. Krehbiel and Randall Davey.

It appears though that Rousseff was interceded for by a friend of his who wrote on his behalf. Prior to being commissioned for the Edgerton mural decoration, Rousseff had been on the WPA and had had all his paintings hung. He had then quit after "he earned a little extra money," which was how his friend described it. Rousseff had taken up his prior job again since he had not been able to support his family. His friend considered him one of the greatest mural artists of their time and believed that he should not be without work. He wrote that the government could do with Rousseff's services as he was an honest and sincere man and that more of his kind of work was needed to preserve cultural values.

Rousseff's work was well known to the Section as he had been commissioned on two previous occasions to undertake mural decorations. In regards to the Edgerton commission he was appointed based on the quality of his work. As a result, Rousseff was invited to undertake the mural decoration for Edgerton on the strength of designs he had once submitted in various competitions carried out under the purview of the Section. The commission he was invited to carry out was for $850.

Rousseff wrote a letter to them accepting the invitation and notifying the Section of his plan to visit the town of Edgerton where he would speak with the postmaster regarding a subject matter suitable

for the mural decoration. Rousseff moved to Green Bay for the winter months which brought him closer to Edgerton. Upon his visit to Edgerton, he met Mr. Hoen, the postmaster, and discussed the subject matter that would be most suitable for the mural decoration. He found out that the chief industry of the town of Edgerton was tobacco. Hoen insisted that the mural decoration depict a phase of that industry as it would have the most relevance and interest to members of the Edgerton community. Rousseff, on the basis of this discussion, then made three preliminary sketches all around the subject of tobacco (two of the sketches related to the sorting, delivery, and packing of tobacco), while the third depicted a tobacco farmer's family in the early days of the tobacco industry in Edgerton, which went as far back as 1850, and was more pictorial. Rousseff also found out during his inquiries that the people of Edgerton were mostly of Norwegian descent.

Rousseff's sketches were carefully considered by members of the Section who felt impressed enough by the character of his work to congratulate him on it. However, of the three preliminary designs that he submitted for their deliberation, they felt that the tobacco harvest had the most significant possibilities for enduring interest among members of the public. They suggested that that design be done in 2-inch-scale color sketch and forwarded to their office for further consideration.

Rousseff made a color sketch of that design, and he then forwarded a negative to the Section of Fine Arts where it was approved for completion and installation.

Rousseff also painted murals for Kaukauna and Iron Mountain, Michigan.

History of Edgerton

Edgerton's area, nicknamed the "Tobacco City," covers part of the Rock County and Dane County in Wisconsin. In the 2010 Census, the population was 5,461 (5,364 in Rock County and 97 in Dane County).[20]

The city was named after Elisha W. Edgerton and his brother Benjamin Hyde Edgerton, a famous businessman and a civil engineer

respectively, in the area in the 19th century. Initially, the city was known as Fulton Station and was well known for its tobacco industry, although the trade has been declining over the years.[21]

During the late 19th and early 20th centuries, the city was a tobacco industry center known throughout the state of Wisconsin. At one time, the city was home to 52 tobacco warehouses and that thriving business was the major source of income.

The Carlton Hotel on Henry Street once acted as surviving proof of the tobacco industry's influence. Although it had been constructed by a brewing firm, buyers and sellers of tobacco were frequent visitors before it burned down in the 1990s. To date, Edgerton's recognition as a tobacco center is evident with its annual cultural events.

The community around the area holds an annual celebration called "Tobacco Days," characterized by living history events, food, music, tobacco demonstrations, family entertainment, and car shows, among other events.[22]

The Edgerton Post Office

104 Swift St., Edgerton, Wisconsin 53534

The Edgerton, Wisconsin post office was constructed by Carl Wesberg & Company Inc., of Chicago, Illinois. The cost of the building when new was about $58,775.

The Edgerton Post Office was completed in 1939 as indicated on the cornerstone on the lower right corner of the building. It reads, *James A Farley—Postmaster General. John M Carmody—Federal Works Administrator. W Englebert Reynolds—Commissioner of Public Buildings. Louis A Simon—Supervising Architect. Neal A Melick—Supervising Engineer.*

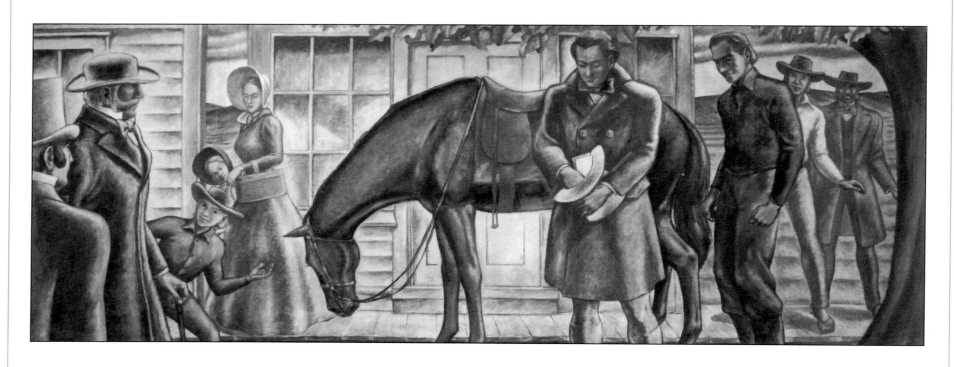

Pioneer Postman, by Tom Rost

The mural *Pioneer Postman* is oil on canvas, measures 12 feet by 4 feet 6 inches, and was installed on June 11, 1938.

ELKHORN

History of the Mural

A commission of $560 was awarded to Tom Rost of Milwaukee, Wisconsin. Rost made three different sketches for the Section to review.

The first sketch was based on the naming and founding of the town. Elkhorn is situated near the geographical center of Walworth County. The sketch included Burr Oak trees characteristic of the town. These trees appeared in other sketches too and are important to the town. One of the large groves of Burr Oaks was preserved in the park of the town's courthouse.

Another sketch made by Rost portrayed the Walworth County Fair. A famous feature of this fair was harness racing. The finest horses that competed in different contests around the country were trained in Elkhorn.

The third sketch that was designed by Rost tells a story of the earliest mail service in the town. The mail was brought down to Elkhorn from Racine on horseback at irregular intervals, and was carried in the postmaster's hat. This particular design attracted the attention of the Section. The only suggestion offered about the sketch was that the landscape and sky (this was between two buildings on the left in the sketch) should not be treated with such definiteness, especially the sky, which initially looked as solid as the architecture. The Section wrote,

There is much handsome drawing in the cartoon, and I congratulate you on it. In transferring the cartoon to canvas, I should like you to consider the suggestion that the second adult from the left be moved into the composition just a little more. This may cause you to make slight changes in the placement of the figures of the mother and the children—possibly moving them slightly right. There is a feeling that the two smaller figures on the extreme right are crowded and it is suggested that they be given a little more room, possibly moving them somewhat more into the background.

Rost made the adjustments that were suggested by the Section, then forwarded them a picture of the mural, expressing hope that they would find his adjustments satisfactory. He had the mural ready for installation by June 11.

The postmaster at the time, Tessa B. Morrissey, sent a report to the Section with glowing reviews of how the mural was well received and was really appropriate. The mural reportedly had the appearance of having been painted directly on the wall even though it was merely hung. Morrissey sent along with her report a newspaper clipping that reported the mural's installation as evidence. Apparently, the newspaper editor had taken an art course at the Chicago Art Institute, and he approved of the work as a fine piece of art.

More about the Artist and the Mural

Rost was born in 1909 in Richmond, Indiana, and died in 2004 in Cedarburg, Wisconsin. He was a resident of Milwaukee, Wisconsin, when he was commissioned to paint the Elkhorn mural. Rost sent three sketches to the Section for deliberation after a busy summer attending to jobs that required his attention, thus causing some delay.

History of Elkhorn

Elkhorn is located in Walworth County, Wisconsin, and is also the county seat. According to the 2010 Census, the town had a population of 10,084.[23]

Horace Coleman, Hollis Latham, and LeGrand Rockwell were the first people to spot Elkhorn in the 1800s.[24] They were looking for an area to build a village when they came across the land with rolling contours covered with oaks and a rich, black loam soil, with some elements of clay, a characteristic that was ideal for farming. An army trail crossed through the area, an indication that it had already been sur-

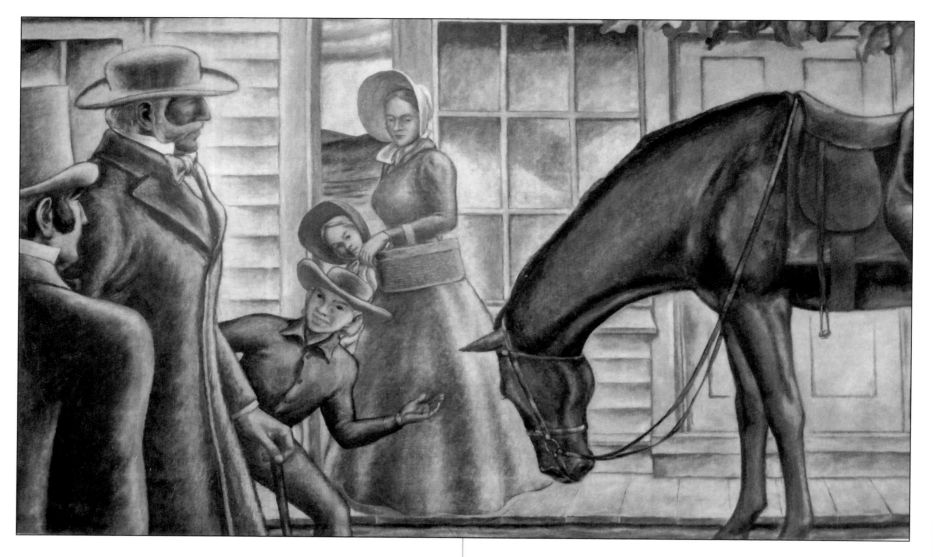

veyed. The city was given its name by Col. Samuel F. Phoenix who had spotted a rack of elk antlers there in 1836.

Due to its location (at the middle of a slough), the land looked worse during the winter, but being near a watershed, it was desirable for farming in the summer. Rockwell informed his brother John Starr, who was at the time working as a government clerk in Milwaukee, of available land. Starr came in February 1837 with his friend Milo E. Bradley and set up a housekeeping tent about a mile east of the city, then filed claims to clear the land for dairy farming.

In January 1838, the area was established through a territorial legislature and included four towns, namely, Whitewater, La Grange, Sugar Creek, and Richmond. By 1846, the population had grown to 539.[25] Its main economic activities remained farming and livestock-keeping.

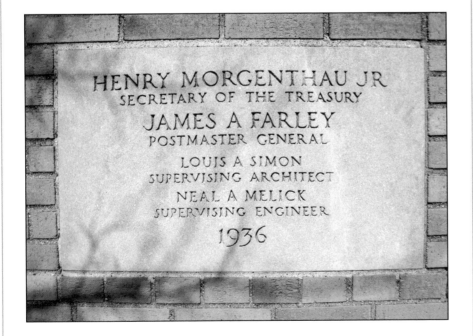

The Elkhorn Post Office

102 E. Walworth St., Elkhorn, Wisconsin 53121

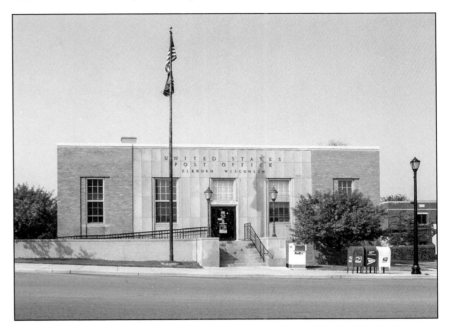

The Elkhorn, Wisconsin post office was constructed by J. P. Cullen & Son of Janesville, Wisconsin. The cost of the building when new was about $49,700.

The Elkhorn Post Office was completed in 1936 as indicated on the cornerstone on the lower right corner of the building. It reads, *Henry Morgenthau Jr—Secretary of the Treasury. James A Farley—Postmaster General. Louis A Simon—Supervising Architect. Neal A Melick—Supervising Engineer.*

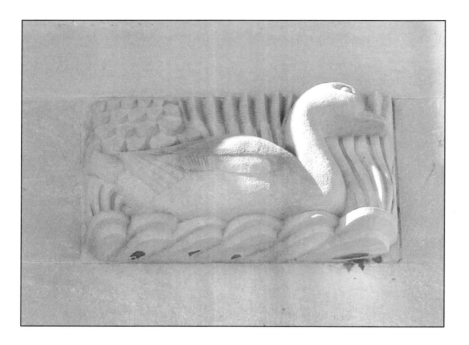 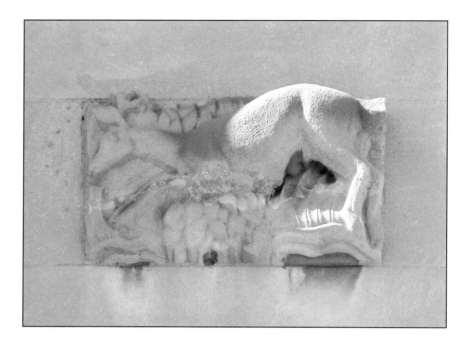

Birds and Animals of the Northwest, by Boris Gilbertson

The former Fond du Lac Post Office has eleven sculptures on the façade of the building. The eleven spandrel sculptures on the building, *Birds and Animals of the Northwest,* are limestone reliefs and were completed on October 25, 1937.

FOND DU LAC

History of the Mural

A commission of $3,300 was awarded to Boris Gilbertson of Chicago, Illinois.

As a result of competent designs submitted by Boris Gilbertson in the National Sculpture Competition for the Bronx Post Office in New York City, the Section of Painting and Sculpture awarded the Fond du Lac sculpture to him and asked that he carry out eleven stone carvings on the Fond du Lac building's façade spandrels with the contract to be drawn up upon approval of his designs.

Upon the completion of the design and its subsequent submission to the Section for review, Gilbertson was informed that his work was received with enthusiasm and that the Director of Procurement approved of it. They offered no specific criticism of the work except a minor suggestion that he further study the head of the grouse and the feet of the bird so that the sculpture would not look as though the lower part was cut out.

When Gilbertson made a short trip to Fond du Lac, Wisconsin, to take a look at the post office, he found that scaffolding for the sculptures was not yet in place, even though he was to begin work on the sculptures the week after.

After his inquiry into the scaffolding, Gilbertson was told that there were certain details that were yet to be worked out with the contractor.

After Gilbertson failed to receive his contract as promised, he sent a letter to the Section inquiring as to what caused the delay in his receiving his contract. He also informed them of certain difficulties he was facing financially due to his having put his other works on hold and having not heard anything from them. After receiving no reply to his letter, Gilbertson once again wrote to them concerning the Fond du Lac building sculpture. He noted in his letter the lack of income and asked that they forward him his contract as well as the first payment which he was due to receive on acceptance of his models and drawings.

Gilbertson sent yet another letter, this time to another member of the staff, after which he received a reply that the complications involved in the sculpture work would be resolved within two weeks. Thereafter, the amount of $3,300 was authorized as payment for execution of the approved models and sculpture on the Fond du Lac Post Office building spandrels, information that was communicated to him in a letter along with a contract for Gilbertson to sign.

It was getting late in the year at the time of their reply, and it seemed that the changing climate would interfere with the completion of the work within the time they had anticipated. Gilbertson was informed that he would hear from the building contractor after which they would appreciate a statement from him regarding the time it would take him to complete the stone carving.

They eventually decided to award him a contract that would enable him to provide the scaffolding and all the other work required for designing and carving the eleven sculptures on the building spandrels.

The Section recommended a proposal from the contractor for a $2,500 credit, exclusively for the execution of sculptures for Fond du Lac. They also recommended a credit for the scaffolding which was necessary for the execution of the sculpture. This brought the total amount required for the execution of the stone carving by the sculptor to $3,300, which was communicated in a letter to Gilbertson. They also informed Gilbertson of their ongoing attempt to take his stone carving out of the general building contract (as the post office was being built at the time the artist was commissioned to add the sculpture). This would give Gilbertson ample time to complete the sculptures without interfering with the building's construction in any way. They were of the opinion that the arrangement would afford Gilbertson a higher degree of freedom and space to work on his sculptures unhindered. The Section felt that the carving of the sculptures should be postponed till after the weather cleared since it was late in the year and the season

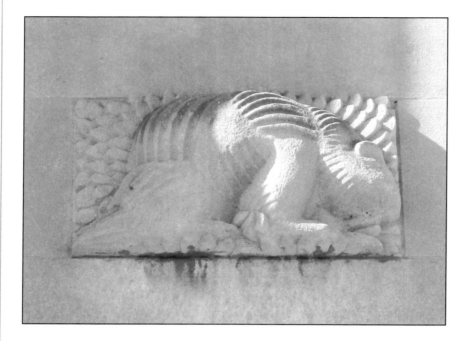

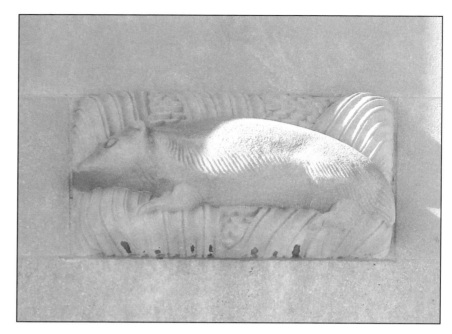

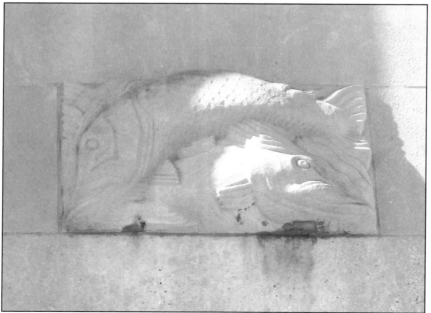

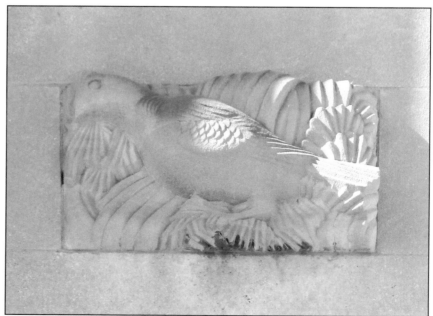

Boris Gilbertson, *Birds and Animals of the Northwest*

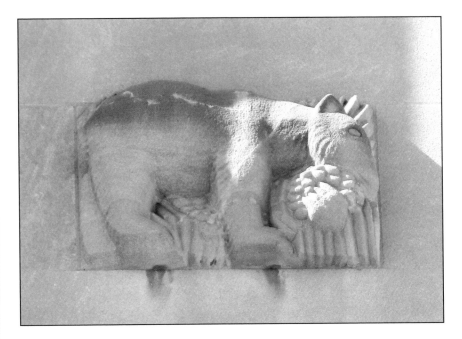

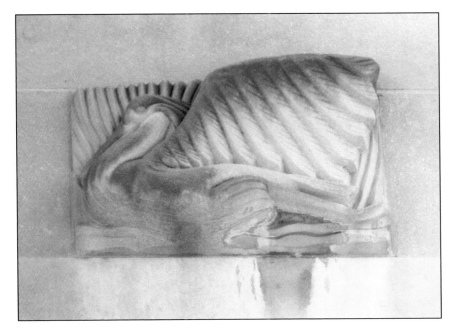

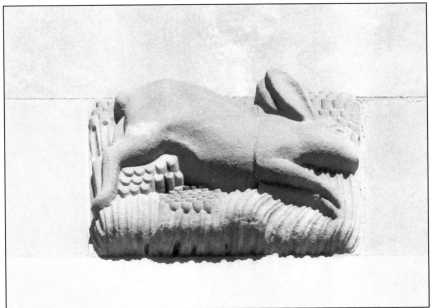

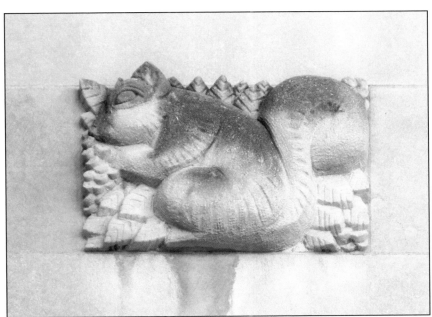

Boris Gilbertson, *Birds and Animals of the Northwest*

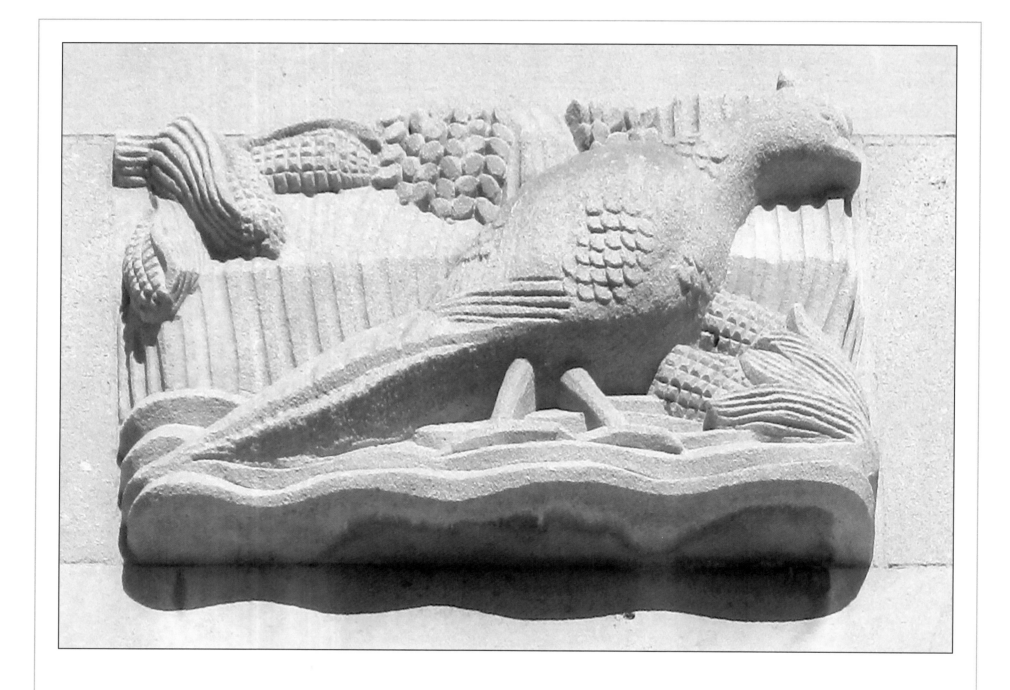

Boris Gilbertson, *Birds and Animals of the Northwest*

was changing. They asked that he send a statement to them as to his stance on that matter.

Gilbertson replied that it was impractical to attempt the Fond du Lac Post Office building sculpture at that time as the weather conditions of the succeeding months would not be favorable. He stated that he would need about four months to complete the work and proposed a starting date of the first of April. Gilbertson expressed appreciation at having been informed of the progress taking place; he also expressed hope that all arrangements for the project would be concluded in a satisfactory manner.

The Fond du Lac postmaster suggested to Gilbertson that instead of the Cedar Waxwing sculpture, he sculpt a pheasant. This view, the postmaster reported, was supported by many people in the town. And because of the fact that many of the town's citizens had taken an interest in the work, Gilbertson proposed that the Section approve the change of subject, following which he would make a design for the pheasant sculpture. However, as time was running out, he asked that he be informed as soon as possible so that he would be able to finish the work. His estimated completion date was one month.

He thereafter forwarded photographs of his progress to the Section, and Gilbertson was informed that if he was willing to put in the extra work required to change the design, they would approve it. As soon as his new design was received, the matter would be taken up with the supervising architect. The suggestion of replacing the Cedar Waxwing carving with that of the pheasant was reported to be satisfactory and acceptable. They wrote that they would look forward to seeing the design when he was done.

The question of whether he had decided on which material to use (whether marble or cast stone) was posed after which mention was made of a structural drawing of the building wall, which was supposed to help in determining the method of installation. Gilbertson replied that he preferred a 3-inch scale, which made it easier to be certain of details, as opposed to the one in their specifications.

He sent with his letter four photographs of the reliefs which had been completed in Fond du Lac. Along with these pictures, he also forwarded negatives as well as photographs of different views of the building. He also forwarded a drawing of the pheasant which he had proposed as a substitute for the Cedar Waxwing, and asked that he get a definite reply on the matter quickly so as to avoid any delay in his completion of the work.

The Section was satisfied with Gilbertson's work, congratulating him on the "high quality" of work done. They also thanked him for keeping faith with his contract and finishing the work in the time stated.

Gilbertson was then asked to forward the preliminary sketches of his remaining relief work, after which he was mailed his final installment of the commission.

MORE ABOUT THE ARTIST AND THE MURAL

Boris Gilbertson was born in 1907 in Evanston, Illinois, and died in 1982 in Santa Fe, New Mexico. At the time he was commissioned for the Fond du Lac work, he was a resident of Chicago.

Gilbertson lived his early years in Minnesota, Wisconsin, and Indiana. He studied sculpture at the Art Institute of Chicago with Emil Zettler and won the Joseph Eisendrath Prize in 1933. He then did some architectural decorations for the stadium situated in Beloit, Wisconsin. He has had his works exhibited and displayed in both public and private galleries.

Upon sending him an invitation for the commission, the Section of Painting and Sculpture requested that he send a statement of his experience in stone carving. The following is the list that he sent to the Section for their records:

1. *Over six months carving stone as an apprentice in the studios of Alfonso Lanelli, Park Ridge, IL.*
2. *Since 1932, various types of architectural decoration, designed and executed by myself, principally for Maurice Webster, Architect, Chicago.*
3. *Work for exhibitions, including figures, animals, etc. Most of my work has been in stone or wood.*

4. *I understand the use of air hammers and the manipulation of various types of stone, but have had little experience with granite. I understand polishing and finishing. Also I have thorough knowledge of wood carving which is generally regarded as an asset to stone carving. All experiences, except the apprentice work has been on my own designs.*

5. *Individuals familiar with my work who are capable of judging as to both technical and designing ability are Emil Zettler, Professor of Industrial design, Art Institute of Chicago, Maurice Webster, Architect, Chicago, Theodore Hofmesster, Architect, Chicago, Increase Robinson, Federal Art Project, Chicago.*

Gilbertson was singled out from a list of sculptors who had had their work submitted in competitions within the vicinity of Chicago. The architect of the Fond du Lac building had admired photographs of a particular brass Gilbertson had done under the PWAP. In the opinion of the architect, the subject matter that was most suitable to use for the cartoons would be the variety of animals and birds that lived in the locale of the building. This was because of the impracticality of using human figures: The space available for the reliefs was quite small and could only comfortably accommodate bird and animal figures. Gilbertson had a considerable ability with subjects of this type as he had handled quite a number of similar works.

The Section's letter was sent on July 2, and when Gilbertson received it, he promptly sent a reply in which he stated that the models and cartoons for the post office building in Fond du Lac would be ready and sent to them a couple of days later. At the time he sent his letter, he was working on 2-inch-scale model of the sculptures. He was also working on ten sketches as he believed that that would be a good way for him to show what he had in mind regarding the sculptures. He, however, wrote that there might be some difficulty in him finishing the carving before the requested date of October.

He made a full-size model, ten two-inch-scale models, as well as ten full-size drawings of what he had in mind for the post office building reliefs and sent these in for the Section's consideration.

He intended to use the full-size model as the central panel while the other models were intended to face towards it (the full-size model) with the animals alternating with the birds and properly arranged by mass on the two sides to ensure balance.

Members of the Section were delighted with the way he had handled the decorative scheme and noted his statement of the animals being alternated with the birds so as to ensure balance. No specific criticism was offered of the work although the suggestion was made that he study the head of the grouse as well as the feet of the bird. They then expressed confidence in his ability to handle this "minor" criticism in further development of the work.

Gilbertson asked that they send him back the models so he could use them to start work. Prior to that time, they had not made any mention of the type of stone that would be used for the sculpture, and so he assumed that it would be limestone.

Because of the short timeframe he had in which to finish the job, Gilbertson had to use an air hammer (which was quite expensive) and an expert stonecutter in roughing out materials so that he would be able to finish the sculpture on schedule. This, however, meant that the initial expense he had calculated and expected the sculpture to incur had been surpassed; consequently, he could not proceed with the work until they forwarded his contract to him which enabled him to receive the first installment for the work.

History of Fond du Lac

Fond du Lac is located in Fond du Lac County in Wisconsin, on the southern part of Lake Winnebago. Its location is where the name "Fond du Lac" is derived from, which means "Bottom of the Lake" in French.[26] According to the 2010 Census, the town had a population of 43,021.

The first settlers arrived in the 17th century. The communities inhabiting the land by this time were the Ho-Chunk Indians, with Potawatomi and Menominee as their neighbors.[27] In 1836, it was nearly voted as the capital for the Wisconsin territory, but it lost to Madison with a single vote. However, its location attracted influential

leaders like James Duane Doty and Nathaniel Tallmadge to pioneer its development. They influenced the establishment of the railroad, schools, and agricultural societies.

The Military Ridge Road was commissioned in 1835 and passed through the town connecting to various forts in the county and Fort Dearborn in Illinois. In 1843, the first school was constructed. These amenities opened the town to many immigrants. The German, Irish, Scottish, Welsh, and Dutch immigrants came in large numbers between 1850 and 1880. By 1870, the city had become the second largest in the Wisconsin territory and a major railroad hub. Its main economic activity was wheat production. Its production capacity was second after that of Duane County.[28] Even up to well into the 20th century, Fond du Lac was still a commercial hub for agricultural products.

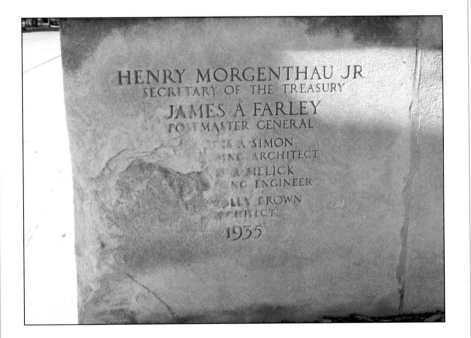

The Former Fond du Lac Post Office

19 W. 1st St., Fond du Lac, Wisconsin 54935

The former Fond du Lac, Wisconsin, building was constructed by J. P. Cullen & Son of Janesville, Wisconsin. The cost of the building when new was about $158,321.

The former Fond du Lac Post Office was completed in 1935 as indicated by the deteriorating cornerstone on the lower left side of the building. It reads, *Henry Morgenthau Jr—Secretary of the Treasury. James A Farley—Postmaster General. Louis A Simon— Supervising Architect. Neal A Melick—Supervising Engineer. R Stanley Brown—Architect.*

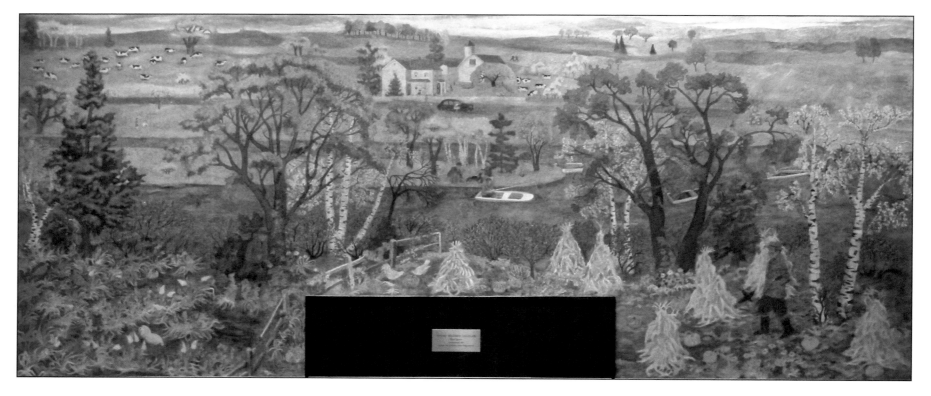

***Autumn Wisconsin Landscape,* by Ethel Spears**

The mural *Autumn Wisconsin Landscape* is oil on canvas, measures 12 feet by 5 feet, and was installed in April 1940.

HARTFORD

History of the Mural

A commission of $720 was awarded to Ethel Spears of the city of Chicago. A report in a newspaper in Hartford on May 10, 1940, after the installation of the mural gave the following description of it:

The mural depicts a Wisconsin rural autumn scene. Bright trees and shrubbery, the golden birch, brilliant sumac and maple and oak, blue and golden flowers are to be observed. Also the comfortable farmhouse with the neat barn and silo are conspicuous as are the Holstein cattle, so unusual in the area. True to their autumn activities, hunters are on the landscape, while on the riverboats lazy fisherman can be noted. Shocks of corn and pumpkins without which no Wisconsin fall-time would be quite complete, are also depicted. Even the automobile drawn up in front of the country residence and children here and there are a part of the delights of autumn season. (Hartford Times Press, May 10, 1940)

Spears visited Hartford's postmaster, hoping to discuss the subject matter for the mural that would be painted in the building. She had with her two mural sketches which she had submitted to the Wausau mural competition: One of these sketches depicted an autumn landscape in Wisconsin while the other depicted a winter landscape. She reported that the postmaster (along with his assistant who was present for the discussion) preferred the sketch depicting autumn in Wisconsin to that depicting winter. A number of changes were suggested so as to have the sketch look more like the town of Hartford with oaks, elms, cedars, and maples suggested replacing the tall hemlocks that were in the Wausau sketch. Meanwhile, Spears had painted the postmaster's car in the Wausau sketch in such a way that he would have had to get out of his car to put the mail in the mailbox during delivery. This, she was informed, was against county rules; she thereby noted her deci-

sion to paint the car in a way such that all the postmaster would have to do to put the letter in the mailbox would be to lean out of his car window. She also decided to add several fishermen as well as pheasants in the grass.

Spears forwarded a 3-inch-scale color sketch of the mural design, which was then approved by the Section. The Hartford mural was a bit larger than the Wausau sketch, which prompted her to add to the ends of the Wausau sketch as well as to the bottom so that it would fit into the space reserved for it. Spears mailed a photograph of the full-size cartoon for the Hartford decoration. After studying it, the Section suggested that she change the way the figures were rendered: The Section asked that the running boy be better placed, and that she should consider placing the hunter near two trees that stood on the far right of the painting.

As Spears worked on the mural, she realized that she might not be able to finish it by the contracted time, which prompted her to ask for a month's extension. The Section granted her the one-month extension she had requested, and upon completion, Spears forwarded photographs of the completed mural for Hartford.

The members felt that the work had been done in a satisfactory manner. However, they felt that the photograph was not high enough quality to be reproducible for the press. They asked Spears to obtain a better photograph and send it with the negative. The Section also stated that, based on reviews of other murals done under this scheme, a number of rectangular panels were found to be difficult to relate architecturally to other features of the wall on which they were installed. It was then suggested that one of the warm colors that had been used in the mural painting be used around the door and bulletin boards in the vicinity of the mural so as to make a complete architectural unit. Spears was asked to make a simple ½-inch-scale drawing show-

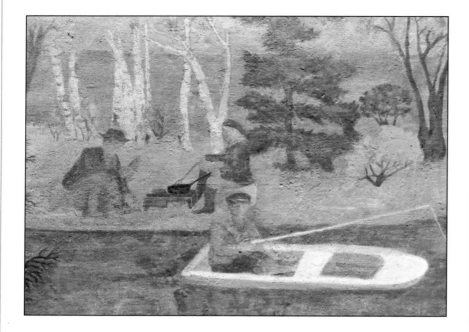

ing the incorporation of her proposed colors before going ahead with the installation.

After Spears sent the photograph and drawing, the Section approved the installation of the mural. A week after the installation, Spears suggested a coat of starch for protection after which washing with a particularly mild solution of ivory soap was to be used for cleaning when necessary. She also communicated her intention to apply a second coat of paint on the area surrounding the bulletin boards directly under the installed mural.

MORE ABOUT THE ARTIST AND THE MURAL

Ethel Spears was born on the October 5, 1903, in Chicago, Illinois, and died on August 2, 1974, in Navasota, Texas. At the time she was awarded the commission for the Hartford mural, she was living in Chicago.

Upon receipt of the invitation for the mural decoration, Spears decided to go to Hartford, Wisconsin, with the sketches she had sub-

mitted for the Wausau Post Office mural competition, to discuss with the postmaster whether one of her two sketches could be adapted to the town. She intended to make either of her sketches fit the space reserved in Hartford for the mural by adding to either side of her Wausau sketches.

Spears intended to use the same canvas material that had been used by George Neville Smith for his Treasury Department murals and asked the Section for permission. The Section asked that she submit a sample of the canvas she intended to use, as it was essential that pure grade linen be used, especially if the work was executed in oil.

History of Hartford

Hartford is located in Dodge and Washington Counties in Wisconsin. According to the 2010 Census, the city's population was 14,223, all residing in Washington County.[29]

The first people to arrive in the Hartford area and give it a name were settlers from New England in the 1600s. These were part of the New England farmers who were migrating towards the west, heading to the Northwest Territory. They cleared the land, started farms, and established postal routes. Farming would become the main economic activity by the beginning of the 1800s.[30]

The first people to survey the land were Nicolas Simon and John Thiel in 1846. However, the man behind the construction of the town was Timothy Hall, who took possession of 100 acres in August 1842.[31] Before it was surveyed, Jehial Case had earlier come to the area with an intention to settle, which he did. In the summer of 1843, Timothy Hall, a Canadian, joined Case. In 1844, Case sold his improvements, which included a shanty and a small clearing, to a Mr. Scheitz.

In 1844, Simon came back accompanied by Charles and James Rossman, bought a 40-acre tract, and constructed a dam. The dam produced

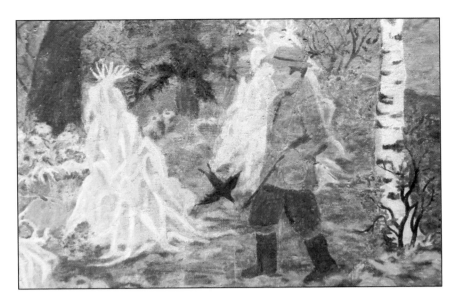

power to run a sawmill erected by the Rossmans. In 1855, the railroad was laid, linking the area with Milwaukee, Minneapolis, Chicago, and La Crosse, which increased the growth of the lumber trade.

The Former Hartford Post Office

35 E. Sumner St., Hartford, Wisconsin 53027

The former Hartford, Wisconsin, post office was built by A. H. Proksch of Iron River, Michigan. The cost of the building when new was about $48,560.

The former Hartford Post Office was completed in 1937 as indicated on the cornerstone on the lower right corner of the building. It reads, *Henry Morgenthau Jr—Secretary of the Treasury. James A Farley—Postmaster General. Louis A Simon—Supervising Architect. Neal A Melick—Supervising Engineer.*

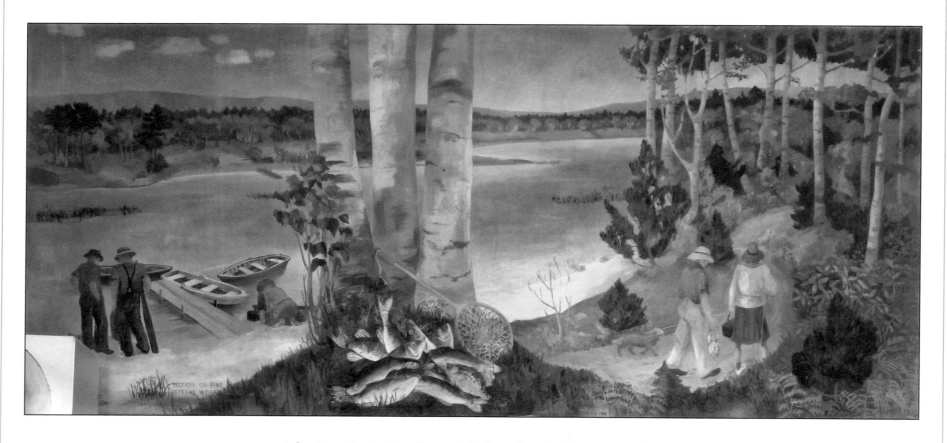

The Land of Woods and Lakes, by Stella E. Harlos

The mural *The Land of Woods and Lakes* is oil on canvas, measures 9 feet 8 inches by 4 feet 7 inches, and was installed in June 1942.

HAYWARD

History of the Mural

A commission of $750 was awarded to Stella E. Harlos of Milwaukee, Wisconsin. Harlos reportedly had a good reception upon her visit to Hayward, Wisconsin, where she had gone to source materials for the mural. She was informed by the postmaster and the staff of the post office that businessmen and the chamber of commerce in the town had been making inquiries about a mural.

The residents of the town were very cooperative and quite willing to provide her with information and ideas. The murals that had been installed in nearby towns had been seen by some of the residents, which was apparent from their conversations and comments to Harlos. Upon her visit, she noticed that Hayward was surrounded by woods and had lakes. The lakes attracted fishermen, while the woods attracted hunters. The whole town was like a tourist attraction, at least for people who wanted to experience a place little touched by civilization. The major influx of cash to the town (according to her) was the fishermen, campers, hunters, and visitors.

She made sketches of her proposed mural decoration in which she attempted to include birches and pine trees, lakes, and "the best fishing in the country," according to Hayward residents. Harlos forwarded her color sketches to the Section. She noted that, due to space constraints, she had left out the ferns, wildflowers, and shrubbery that were native to that part of the country, but that she intended to include all these details in the large mural painting.

The Section suggested that she further make the painting authentic in her handling of the vegetation as the work progressed. They noticed that the figures on the path in the mural seemed a bit small, especially when compared to the treatment of the fish in the mural's immediate foreground. It was felt that this could be revised in the cartoon she was to make.

Harlos proceeded to send an 8 x 10-inch negative as requested and a print of the black-and-white sketch she had made for the Hayward decoration, which the Section found satisfactory. Upon completion of the mural, she invited Ms. Partridge of the Layton Gallery of Art to view her work, who then invited Harlos to exhibit the work in the gallery during an American Library Association convention that was being held in Milwaukee, Wisconsin.

During installation, there were quite a number of comments from residents who came into the post office to view the mural, including one made by a man who had come in while she and the building's janitor were getting things ready. He saw the canvas on the floor, scratched his head, and exclaimed, "Holy Jesus, a painting."

Upon reception of the photographs and negative of the mural, the Section initiated the payment of the final settlement and sent a letter to the Hayward postmaster for confirmation of installation of the mural. He replied, "It is a beautiful addition to our new Federal Building. All patrons speak very highly of the painting and advise all tourists to stop at the Post Office and see the mural."

MORE ABOUT THE ARTIST AND THE MURAL

Stella E. Harlos was residing in the city of Milwaukee, Wisconsin, at the time she was commissioned to paint the Hayward mural.

The Section sent her an invitation to produce designs for a mural painting for Hayward based on the quality of sketches she had sub-

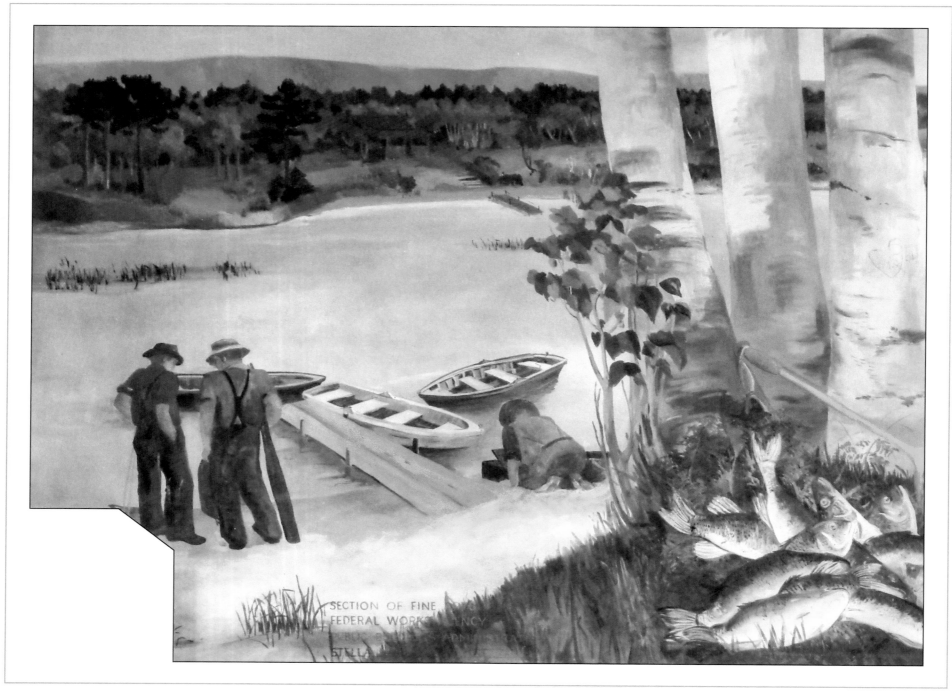

Inside the image: SECTION OF FINE FEDERAL WORKS AGENCY ... STELLA

Stella E. Harlos, *The Land of Woods and Lakes*

mitted in the Milwaukee, West Allis mural competition. She planned to visit Hayward within two weeks of getting the letter, and to meet with the postmaster there to discuss what subject matter she would use in her mural decoration. After this, she would make preliminary sketches for the Section.

History of Hayward

Hayward is located in Sawyer County in Wisconsin. According to the 2010 Census, it had a population of 2,318.[32]

The founder of the city was Anthony Judson Hayward, who came to the area in the 1870s. He was attracted by the large area of seemingly inexhaustible pine lumber, making the area an ideal location to construct a lumber mill. The railroad was laid in 1881, and in the summer of 1882, power dams to power the lumber mills were erected on the Namekagon River. However, since these mills were small, a larger mill was erected and was completed in 1883.[33]

The Hayward Post Office

10597 Main St., Hayward, Wisconsin 54843

The Hayward Post Office was completed in 1940 as indicated on the cornerstone on the lower left corner of the building. It reads, *Frank C Walker—Postmaster General. John M Carmody—Federal Works Administrator. W Englebert Reynolds—Commissioner of Public Buildings. Louis A Simon—Supervising Architect. Neal A Melick—Supervising Engineer.*

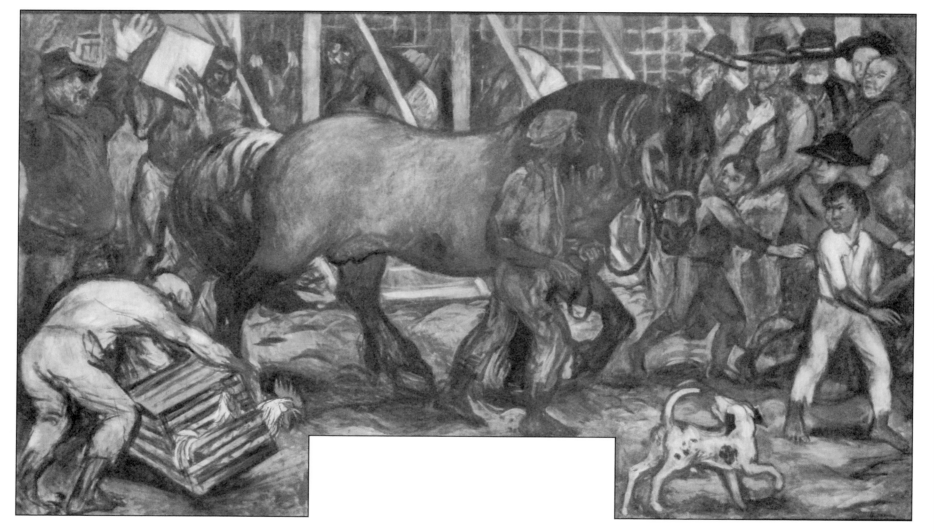

Unloading a River Barge, by Ruth Grotenrath

The mural *Unloading a River Barge* is tempera on canvas, measures 12 feet by 6 feet, and was installed on September 29, 1943.

HUDSON

History of the Mural

The commission of $750 was awarded to Ruth Grotenrath. Grotenrath was chosen for the Hudson mural decoration on the basis of competent designs she had submitted in the Social Security Mural Competition. Grotenrath made four preliminary sketches and forwarded them to the Section, after which she was directed to forward a two-inch color sketch. The eventual sketch was a different design from the black-and-white sketch which she had previously forwarded, even though they both depicted the same subject of a riverboat being unloaded on the Hudson River. The reason for her changing the design was that, upon enlarging of the original design, she noticed a weakness which would have rendered the mural unpalatable. She expressed hope that her new sketch would be approved.

The Section of Fine Arts thought that the color sketch's design was a welcome development and that it was an improvement over the initial black-and-white sketch. She was then directed to make a full-size cartoon of the design with a photograph and negative. But upon receiving the picture and negative of the cartoon, the Section was not enthusiastic about several features: for example, the head of the cow in the painting was out of scale with the body of the same cow, and the drawing of the figures in the cartoon was hasty and careless (one of these figures had three hands). It was felt that Grotenrath was not working up to her potential and authorization on the work was withheld. She was asked to thoroughly go through the cartoon drawing, make the necessary adjustments, and send another photograph and negative for their consideration.

A voucher covering the cartoon payment was, however, sent to Grotenrath so as not to inconvenience her. She was asked to revisit the work and subsequently submit a new photograph. She was also asked to submit an architectural rendering depicting the intended placement of the mural decoration on the wall of the post office relative to the position of other items.

The reason why they requested an architectural rendering was that in previous communications the Hudson postmaster had written that he gave Grotenrath the dimensions of the space above the door of the postmaster's office but not that of the space around it. But in a letter, Grotenrath stated that the mural would be installed "over and around the postmaster's door." This phrase evoked the feeling that the mural painting would extend downward on both sides of the door to the postmaster's office, resulting in interference with the bulletin boards in the public lobby.

She was asked to clarify what she meant so that plans would be made accordingly. Grotenrath noted the excerpt included in the postmaster's letter and wrote to them explaining her statement: The mural—according to her—was meant to occupy the free space above the door of the postmaster's office as well as that above the bulletin boards. She subsequently assured them that no interference whatsoever would occur with the bulletin boards.

It appears, though, that Grotenrath did not as at that time send any update as to how work was going on the new cartoon drawing that she had been asked to make. The Section therefore advised her to be prompt in completing the mural since the government could levy penalties by means of administrative costs when artists delayed the work they were commissioned to do.

Grotenrath's eventual revisions of the cartoon were found acceptable, and it was regarded a significant improvement over her former cartoon. At the time she was commissioned to work on the Hudson mural, she was also working on a mural for the post office at Wayzata, Minnesota. She sent the Section the contract details and technical outline for that mural as well as a photograph of the completed mural for Hudson. The Section replied that the mural was indicative of "an extremely lively, entertaining and spirited painting." A few revisions were called for, though: For instance, certain areas under and at

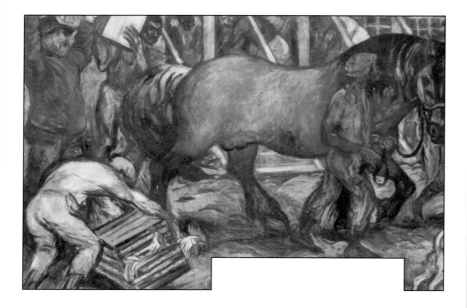

the back of the horse depicted in the painting needed more definition and clarity, and the lower extremities of the figures on the right in the background were not appropriately realized with the same authority characterizing the other parts of the panel. A hasty tracing was sent to her indicating the areas where they felt corrections were needed, and she was then directed to forward a photograph of the painting along with a negative after she was done making the changes requested.

Grotenrath's final correction was accepted. But the postmaster was not impressed with the painting, which he pointed out in a letter to the Section of Fine Arts: paintings like that done by Grotenrath were not what the Federal Works Agency had in mind for the walls of the new, beautiful post office buildings.

The Section, however, supported Grotenrath. They wrote that people familiar with mural paintings would appreciate and respect the piece Grotenrath had painted for the Hudson Post Office. After this, they wrote to Grotenrath, urging her to find a way to get the mural installed in Hudson without delay as the postmaster had again written to them on the subject.

The Section of Fine Arts was liquidated on June 23, 1943. However, efforts were made to settle and fulfill all commitments engaged in by them. The mural was eventually installed on September 29, by John K. Daniels. The postmaster apparently never felt satisfied with the mural as indicated in a letter he wrote:

> You read the comments from the newspaper I sent you and I do not care to add anything more other than it's a damn shame to have such a painting on the walls of this beautiful Post Office Lobby.

MORE ABOUT THE ARTIST AND THE MURAL

Ruth Grotenrath was a resident of Milwaukee, Wisconsin, at the time she was commissioned to work on the Hudson mural. *The Hudson Star-Observer* wrote the following about the mural:

> The theme of "Unloading a River Boat." It goes back to the days when hundreds of Mississippi river packets docked at Hudson every year. The boat is indicated in the background. Deckhands are doing the work, with townspeople in everybody's way. A fine big draft horse, somebody's dog and a red combed white rooster thrusting his head out of a crate in the foreground. At the extreme right is a small Indian boy. The dock hands are black as well as white. The whole scene is animated and presented in rather agreeable colors.

History of Hudson

Hudson is located in St. Croix County in Wisconsin. According to the 2010 Census, the town had a population of 12,719.[34]

The first person to settle in Hudson was Louis Massey in 1840, accompanied by Peter Bouchea, his brother-in-law. They were joined by William Steets. Later in the same year, Joseph Sauperson, commonly referred to as Joe LaGrue, built a residence. The four men were

the first residents in the area and are considered to be the ones behind the growth of the town. Massey and Bouchea built their residences near the Willow River mouth, along what are presently called First and St. Croix Streets. In the 1840s, other settlers came to the area, including the Noble brothers, Captain John Page, Amah Andrews, Colonel James, Daniel Anderson, and Philip Aldrich, among others.[35]

The town was initially called Willow River, but the founder of River Falls, Judge Foster, renamed it after he returned from the Mexican War. In 1852, a petition to change the name was filed by Almon Day Gray to "Hudson." This name was due to the bluffs along St. Croix that he claimed reminded him of his native New York's Hudson River.

During the 1850s and 1860s, many other settlers arrived in the area, attracted by the lumber industry, which was the main employment and economic activity at that time. The settlers established a number of sawmills across the whole St. Croix Valley area. The U.S. Highway connected the town with other towns in Wisconsin and Minnesota, further opening it up for trade and generating revenue for the town. Hudson has, however, grown from a logging-based economy to a tourist attraction destination with restaurants, hotels, and shops. Hudson is served by Interstate Highway 94[36]

The Former Hudson Post Office

225 Locust St., Hudson, Wisconsin 54016

The former Hudson, Wisconsin, post office building was constructed by A. H. Proksch, of Iron River, Michigan. The cost of the building when new was about $48,560.

The former Hudson Post Office was completed in 1939 as indicated on the cornerstone on the lower left corner of the building. It reads, *James A Farley—Postmaster General. John M Carmody—Federal Works Administrator. W Englebert Reynolds—Commissioner of Public Buildings. Louis A Simon—Supervising Architect. Neal A Melick—Supervising Engineer.*

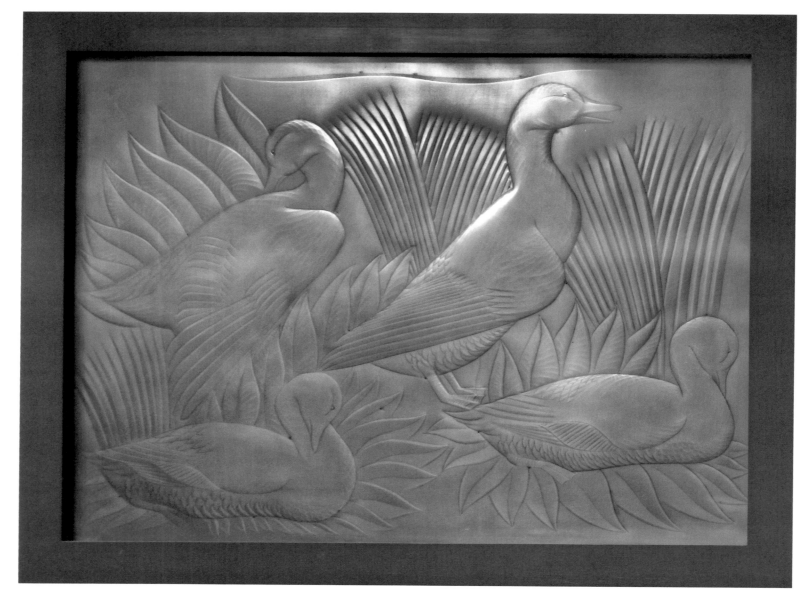

Wild Ducks, by Boris Gilbertson

Wild Ducks is composed of four brushed panels of aluminum and was installed on May 24, 1941.

History of the Mural

The commission of $2,350 was awarded to Boris Gilbertson of Herbster, Wisconsin.

A press release by the Section reported the installation of the aluminum sculpture decoration for Janesville. The release stated the subject matter was the wild ducks of southern Wisconsin and that the sculpture was installed on the public lobby's east wall.

Gilbertson had worked in different mediums prior to that time in his capacity as a sculptor, and like many artists at that time, he had experimented successfully with industrial metals. The metal used for the Janesville sculpture is satin-finish sheet aluminum.

He showed the birds nesting amidst water grasses using four related and similar panels that formed a vertical strip. Another panel above depicted the birds hunting for food in the shallow waters of a lake, while the top two scenes depicted first the birds taking flight and then the birds in flight.

The Section provided Gilbertson with a number of opportunities to portray the wild animals in the Northwest. He was first brought to the attention of the Section by his participation in anonymous competitions that were frequently held to select artists for decorations of federal buildings. The exterior sculpture that Gilbertson had done in Fond du Lac became famous in the Middle West. When he was commissioned to sculpt the decorations for Janesville, he had recently just installed two large bas-reliefs that depicted American moose and bison. He had been commissioned to do these reliefs in the new building in Washington for the Department of the Interior.

He worked from a shack-like studio he built in the woods a couple of miles from Herbster. He was an alumnus of Chicago Art Institute and worked at a commercial shop in the city of Chicago before making a name for himself. Also, in the years leading up to the commission, he had traveled extensively across the Northwest, earning a living doing various jobs such as farmhand, cowpuncher, and stone blaster for the Union Pacific Railroad.

About his work at Fond du Lac, Gilbertson told an interesting story:

The town is in the midst of a prosperous dairy region of Wisconsin, and at first the conservative farmers were curious but somewhat hostile when I began working on the exterior bas-reliefs. It was particularly interesting to me that on discovering that I had been elected to do the job through an anonymous competition, instead of being appointed through some sort of patronage, they warmed up considerably.

In fact, by the time I had finished my work we all felt we had done the job together. Invariable, their own knowledge of local animals was a complement to my own, and their criticisms were always highly constructive. The Saturday afternoon sessions we used to have in front of the Fond du Lac Post Office, discussing my sculpture, represents some of the best training I've ever had.

More about the Artist and the Mural

[See the listing under Fond du Lac for more information.]

The Section sent Gilbertson an invitation to submit designs for the post office building decoration based on the excellent quality of work that he did on a model submitted in the Federal Trade Commission Building Competition.

The location for the sculpture decoration in the post office building was decided to be the east end of the public lobby. Gilbertson had a choice to design either two sculptures in the round on corbels situated over a particular door number that was highlighted in the blueprint, or a sculpture relief that would be in the inset panel between the two doors. The dimensions for the two sculptures in the round was decided to be about two feet in width by five feet in length, and the architect

preferred that the sculptures be executed in bronze because that was the metal trim that was used in the building's lobby. The dimensions for the relief, on the other hand, were specified to be four feet five inches in width and twelve feet six inches in height, which were the same dimensions as that of the space present over the inset panel's bulletin boards. The material preferred by the Section for the relief was aluminum, while the subject matter was the local fauna.

Gilbertson was of the opinion that the space was better suited for the sculpture and that he had tried a brushed aluminum on it, concluding that the aluminum looked really attractive with the color of the wall, marble, and the bronze trim. He then promised to send aluminum samples for them to approve when he returned to his studio.

The Section was delighted with the aluminum reliefs and the technique he used. Gilbertson decided to create an aluminum model to send to the Section. He had to divide the panel into four, due to the constraints posed by working on the large aluminum sheet stock.

Gilbertson planned to install the panels by fastening them to waterproof marine plywood that had aluminum bar stock of ¼" by 1 ½", which would also serve as a frame/border and would also enable the four panels to be hung together on the wall as a single unit in whichever way the engineering department found agreeable. The weight of the panels along with that of the plywood would not exceed 80 pounds.

Gilbertson chose the animals he would depict on the panels through his observation of the fauna of the Janesville environment. The Section was very pleased with the work, but offered one criticism of the job in the form of a suggestion: The panel that depicted ducks seemed more unified than the other panel which depicted four different species of animals, although he was asked to proceed if he did not feel any lack of unity in the panels.

Gilbertson wrote that he planned to use just one panel for the post office building decoration and that he sent the different panels so that they could make a choice and send their preference for him to

Boris Gilbertson, *Wild Ducks*

Boris Gilbertson, *Wild Ducks*

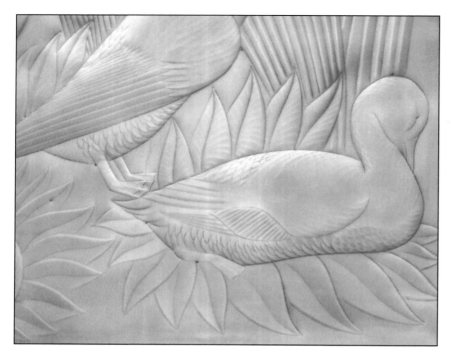

work on. He reportedly preferred the sketch showing the ducks and hoped that members of the Section would feel the same way. The Section in their reply letter apologized for what they termed "acquisitive instincts"—they conceded that it would be overly generous for him to execute the two reliefs for the amount paid in the contract. They chose the duck panel and asked that he go ahead and work on that.

The Section made several suggestions for Gilbertson to consider in his development of the panels; they were of the opinion that the composition he had made did not look very good from the second panel downward to the bottom panel. They suggested that he eliminate one of the ducks in his design and redesign the one in the middle in a way that the composition would appear to be a more obvious V in the panel. The Section also felt that the lower panel in the sketch had a better, more successful design as it had succeeded in creating solidity.

Also, in the cartoon Gilbertson had failed to account for foliage which he had included in his sketch, and he had developed the birds in the cartoon thinly when compared to the solidity and greater mass of the birds in the sketch. They asked that he take notice of these and work on them in the metal version.

Gilbertson agreed that he had let some things slip in the transition from sketch to cartoon, maybe because of the greater attention that he had paid to detailing the ducks. He promised to rework the entire cartoon and send the reworked version to the Section. The aluminum molding, he wrote, would be painted in a dark grey that contrasted with the color of the aluminum panel, as the architect had suggested.

Gilbertson updated the Section by sending photographs of the progress he was making on the project. In the process of making the reliefs, Gilbertson was entitled to a payment of $600 when the project was half finished; this he was to confirm to them via a photograph. Gilbertson wrote that work on the installation of the panel would begin on May 23 or 24 and that it would take about three to four days for him to complete.

History of Janesville

Located to the southwest of Milwaukee, Janesville serves as the seat for Rock County.[37] The area was first surveyed by the United States in 1833 after the resolution of the Black Hawk War. After the survey, news about the fertile land spread eastwards, and settlers retraced the route of the soldiers. This led to the settling and eventual development of Janesville. John Inman and William Holmes were the first men to arrive in the area on July 15, 1835. They stumbled upon the remains of a Black Hawk Camp, liked the land, then sent back to Milwaukee to make plans for the settlement. They returned three months later and began building a log cabin, a structure that still exists in present-day Janesville. More settlers arrived during the spring season.[38]

The city was named after Henry Janes, an American settler and a native of Virginia, who claimed the area for the county seat. He had occupied a small tract of land located on the east side of Rock River where Main Street and Milwaukee Street intersect today. A proposal by Janes to name the town "Blackhawk," after the famous chief, was

Boris Gilbertson, *Wild Ducks*

declined by the government office. A decision was arrived at, and the place was named after Janes himself.[39]

The settlements at Janesville during its founding in 1835 were mainly by American settlers and immigrants from Europe who focused on farming the large tracts of land in the area. Main crops included wheat and other grains.[40]

One of the interesting facts about Janesville is its link with Abraham Lincoln who spent a night in 1859 at the Tallman House courtesy of William Tallman, an influential settler in Janesville. William Tallman at the time had acquired large tracts of land to influence fellow New Yorkers to settle in Janesville. Tallman was a great supporter of the Republican Party and was thus close to Lincoln.[41] The city remained very active during the Civil War. The first dam on the Rock River was built in 1844. The Civil War created a surge in agriculture, and a demand for new farming technology emerged. Currently Janesville has a population of about 65,000 people.

The Former Janesville Post Office

210 Dodge Street, Janesville, Wisconsin 53545

The former Janesville, Wisconsin, post office building was constructed by J. P. Cullen & Son of Janesville, Wisconsin. The cost of the building when new was about $141,932.

The former Janesville Post Office was completed in 1938 as indicated on the cornerstone on the lower right corner of the building. It reads, *Henry Morgenthau Jr.—Secretary of the Treasury. James A Farley—Postmaster General. Louis A Simon—Supervising Architect. Neal A Melick—Supervising Engineer. RW Dewey Foster—Architect.*

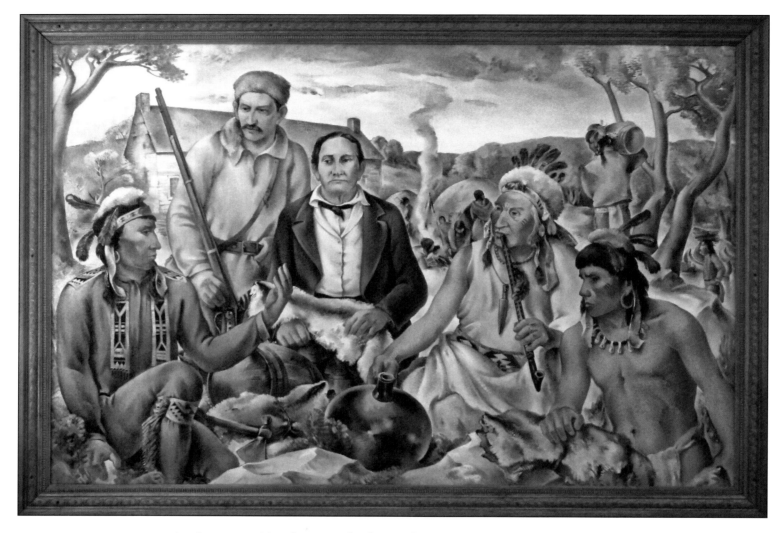

A. Grignon Trading with the Indians, by Vladimir Rousseff

The mural *A. Grignon Trading with the Indians* is oil on canvas, measures 6 feet by 4 feet, and was installed on October 20, 1938.

 The mural painting depicts early morning trading involving the Indians and some trade agents. Augustin Grignon can be seen seated in the center of the painting with the Dominique Ducharme home painted in the background. The Indians are depicted as busy preparing their breakfast while Grignon has a fox hide on his lap which he must have gotten from the Indians in exchange for a barrel of rum, as an Indian is seen walking away with a barrel of rum hoisted on his back. There can also be seen in the painting a French decanter that has been converted to a wine container.

KAUKAUNA

History of the Mural

The commission of $350 was awarded to Vladimir Rousseff who lived in Fish Creek, Wisconsin. Rousseff made a sketch of the design that he had in mind for the members of the Section. The design was approved for further development, and Rousseff was directed to make a two-inch-scale color sketch showing a better realization of the figures (especially the Indians) he had drawn in his sketches. It appears that a sample of the canvas material that Rousseff planned to use was requested by the Section in a letter they sent on December 7.

While working on the two-inch color scale drawing, Rousseff had been in contact with the Kaukauna postmaster, learning more about the costumes of the Indians of that area, including the fact that the feathers worn by the Indian chiefs of that time were different from the ones he had portrayed in his drawings. The Indian chiefs had worn small feathers arranged on a single, fastened bucktail, resulting in it lying from the front to the back across the head. He wrote that he would correct that mistake in subsequent paintings for the sake of authenticity. He planned to leave the movement of the composition and figures the way they were. He felt that feathers were more pictorial and that if further investigation into the matter disclosed that they were worn occasionally, he would prefer executing the composition as it was.

Rousseff went ahead and changed the composition of the tepee in the painting so that he could accurately depict Indian customs and traditions. He incorporated the postmaster's suggestion about the way the Menominee Indians wore their feathers, changing the headgear and painting the chief wearing a fur headdress with a number of feathers. He painted the Frenchmen wearing fastened buckskin tails. The pipe being smoked was of the Menominee style. Outside of these changes, he left the composition and dimensions much the same way he previously had them. The Menominee's costumes and feathers were different from those of other Indian tribes, which he felt gave them authenticity. He said that he would write to inform the Section if any change was required.

When Rousseff finished the painting, the Section commented on the Frenchman depicted in the painting, who, they wrote, had really expressive facial features. They also offered a suggestion that Rousseff undertake further studies of one of the man's hands and arms.

The Kaukauna postmaster was asked by the Section to verify the installation of the mural and to give his opinion on the piece. He informed the Section that the mural was installed above the door that led into the postmaster's office as that was the only place available from which the mural could be seen well. He thought that the mural was a fine piece of art and that the scene it depicted was faithful in its authenticity. Along with his letter, he sent a clip of the *Kaukauna Times* commenting about the mural's installation.

MORE ABOUT THE ARTIST AND THE MURAL

[See the Edgerton entry for more information.]

The Section invited Rousseff to submit two designs for mural decorations in two different towns: Kaukauna, Wisconsin, and Salem, Illinois. The submission of designs for the post office buildings was not competitive. It should be noted that the decision to award two contracts to the same artist at the same time was questioned by the Director of Procurement as evidenced in letters that exist from that time.

The contract for Kaukauna was signed on March 3, 1938, by Rousseff, and it stated that all work on the mural would be completed within the space of one hundred and eighty-one calendar days after the date of the signing unless otherwise extended by the Director. Rousseff was, however, impaired from progressing with the work on a normal basis, and so his contract was modified and the time extended to two hundred and seventy-two days.

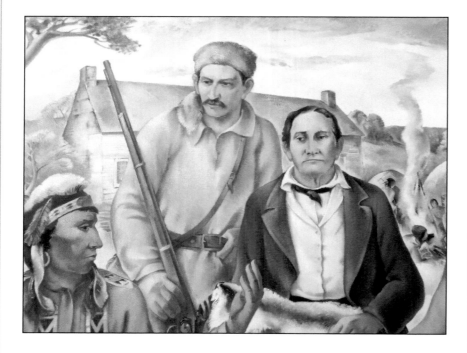

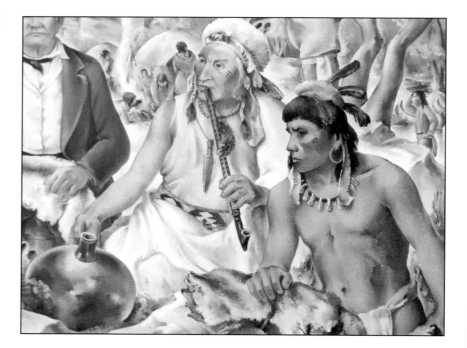

Rousseff had been under the impression that he had about two years to complete and install the Kaukauna and Salem murals. He got this notion from a letter he received on July 23, 1937 and had somehow failed to notice that particular clause in the contract sent to him.

He had, however, finished the Kaukauna mural prior to the time and had outlined a procedure of installation for the two pieces in their respective locations. He wrote that he intended to hold onto the Kaukauna mural until sometime later when he would have finished the Salem, Illinois, mural. This was so he could travel to both towns and have the murals installed. The canvasses were on the small side, and he was of the opinion that they would not constitute much work for him regarding their installation. He asked that the Section inform him if they would rather have another person install the mural so that he could ship one of the murals to Washington, where the Section was

located, for inspection. He then inquired about an extension until December in order to finish the Salem, Illinois, mural.

His request for more time to finish was granted by the Section, but they also urged him to strive to install the murals by the end of November as the postmasters were not fans of artists installing murals or sculptures during the holiday season.

Sometime later, Rousseff informed the Section of the successful installation of the murals in Kaukauna as well as in Salem. Enclosed with his letter were negatives and prints of the murals taken before their respective installations. Also, the prints were a bit enlarged, and he included completed lighting forms. There was a particular fixture at Kaukauna that was a bit of an obstruction which was taken care of; something similar also came up in Salem, which the postmaster there had remedied. Molding was put around the murals, and he was of the opinion that they looked quite good upon installation on the wall.

Vladimir Rousseff, *A. Grignon Trading with the Indians*

History of Kaukauna

Kaukauna is built around the Fox River. Kaukauna was established in 1634 after an explorer traveling the river named it Kakalin.[42] In 1793, Dominique Ducharme obtained land from Indians in exchange for rum and other gifts. It has been given many names connected to pickerel, a fish, abundant in the region. The place mostly harbored Indians and French as they portaged around the river. The main economic activities were farming and fur trading, and the main form of transportation was river travel.[43]

Reverend Jesse Minor, who was leading the Presbyterian Church of North America, founded a school in 1924 in order to prepare people to understand the gospel. The first post office in Kaukauna was built in 1932, and in 1992 the building was listed as a National Historic Site. A mansion that was built in 1828 by Grignon serves as a regional museum. Grignon purchased the land from Dominique Ducharme after Ducharme obtained the land from Menominee Indians.[44]

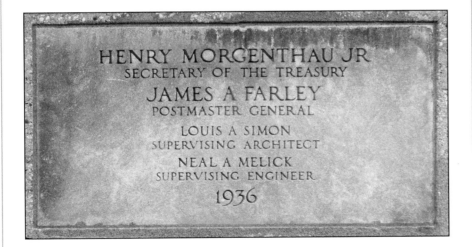

The Former Kaukauna Post Office

112 Main St., Kaukauna, Wisconsin 54130.

The former Kaukauna, Wisconsin, post office was built by Charles Bloss & Sons of Ashland, Wisconsin. The cost of the building when new was about $43,938.

The former Kaukauna Post Office was completed in 1936 as indicated on the cornerstone on the lower left corner of the building. It reads, *Henry Morgenthau Jr—Secretary of the Treasury. James A Farley—Postmaster General. Louis A Simon—Supervising Architect. Neal A Melick—Supervising Engineer.*

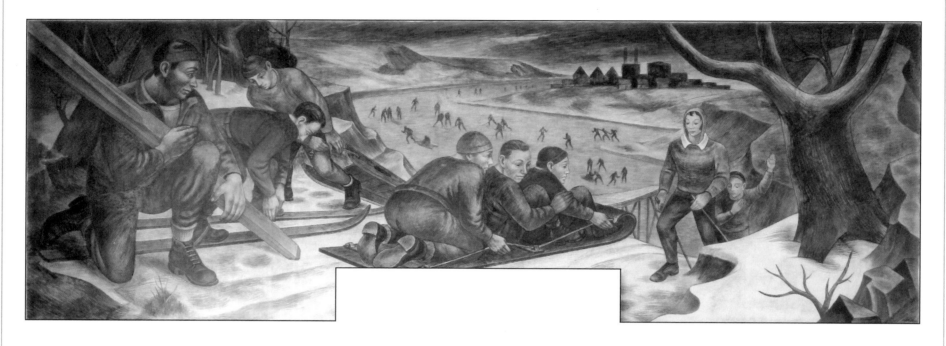

Winter Sports, by Paul Faulkner

The mural *Winter Sports* is a fresco, measures 13 feet by 4 feet, and was installed in November, 1939.

KEWAUNEE

History of the Mural

The commission of $730 was awarded to Paul Faulkner of Chicago, Illinois.

Faulkner was unable to visit Kewaunee, and so he made black-and-white pencil sketches for the Section based on the blueprints that were forwarded to him. Of the six pencil sketches sent, one was chosen, and he was told to develop a 2-inch-scale color sketch. After he sent the sketch, the Section suggested that further attention be given to the trees on the extreme right and left of the painting. These suggestions were to be implemented when he made the cartoon of the design.

Later on, Faulkner had a meeting with the postmaster, and they discussed what material the people of Kewaunee would like to propose for use in painting the mural. The citizens of Kewaunee were appreciative of the interest taken in their community and were willing to give their full support and cooperation to Faulkner for the duration of the work.

A photograph of the 2-inch-scale color sketch of the approved design had been forwarded to the postmaster of Kewaunee, who wrote that although the design was appreciated, members of the Kewaunee Historical Society asked him to request that the Section paint a mural depicting an early history of the town. A photograph was enclosed which was meant to serve as an example of what was being requested. The enclosed photograph was a reproduction of an old tintype which had been taken in 1856. The photograph showed the first crude buildings in the town, the first pier, and the town's first sawmill.

The postmaster wrote that the approval of a mural decoration depicting the history of the town would be greatly appreciated by the citizens who had witnessed the growth of the town from a wilderness with nothing of repute into a thriving lake post and manufacturing city. They felt that the mural would serve as a lasting remembrance to the older citizens, the youth of the town, and future generations. It would serve as a constant reminder of how far the town had come and what it had accomplished.

The Section investigated the suggestion made by the postmaster in his letter with the hope that it would be feasible to commission the artist to undertake a second mural painting that would incorporate the theme wished for by the citizens of the town. They found, however, that there were no longer funds to expend on the project.

Faulkner reported to the Section that the citizens of the town seemed bewildered as to what was taking place, although they seemed to enjoy it. He also mentioned that he had had to answer a couple of questions regarding the fresco and that it had been a pleasure doing so.

Upon completion of the fresco, Faulkner forwarded the color sketch and cartoon to the Section, reporting that he had encountered difficulty getting the completed work photographed as there were no professional photographers in Kewaunee. He did, however, find a man in a drug store that was willing to take pictures of the mural. He wrote that he would forward prints of the completed mural to the Section once they were ready.

The Section of Fine Arts requested that the postmaster comment on the installed mural. In his reply, he reported that many patrons of the post office watched each day while work was done on the mural, and that, upon its completion, an informal reception was held on November 30 in honor of the artist, who took time to explain the principle involved in the painting of a fresco.

Before commencing work on the mural, Faulkner had written to the postmaster, asking for suggestions on what to paint as the mural decoration. The postmaster suggested the old piers for the subject matter as these were a subject of great interest in Kewaunee, having been the first outlet for the products of the town when it was a new settlement in the wilderness. He was of the opinion that a scene depicting one of the piers in the early days of their existence along

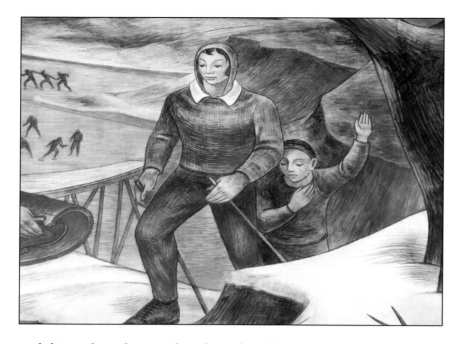

with big sailing ships tied to them, loaded up with goods and wares (such as tree bark and lumber), would be worthy of commemoration. The painting could include teams of oxen dragging the lumber and bark, with hardy pioneers passing the lumber to men stationed on the boats. Visible in the painting's background would be the first crude dwellings and shacks constructed in the early days of the town, perhaps with the old mill.

According to one story, Kewaunee was given its name as a result of the elusiveness of the old river outlet that existed before the harbor was created. After a long trip along the lake shores, the Indians upon their return home in their canoes would yell "Ke-wau-nee," which meant "Where are you?" whenever they thought they were close or around the vicinity of where the river formerly emptied its contents into Lake Michigan. Upon hearing the yelling of their tribesmen, the Indians on the shore of the river would respond with the same sentence, "Ke-wau-nee." The two groups of Indians would yell back and forth until those on the canoes wound their way up the lake and into

the mouth of the river. It was on account of this repeated yelling that the town came to be called Kewaunee.

The postmaster asked if the scene (a couple of Indians in their canoes on Lake Michigan yelling out at dusk) could be depicted in a mural. The river mouth in those days used to fill up with sand at times when there was a big northeasterly wind blowing. This constituted one of the greatest trials of the fishermen of those days as they used to have to drag their boats through the river, clogged as it was after the storms. Depicting this in a mural would have been a way of showing how far the community had come as well as serve as a colorful reminder to the citizens of what they went through to get to where they were.

More about the Artist and the Mural

Paul Faulkner was born on April 2, 1913, and died on January 5, 1997, in Montville, Connecticut. He was living in the city of Chicago, Illinois, when he was commissioned to paint the Kewaunee, Wisconsin, mural. After he finished painting the mural, he relocated to North Platte, Nebraska, which was the place of his birth.

Faulkner worked as an instructor at the Layton School of Art located in Milwaukee, Wisconsin. He was also at one time in the employ of the Smithsonian Institution in Washington, D.C.

Faulkner was commissioned to paint the Kewaunee mural in 1939 based on a design he had made earlier; however, he added a local factory to indicate the location of the mural painting.

History of Kewaunee

Kewaunee city, the county seat of Kewaunee County, is located at the western shore of Lake Michigan in Wisconsin. Jean Nicolet, a French explorer, is credited as the first non-native person to visit the area in 1634. Potawatomi Indians were the native inhabitants of the site, which would later become the county seat by 1852. The site has a history that can be traced to missionary and explorer Father Jacques Marquette, who often conducted Mass there in 1674. Kewaunee was founded in 1836 following the discovery of gold that attracted a number of fortune seekers in the area to mine and compete with the gold market in

Chicago. The industrial activities attracted the construction of a sawmill, which later led to growth of the Kewaunee village into a town.[45]

As German and Czech immigrants settled in Kewaunee to farm, the Kewaunee deep harbor continued to contribute to the growth of the city. Today, the city is well known for its tourism activities and commercial fishing. Plans for the town were first drawn by Joshua Hathaway. He also drew plans for the first social amenities. Mr. Hathaway became a prominent land developer, immediately after discovery of the gold deposits and the expansion of the lumber industries in 1836.[46]

One interesting fact about Kewaunee is the first visit by a sailing craft in 1847 by the schooner Rochester. Apart from its positive history, Kewaunee has experienced devastating fires. The Peshtigo fire in 1871 killed 150 people and consumed over 400 square miles of the town. In 1898, Kewaunee experienced the "great fire" which destroyed almost the whole central business district.[47]

The Kewaunee Post Office

119 Ellis St., Kewaunee, Wisconsin 54216

The Kewaunee, Wisconsin, post office was built by James I. Barnes Construction Co. of Culver, Indiana. The cost of the building when new was about $55,560.

The Kewaunee Post Office was completed in 1937 as indicated on the cornerstone on the lower left corner of the building. It reads, *Henry Morgenthau Jr—Secretary of the Treasury. James A Farley—Postmaster General. Louis A Simon—Supervising Architect. Neal A Melick—Supervising Engineer.*

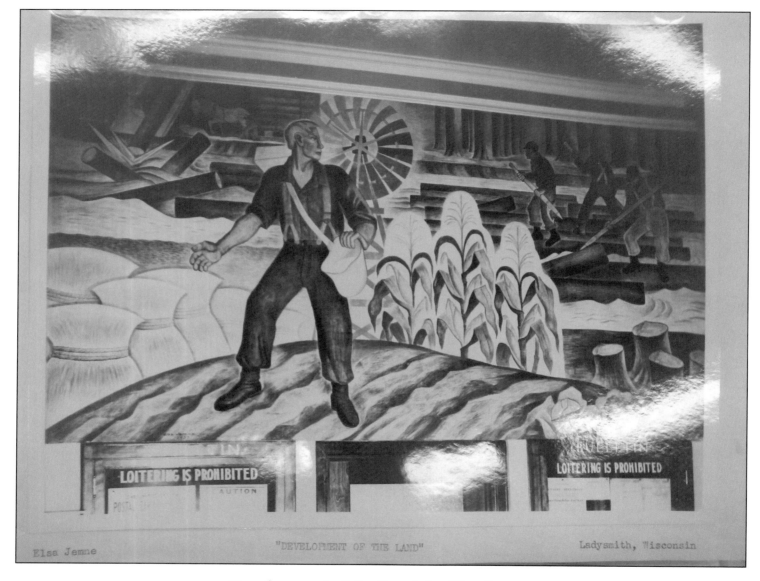

Development of the Land, by Elsa Jemne

The mural *Development of the Land*, originally titled *The Log Roller*, is egg tempera applied directly to the wall, measures 6 feet by 12 feet, and was installed on December 18, 1937.

LADYSMITH

History of the Mural

The commission of $550 was awarded to Elsa Jemne.

Jemne had at first submitted designs in a Rochester, Minnesota competition. The Section commended her on quite a number of features, including the "good spacing" and the "large simple pattern." The Section then provided a few suggestions concerning the position of the man driving the team of horses and the position of the figure farthest right.

When Jemne finally made a visit to Ladysmith, she also suggested painting the strips around the bulletin boards and the postmaster's door to match the color and tone of the mural as approved by the Section.

The mural was a depiction of the virgin timber in the county before farming dominated, the logging and lumbering mills, the stump period, and finally the soil's productivity after clearing the land. The crops shown are corn and cabbage (the area and many miles south of it is basically dairy country). The stalks of the corn in the mural show two ears on one, three on the second, while the third one has five ears.

MORE ABOUT THE ARTIST AND THE MURAL

Elsa Jemne was born Elsa Laubach on July 7, 1887, in St. Paul, Minnesota.

Jemne eventually visited Ladysmith to make preparations for the painting on the building wall on October 25, 1937. (Note: not all murals were painted on walls; most were painted in the artist's studio before being shipped off to the post office where they would be installed.) She was ready to start work in November, but the postmaster was concerned that work would interfere with the holiday rush and recommended postponing the work to January 1, 1938. She was approved to proceed on November 30, 1937, which would have given her about 15 days to complete the mural before the scaffolding would be removed for the forthcoming Christmas season.

When asked about the comments from the people, she wrote,

After painting in the Post Office for several weeks and hearing the various comments (which I found an interesting experience), I had no illusions as to what the average person asks for in art. "Is it real? Is it literal?" That is the important thing to them. It is up to the artists to give them more than this. I doubt that anyone entering the lobby ever considered the painting from the standpoint of design or composition or any of the things for which an artist works.

She died in St. Paul on June 26, 1974.

History of Ladysmith

Acting as the seat of Rusk County, Ladysmith is located northwest of Wisconsin. Ladysmith was founded in 1885. The original name of Ladysmith town was Flambeau Falls. The name "Ladysmith" was coined on July 1, 1900, after the bride of Charles R. Smith, who was head of the Menasha Wooden Ware Co.[48]

The main economic activities during the time of Ladysmith's establishment and growth were logging and farming. Pine and hemlock trees covered over six million acres of land that provided survival to the population from the 1840s to 1915. After 1915, logging decreased and farming replaced it, leading to the burning of trees to clear land for farming.[49]

During the founding of the town in 1885, Robert Corbett built the first hotel, which provided rooms that acted as the town's first school classrooms. The first newspaper was published in 1898 as a weekly paper and operated from Richland Center. The same year saw the

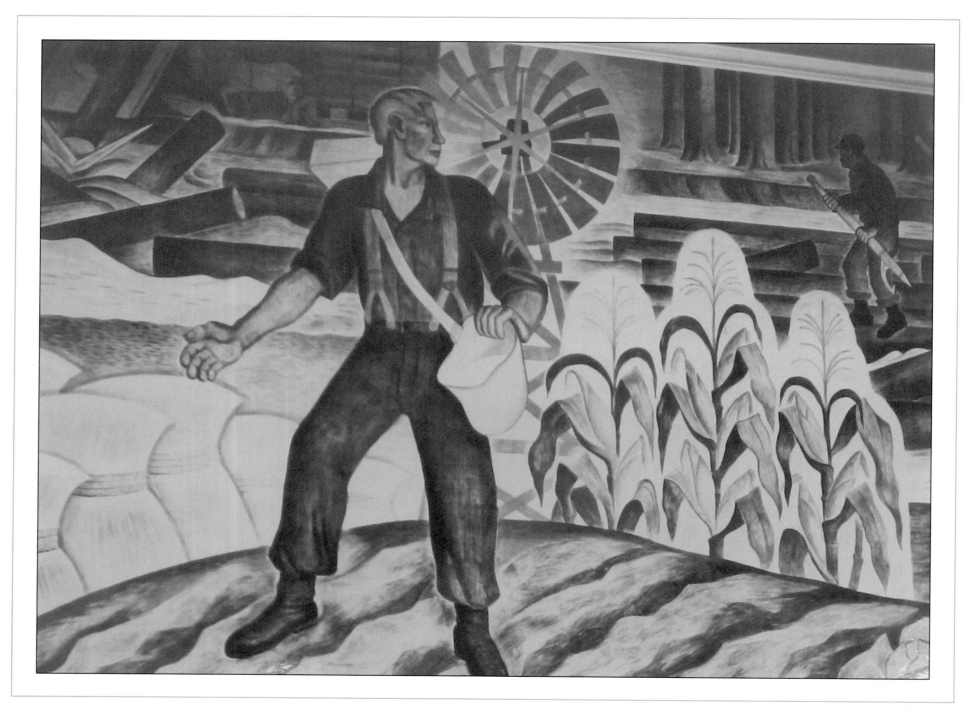

Elsa Jemne, *Development of the Land*

establishment of the first cemetery after the death of a daughter of one of the town's settler families. An interesting piece of Ladysmith lore is the "Petrified Man" hoax which has seized the public imagination ever since 1926.[50]

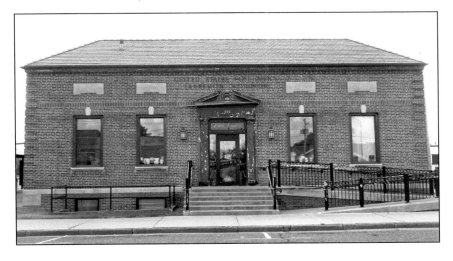

The Ladysmith Post Office

212 Miner Ave., Ladysmith, Wisconsin

The Ladysmith, Wisconsin, post office was built by Maas Brothers of Watertown, Wisconsin. The cost of the building when new was about $36,900.

The Ladysmith Post Office was completed in 1935 as indicated on the cornerstone on the lower left corner of the building. It reads, *Henry Morgenthau Jr—Secretary of the Treasury. James A Farley—Postmaster General. Louis A Simon—Supervising Architect. Neal A Melick—Supervising Engineer.*

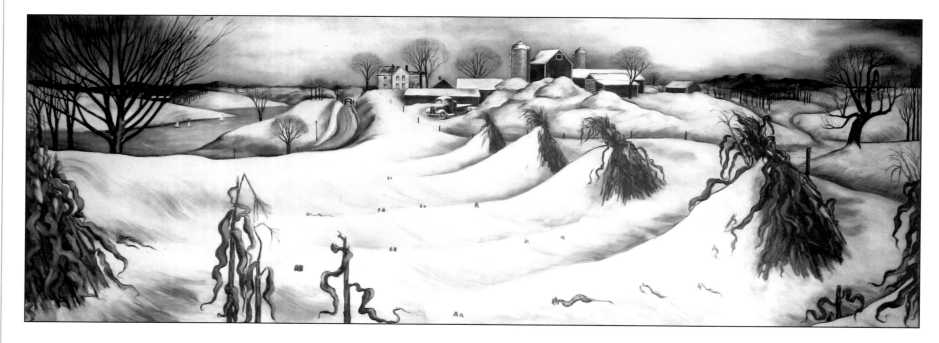

Winter Landscape, by George A. Dietrich

The mural *Winter Landscape* is oil on canvas, measures 12 feet 10 inches by 4 feet 8 ½ inches, and was installed on October 2, 1940.

History of the Mural

The commission of $900 was awarded to George Adam Dietrich.

While carrying out research for the Lake Geneva Post Office, Dietrich called on the Lake Geneva postmaster even before the Section of Fine Arts informed the postmaster of a commission having been awarded to paint a mural for the post office. And, in a surprising twist, the postmaster wrote to the Section, objecting to having a mural painted for their new building.

The postmaster informed the Section that Dietrich had called at the post office regarding the mural decoration for the building's lobby. Prior to that, he had heard nothing from the government, which made him a little taken aback when he heard what Dietrich had to say. He told Dietrich that he would wait to receive orders from the government before giving his approval and permission.

In his words,

The lobby of the Lake Geneva Post Office is so very complete and beautiful as it is that we would very much dislike to have anything placed there that would detract from the architectural beauty of it. The people of Lake Geneva are satisfied with the lobby as it is. I have discussed the matter with several of our prominent residents, some of them artists, and they feel that the wall space in the lobby is entirely too small for a mural.

Mr. Dietrich said that it would be placed over the door entrance to the postmaster's office. The position of that space is rather high for such a mural decoration. Furthermore, the vestibule would interfere with the view of it from the opposite side of the room.

Mr. Dietrich said that the cost of the mural would be $900. That is quite an amount of money and I believe that the matter should receive proper consideration before the painting was undertaken.

It is my opinion that the people of Lake Geneva would prefer to have the lobby remain as it is without further decoration. Will you kindly advise me?"

The Section informed the postmaster that they had invited Dietrich to undertake the mural decoration; they apologized that they had not gotten in touch sooner, which was due to Dietrich's not having informed them that he planned to visit. They wrote that the Lake Geneva post office building was not any different from other post office buildings their office was decorating with murals and sculptures. He was assured that the mural Dietrich had undertaken to paint would be satisfactory to both him and members of his community. They informed him that several hundred letters had been written to their office by various postmasters who wanted to express their gratitude as well as the criticisms of their communities for the murals that were painted and used to decorate their respective buildings.

Dietrich thereafter sent two preliminary sketches for the Lake Geneva mural decoration. One of the sketches was a winter landscape that depicted a typical Lake Geneva farm as well as a view of the immediate countryside on the outskirts of town.

The subject of the other sketch was similar to the design he had submitted in the 48 States Mural Competition. It was arranged to give more attention to Lake Geneva and to promote it as an ideal place for winter sports and year-round living. It was also arranged to show it as being a nationally known summer resort.

Dietrich described the space reserved for the mural decoration as beautifully lighted and really well located. This was good as it allowed for easy viewing of the mural to whoever entered the lobby.

The Section preferred the winter landscape over the other design by Dietrich due to what they considered its general appeal and also for the interesting rhythms which they felt he had achieved in its compo-

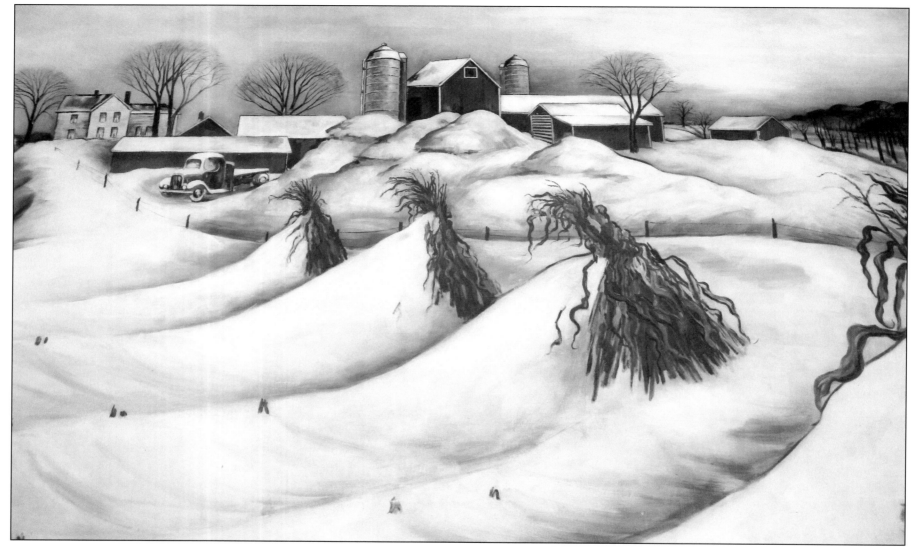

sition. They photographed the designs and sent them back to him for further development.

Dietrich wrote that he had made good progress on the full-size cartoon that he was developing despite the unusually late winter weather

two weeks prior. This thick falling of snow, he wrote, would be quite useful in his depiction of the subject.

Dietrich had reported that there were no lighting fixtures present to obstruct the mural, but the Section asked him to forward the lighting

George A. Dietrich, *Winter Landscape*

report of the building along with a personal statement for the Section's files all the same.

Lake Geneva is one location where the town's Chamber of Commerce as well as its residents protested the mural's installation in their new post office. It was so serious that the president of the Chamber wrote a letter to the postmaster requesting that he protest the installation of any mural in their Post Office:

It seems that some governmental order has been issued for a mural decoration in the lobby of our new Post Office building, as indicated by a write-up of the same in the local paper of last week, which has created comment by our local people. We have some artists in the city who are making a decided protest against the walls of the new building being encumbered by any sort of a decoration of this nature.

To begin with, they claim that there is no appropriate place for a mural on account of the lowness of the ceiling and the distance across the lobby. They also feel that a decoration of any kind on the walls would be rather unsightly, inappropriate and not in keeping with the general setting of the lobby.

These protests have come from our citizens to the Chamber of Commerce, and they have requested me to make a protest to the Government against any decoration whatsoever being put in the lobby of the new building. Will you kindly forward this letter to its proper destination?

If there is more than one department to be approached in order to register this protest, I am enclosing an additional copy of this letter for that purpose.

The postmaster forwarded the president's letter to the Section along with comments of his own highlighting that his protesting the installation of the mural was not on account of his own opinion but rather a result of the sentiment of the people of his town.

The Section had received a lot of support from artists and organizations all over the United States on the basis of the decorations that they were overseeing in federal buildings, which made the strong opposition to the installation of a mural in Lake Geneva something of a shock. They wrote that since they had no knowledge of the artists who had criticized the installation of the mural, they were unable to judge their critical capabilities, notwithstanding that the designs selected for the post office were chosen by four very experienced artists of good reputation, Maurice Sterne, Henry Varnum Poor, Olin Dows, and Edgar Miller. They had decided upon the design for Lake Geneva after carefully considering the lobby and how appropriate the mural was to it.

The mural decoration was to be done by an artist native to Wisconsin who had won a competition with 1,478 entries. Furthermore, the chosen design had the unwavering endorsement and support of the Section of Fine Arts under the Public Buildings Administration of the Agency of Federal Works. It felt unfair that against all these experts rooting for the mural decoration, the opinion of some unnamed artist would hold sway.

The Section wrote that although the interest of the postmaster was appreciated, they felt the majority of the town's citizens would be proud of the mural once they viewed it upon completion. The forms taken by snow in winter and the way the ice swept presented a scene of great and unusual beauty that was worthy of depiction. Not all the town's citizens were excited about the final mural, though. The *Lake Geneva Regional News* wrote that the artists of the town generally considered the mural painting as unrepresentative of their region as did many citizens who commented on it openly.

Dietrich finished the mural and submitted the photographs and negatives he had taken of it around September 1940. The postmaster, in response to an inquiry by the Section asking him to confirm the installation of the mural, wrote that it was installed on October 2. The mural was placed on the west wall lobby, directly on top of the door to the postmaster's office, taking up almost the entire space.

More about the Artist and the Mural

Dietrich was a resident of Milwaukee when he was commissioned to paint the Lake Geneva mural. He studied at the Art Institute of Chicago. Between 1928 and 1937, he was a teacher at the Layton School of Art in Milwaukee, after which he was on the faculty of the University of Michigan's College of Architecture. He also studied at the Shorewood Vocational School while at the same time opening a studio.

Dietrich reported to the Section that quite a number of the residents of Lake Geneva congratulated him on the mural painting, especially the old-timers who had witnessed a plethora of winters in the town. Dietrich forwarded a copy of the *Wisconsin Guide* which had reproduced the artwork with the approval of the Section; he asked that some members of the Section autograph his copy of the book and mail it back to him whenever they could.

History of Lake Geneva

Lake Geneva city was established in the 1830s and is situated in Walworth County. It was originally known as Big Foot until it was later named Geneva. The name was derived from Geneva in New York by John Brink as he saw a resemblance between the two towns.[51] The area also attracted many people as it served as a great recreation facility. The railroads in the area further helped the city to grow, as a means of transportation for trade goods.

The main economic activity of the area was manufacturing. The main trade commodities were salt, oil, and chewing gum. Most of the people working around Lake Geneva were rich Chicagoans and settlers from New England and New York. Also, many vacationers from different places used to visit the city.[52]

Many families came to Lake Geneva after the Chicago fire of 1871 had consumed their houses and goods.[53] They stayed there as Chicago was being reconstructed. Soon after the Second World War, the town grew at a higher rate and many industries were established.[54]

The Lake Geneva Post Office

672 W. Main St., Lake Geneva, Wisconsin 53147

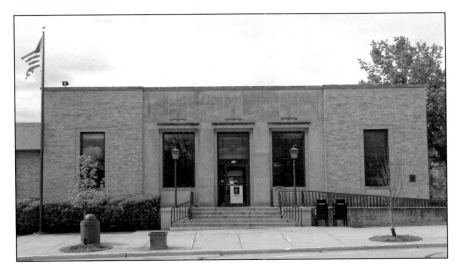

The Lake Geneva, Wisconsin, post office was built by Henke Construction Co., Chicago, Illinois. The cost of the building when new was about $47,913.

The Lake Geneva Post Office was completed in 1939 as indicated on the cornerstone on the lower left corner of the building. It reads, *Henry Morgenthau Jr—Secretary of the Treasury. James A Farley—Postmaster General. Louis A Simon—Supervising Architect. Neal A Melick—Supervising Engineer.*

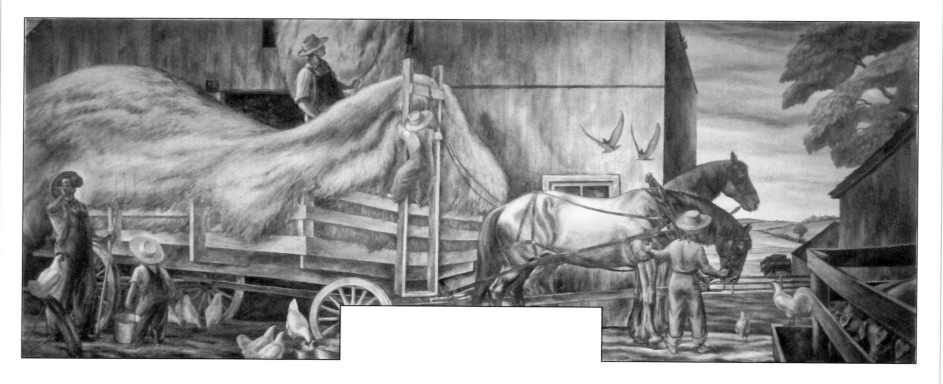

Farm Yard, by Tom Rost

The mural *Farm Yard* is oil on canvas, measures 14 feet by 5 feet 5 inches, and was installed on October 13, 1940 by Carl Westberg and Company.

LANCASTER

History of the Mural

The commission of $800 was awarded to Tom Rost.

The postmaster of Lancaster at the time was a Roger R. Austin. Lancaster proved to be yet another town that resisted the installation of a mural in their post office.

After the contract was awarded to Rost, a letter was written to the town's postmaster notifying him of the appointment. The postmaster, however, replied that he did not recommend that a mural decoration be made for the lobby. He wrote that

The walls of the lobby are very beautiful finished as they are and there is not any larger space open. There is nothing of any historical significance pertaining to the city for subject matter. There is no particular industry here, this is being a strictly agriculture community.

He concluded that if it was the Section's absolute wish to install the mural, he would gladly cooperate with the artist. The Section replied that postmasters from different parts of the country had written to request that murals and/or sculptures be made for their buildings. The Section also gave a brief introduction to Rost and informed the postmaster that Rost would be visiting the town in order to discuss the space available for the mural as well as what subject matter would be featured.

Rost sent three rough pencil sketches that depicted the designs he had in mind for Lancaster. The Section chose *Farmyard*, which depicted a farm with swine and cattle in the background, since the county was the leading producer of such livestock. After approval of the *Farm Yard* design by the Section, Rost was asked to fill in a technical outline which he was to return to them. They also directed that Rost proceed with the project and make a three-inch-scale color sketch for

their approval. After some suggestions from the Section, Rost made a cartoon that the Section considered both beautiful and convincing, except for the minor suggestion that he observe the scale of the heads of the horses relative to their hindquarters, and that he observe the hay and foliage of the trees as he progressed with the work so that they would all look convincing and not distorted.

During the course of the work, it seems that another Section within the Public Buildings Department had given out a contract to incorporate two wooden panels directly above the bulletin boards so as to bring the top of the boards level with the top of the postmaster's door. Rost was contacted to find out if he would be able to execute the mural despite this or if it would be too much of a hindrance.

Suggestions were made on what he could do, which were to relocate the man pitching the hay or to cut off a strip from the bottom of the canvas containing the wheel of the wagon as well as the feet of the horses. Rost made the adjustments to the mural and agreed that the panels could be installed. He then finished the mural after which he sent the photograph and negative of the completed mural to the Section for approval.

The mural was installed on October 13. The postmaster was reportedly quite pleased. Most people who saw the painting thought that it was an excellent piece of work.

MORE ABOUT THE ARTIST AND THE MURAL

Tom Rost was born February 14, 1909, in the town of Richmond, Indiana. He died in 2004 in Cedarburg, Wisconsin. He was living in the city of Milwaukee when he was awarded the contract to paint the mural.

Rost visited Lancaster to discuss with the postmaster the subject matter for the mural. He found that the postmaster was not very supportive of the project but ended up convincing him to see things dif-

ferently. His visit to the post office exposed two minor problems that would serve as hindrance to the installation of the mural: one was a clock and the other was a lighting fixture on the wall space where the mural was to be installed. The clock, as reported by him, was hung on a brass outlet with its wiring going through the wall. Removing this would deface the wall, and a little patching would be needed for the plaster to be restored to its former state.

For the lighting fixture, Rost suggested that the mural stay above the top of the doorframe as the fixture would jut out through the painting if made to come lower. He argued that this would look inappropriate. He then sent a photograph of the wall with the thought that the Section would approve of him covering the wall all the way to the top of the doorframe, and leaving about two inches of space above the doorframe, its sides, and the ceiling.

Rost also visited the countryside surrounding Lancaster. He wrote that the beauty of the county made a lasting impression on him. The mural that we see and admire today captures this beauty of the southwestern Wisconsin landscape.

At the time of the painting, the use of manual labor and beasts of burden for farm activities was being phased out, with gasoline-powered machines brought in as replacement. Rost included in his mural painting a hay wagon and a team of draft horses as a reminder to people of what farming was like before the advent of mechanized equipment.

Tom Rost, *Farm Yard*

History of Lancaster

Lancaster is the county seat of Grant County. The discovery of lead in this area during the early 19th century was the major contributing factor to its growth, and Lancaster was one of the first places to attract massive settlements in the state. It is among the oldest settlements in Wisconsin.

The first newcomers in the area were Tom Segar, Ben Stout, and Nahem Dudley who, by virtue of locating the area, became first-time settlers of Lancaster).[55] Stout and Segar, however, migrated after a short time and Dudley moved out two years later after selling his land to Aaron Boice. Boice engaged in farming and only occupied a few acres, growing corn, wheat, and onions.

In 1837, Morgan Price's proposal to have Lancaster as the county seat was accepted, winning over two other proposals that had suggested other speculative town sites and other areas in the county where communities had already been established. Part of the convincing reason for the adoption of Lancaster, apart from its location, was Price's donation to the construction of the public square.

Some interesting facts about the town: It is where the first publicly conceived Civil War monument stands, after its dedication in 1867. It is also where the first Wisconsin governor, Nelson Dewey, is buried, as well as the location of the Frank Lloyd Wright home, the Patrick Kinney House.[56]

The Lancaster Post Office

236 W. Maple St., Lancaster, Wisconsin 54813

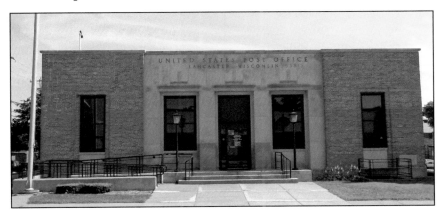

The Lancaster Post Office was completed in 1938 as indicated on the cornerstone on the lower right corner of the building. It reads, *Henry Morgenthau Jr—Secretary of the Treasury. James A Farley—Postmaster General. Louis A Simon—Supervising Architect. Neal A Melick—Supervising Engineer.*

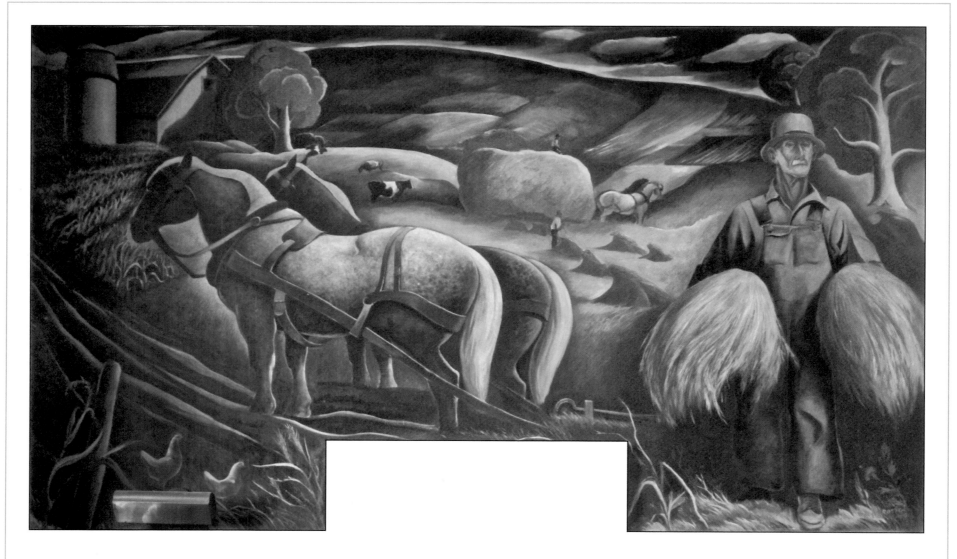

Wisconsin Rural Scene, by Peter Rotier

The mural *Wisconsin Rural Scene* is oil on canvas, measures 12 feet by 7 feet, and was installed on November 17, 1940.

MAYVILLE

History of the Mural

The commission of $800 was awarded to Peter Rotier.

Rotier was invited by the Section to submit designs for the Mayville mural decoration; included with the invitation were blueprints, as well as other information considered necessary for him to construct a design for the building. He was directed to visit the town or communicate with its postmaster by letter to decide on an appropriate subject matter.

The Section thought that the sketch Rotier had submitted to the 48 States Mural Competition was applicable to the town of Mayville. They wrote that they still had the design on exhibition in their gallery and wished him success on the project. He was then asked to confirm whether he would undertake the project or not.

Rotier accepted the invitation and visited the town, where he spoke to the postmaster as well as made inquiries into the town's history. He found out that it was almost completely dependent on the surrounding farms. The manufacturing of the town was limited to two small factories and a couple of iron mines that had been abandoned a few years earlier.

The Section decided on the second of the designs Rotier sent, in which he depicted a farmer with wheat under his arms, on the right side. After the approval of the design, Rotier proceeded to make a color sketch. The light fixture that had been an obstacle was replaced by a trough light which made it necessary that the lower part of the mural be designed to accommodate it without distortion. The Section approved of all of Rotier's suggestions about the dimensions of the mural painting as well as what he planned to do about the light fixture. The light fixture, however, could not completely be eliminated as it was one of the requirements of the post office in order to accommodate the writing desk sitting under the bulletin boards.

Rotier sent a sample of the canvas he planned to use for the mural painting—a Belgian linen of quality grade—which was also the only canvas of the right dimension available in the vicinity. The Section approved of Rotier's color sketch and asked that he proceed with the full-size cartoon. However, they criticized the painting of the wheat under the farmer's arms as not convincing in form; they suggested that he observe and study this part of the painting more closely as he made progress.

The sample of canvas sent by Rotier was rejected by the Section on the basis that the threads had too much jute, a factor which significantly reduced the possibility of permanency of the painting. He was directed to make a better and more satisfactory selection of pure linen canvas which he was to forward to them for approval. Rotier sent three linen samples to the Section, two of which were considered acceptable.

The cartoon painting by Rotier was approved by the Section, and he was asked to proceed with the mural painting. He encountered some problems while painting the mural, however: The canvas he had requested from his dealer twice arrived in conditions unsuitable for use. This made it necessary that he ask for an extension of two to four weeks from the Section.

Upon completion of the mural, Rotier did the installation. He reported to the Section that the trough light fixture did not interfere with the mural nor did it detract from it. Also, the color of the mural fitted in with that of the surrounding walls. He sent a photograph of the installed mural as well as an 8 x 10 negative. He asked to scrap the cartoon and some other drawings, but the Section wrote that they would prefer to have them for exhibition in their office.

The postmaster of Mayville wrote regarding the mural that it was a worthy and beautiful adornment for the post office building's lobby. The mural, he reported, had received favorable comments from those who viewed it.

Rotier had asked the local photographer of the town of Mayville to take a picture of the mural, but the photograph was unsatisfactory, and therefore he could not send a print to the Section. He promised to have

a better and more experienced photographer from Milwaukee photograph the installed mural, which he would then forward to them.

Rotier some years earlier had painted a mural for West Bend which he reported still looked as fresh as when he had first installed it. But he did not think that it had been varnished and therefore enquired of the Section if varnishing it was his responsibility. They replied that since it was not a requirement of his contract, it was not his responsibility. They wrote that they would prefer, however, that he undertake the varnishing as opposed to an inexperienced postmaster.

The mural painted by Rotier depicts a rural scene of the Mayville community and is considered a faithful depiction of what a typical Wisconsin farm would look like. In the background are rolling farmlands and in the right foreground stands a farmer with bundles of wheat under his arm. Also depicted is a grain-filled wagon drawn by a pair of husky horses.

On the left of the painting are typical Wisconsin farm buildings as well as a silo, and at the right bottom of the scene is a plant, the pesky Canada Thistle, which is not so apparent except on close observation.

MORE ABOUT THE ARTIST AND THE MURAL

Peter Rotier was born on November 5, 1887, in Baldwin, Wisconsin. At the time when he was invited to submit designs for the Mayville mural decoration, he was residing in Milwaukee, Wisconsin.

His study of art began at the age of fifteen at the Milwaukee Art Students League, and he left when he was eighteen years old. Rotier hoboed for about ten years over the western United States, after which he enlisted for service when World War I broke out. He served for two years overseas during the course of the war. After the war, Rotier studied painting at the Milwaukee Normal Art School, the Chicago Academy of Fine Arts, and the New York Art Students League. He thereafter took up commercial artwork as a newspaper artist during the Depression. Rotier was the recipient of the Milwaukee Journal Prize in 1938.

Rotier got a break under the Public Works of Art Project where he secured a job with pay. He and four other artists were chosen from the watercolor section of the Public Works of Art Project to travel to Key West, Florida, where they were to work on a Federal Art Project.

Rotier was a member of several associations, including the Wisconsin Painters and Sculptors, the North Shore Arts Association, the American Water Color Society, and the Rockport Art Association. Rotier was employed in a number of different occupations: he was a housepainter, a scenic painter, a sign painter, a locomotive painter, a telephone lineman, a commercial artist, a farmhand, and a laborer working on railroad construction. He worked on sheep and cattle ranches. He was a short-order cook, a hotel clerk, a grocery store clerk, a boiler-maker helper, a locomotive mechanic helper, and a dishwasher. At the time that he was commissioned to paint the mural for Mayville, he taught a painting class at the Milwaukee Institute one day a week. He spent the rest of the time on his own painting. He was described as a happily married man.

History of Mayville

Mayville was mapped in 1845 by Chester and Eli May, the two brothers and settlers who are behind the growth of the town.[57] The first post office was established two years later in 1847. In 1873, the city was created through an act of the legislature and later incorporated in 1885. Up until 1889, Mayville consisted of two townships, Mayville itself and Hoard.[58] In 1889, Hoard was separated from Mayville and made an independent city, thus decreasing the initial Mayville boundaries to what they are today.

Mayville did not receive many settlers until the construction of a road on the eastern side of town. This is the present-day Chicago-St. Paul main line. This road formed a junction to the southeastern part of the town, which is today called Abbotsford.[59] The Wisconsin Central Company wanted to open up the town to other towns and ease transportation of goods, as well as to alleviate the isolation of the settlements on the eastern side along the railroad and near present-day Dorchester. In the 1880s, the company also constructed more roads westwards through the southern region of the town through to the northern side of the county.

Due to the rolling and slightly elevated terrain, the soil was well-watered, fertile, and ideal for agricultural production. The people practiced crop farming, planting a variety of grains and vegetables. The forests also offered a source of timber consisting of hardwoods and pine. Until today, logging has received much more attention than farming, and there are still forests that have the potential to supply timber for many coming years. A few sawmills are still located in the town. However, farming interests continue to increase as lumbering interests decrease.[60]

Peter Rotier, *Wisconsin Rural Scene*

The Mayville Post Office

7 N. School St., Mayville, Wisconsin 53050

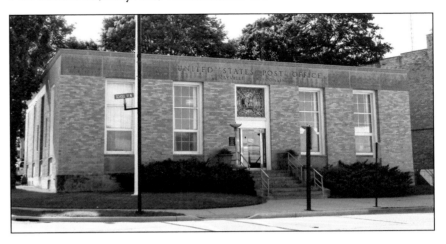

The Mayville Post Office was completed in 1939 as indicated on the cornerstone on the lower left corner of the building. It reads, *Henry Morgenthau Jr—Secretary of the Treasury. James A Farley—Postmaster General. Louis A Simon—Supervising Architect. Neal A Melick—Supervising Engineer.*

***Wisconsin Wildflowers—Spring* and *Wisconsin Wildflowers—Autumn,* by Frances Foy**

The two murals measure 14 feet 3 inches by 6 feet and were installed in April, 1943.

MILWAUKEE (WEST ALLIS)

History of the Mural

A regional competition was held for the Milwaukee West Allis Branch mural, limited to artists who resided or had a connection with the states of Illinois, Minnesota, or Wisconsin. The Section had the authorization of $1,800 for the mural and sent invitations for the painting of two murals: one on the east wall of the lobby over the door to the postmaster's office and the other—the same size as the first—on the west wall.

The jury initially recommended work by L. W. Bentley, but the Section wrote to Bentley about its ultimate decision:

One of the two designs which you submitted found great favor with the local jury and if both designs had been of equal quality they would have been the successful entries in the competition. In view of the fact that the artist, who turned out to be Miss Frances Foy, whose work was rated second by the local jury, submitted two successful designs which the jury referred to as perfectly fitting in the Post Office from the standpoint of composition, color, key and subject matter of considerable interest, the award was given to Miss Foy.

Permit me to thank you for submitting a design in the mural competition for the Milwaukee, Wisconsin Post Office, West Allis Branch.

Foy made some revisions to the designs she submitted for the competition, which the Section approved as well as informing her to proceed with the color sketch.

Foy visited the West Allis Branch in Milwaukee so she could make the color sketches of the walls, as suggested by the Section. She decided to take a look at the size of the panels, but she found when she measured them that they were not consistent with the dimensions she had been provided: the dimensions which were supposed to be 6 feet in height and 14 feet 3 inches in width according to the contract turned out to be 6 feet 11 inches in height and 11 feet 6 inches in width.

Foy was particularly slow in painting the mural since she had to combine first-floor rooms in an old house to create a studio. But once finished with that, she made quick progress on the mural. The Section requested that photographs and an 8 x 10-inch negative of the cartoon be sent to them so they could review it further. She asked if copies of the photographs taken of the design sketch existed since the Chicago Art Institute had requested that she send one. She intended to make a color slide from a photograph so that she would be able to use it in her lectures.

Foy made it a habit to leave her studio and go into the woods during spring weekends so she could make detailed drawings of the flowers.

During the course of the project, the Chief of the Section of Fine Arts, Edward Bruce, passed away in January 1943. He was an admirer of Foy's work, and he had always felt that if the murals were placed in the manufacturing section of Milwaukee, they were going to serve as "a little oasis of beauty in a naughty world."

MORE ABOUT THE ARTIST AND THE MURAL

Frances Foy was born in 1890 in Chicago, Illinois. At the time she was commissioned to paint the murals for Milwaukee, she was a resident of Chicago.

She studied at the Art Institute of Chicago, and exhibited her works continually at the Art Institute of Chicago Annual Exhibitions, among other locations. She exhibited for many years with a group of Chicago painters known as *10 Artists*, had several one-woman shows, and exhibited her works nationally from 1924, earning several awards and honors in the process. Her works were also well represented in private collections throughout the country, many of them portraits of people and flowers. Before the Wisconsin Wildflower murals, she had successfully completed five murals for the Section.

Frances Foy, *Wisconsin Wildflowers—Autumn*

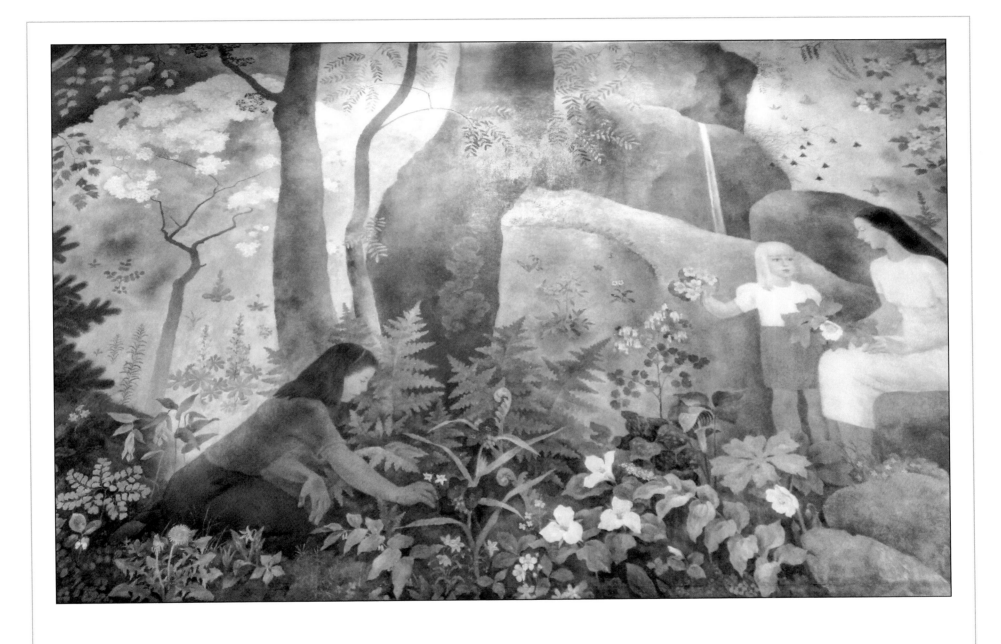

Frances Foy, *Wisconsin Wildflowers—Spring*

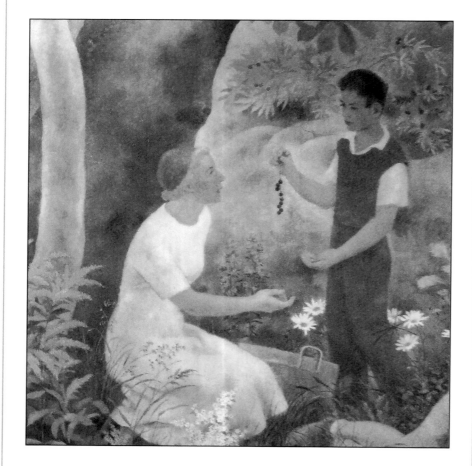

The murals she painted for the West Allis Branch depict the flora of Wisconsin. One begins in early spring and then moves to mid-summer, while the other begins in mid-summer and runs until frost. The flowers have a typical Wisconsin landscape used as their background.

She married Gustaf Dalstrom, who was a fellow artist, in 1923 after which they both lived in Europe for a year between 1927 and 1928. During their year in Europe, they sketched from Sweden to Italy, and also studied independently and intensively at the old galleries.

When the Government Art Programs began, she was on the technical committee of the PWAP. While she was working on the murals, she made the following statement: "I have spent the spring weekends in the woods making detailed drawings of the flowers, and loving it."

History of Milwaukee

Milwaukee is the largest city in Wisconsin. It is located at the junction of the Kinnickinnic and Menomonee rivers.[61] Milwaukee extends to West Allis, a suburb that forms part of the Milwaukee metropolitan area. West Allis was named after Edward P. Allis, the owner of the Edward P. Allis Company which was the largest employer in the Milwaukee area in the late 19th century.[62]

Before the arrival of the first European, it is believed that several American Indian tribes had lived in the Milwaukee region for 13,000 years. The first record about Milwaukee was left by Father Jacques Marquette in 1674, followed by that of other French explorers in 1679, 1681, and 1698. The first European to be associated with Milwaukee was Lt. James Gorrell, a fur trader who arrived in 1762, alongside other traders.[63]

The modern history of the city, however, dates back to 1795 when Jacques Vieau, a fur trader, constructed a post on the east side.[64] He resided there until 1818 when he transferred all his assets to Solomon Juneau, his son-in-law. Juneau would then become the founder of the city, as well as the first non-native, permanent resident. In 1822, he constructed a log cabin and the first frame building two years later. In 1833, he joined efforts with Morgan Martin to construct a village on the east side. In 1835, they both started to lay streets and survey lots then sell them to the settlers who had started coming to the area. Juneau served as the mayor and postmaster of Milwaukee for the next two decades.[65]

Frances Foy, *Wisconsin Wildflowers—Spring* and *Wisconsin Wildflowers—Autumn*

The city's fur traders increased between 1835 and 1850 to 20,000 settlers. More German immigrants arrived, and they introduced new skills, Catholicism, and liberal politics. Soon the area grew into a metalworking and machinery hub. Other economic activities included grain trading and brewing.

However, a fire erupted on October 28, 1892, wiping out a third of the city and leaving 2,000 immigrants homeless.[66] The settlers and leaders reconstructed the city, cleaned the neighborhoods, and introduced new sanitation systems, power systems, educational opportunities and municipally operated water systems. It was known for its "sewer socialism" thanks to Victor Berger who organized a successful political movement in the larger German population, as well as an active labor movement. Today, the city's manufacturing sector no longer dominates, but traditional industries still survive, and the service sector provides employment to the majority of its population.[67]

The Milwaukee (West Allis Branch) Post Office

7440 W. Greenfield Ave., Milwaukee, Wisconsin 53214

The Milwaukee (West Allis branch), Wisconsin, post office was built by The Weitz Co. Inc. of De Moines, Iowa. The cost of the building when new was about $110,000.

The Milwaukee (West Allis branch), Wisconsin, post office was completed in 1939 as indicated on the cornerstone on the lower left corner of the building. It reads, *James A Farley—Postmaster General. John M Carmody—Federal Works Administrator. W Englebert Reynolds—Commissioner of Public Buildings. Louis A Simon—Supervising Architect. Neal A Melick—Supervising Engineer.*

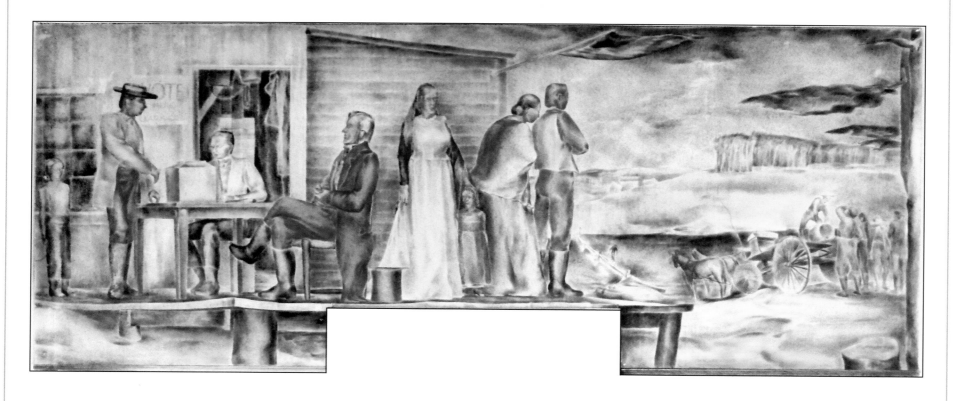

The Choosing of the County Seat, by John Van Koert

The mural *The Choosing of the County Seat* is egg tempera on panel, measures 12 feet 9 inches by 4 feet 8 inches, and was installed on February 20, 1940.

NEILLSVILLE

History of the Mural

The commission of $700 was awarded to John Van Koert of Madison, Wisconsin on December 1, 1939.

In the mural, about one third of the wall was proposed to be used to portray an organized system of voting. The sole citizen seated at the table represented the proprietor of the township, James O'Neill, whose descendants still participated in important matters of the town at the time.

There were two polling units: one at Neillsville and the other at a house eleven miles below Neillsville, Black River. As there was no bridge to cross to get through O'Neill Creek, the voters had to cross the dam. It is said B. F. French conceived an idea to place a barrel of whiskey at the north bank of the O'Neill Creek on one end of the dam. It was from this direction that the men from Weston would approach the polling unit in order to cast their votes. The path was so narrow, however, that stopping to drink the whiskey hindered them from moving on to cast their votes and they remained on the north side of the creek.

The Section of Fine Arts regarded the design as satisfactory but felt that the dam which crossed the river and was right above the door in the right-hand area could be explained better. Van Koert made some revisions and extended the decoration downwards to about three inches short of the bulletin boards that flanked the postmaster's door, which allowed him to make use of more wall space.

Van Koert was given until August 1, 1940, to complete the mural painting and to also install it. The finished work was intended to be egg tempera on a gesso panel; the completed panel would then be anchored to the hollow walls using ten toggle bolts. The heads of the bolts would be countersunk, plugged with gesso, and then touched up with tempera. The panel would receive extra support from the trim which was around the door.

The installation was delayed because of some damage to the building. The Section asked that Van Koert look into the matter as it was necessary that any mar which resulted from the installation process be remedied. A report was also requested to be sent as soon as possible. The postmaster at Neillsville sent an update to the Section indicating his satisfaction with the installation of the mural as well as to inform them that the damage sustained by the post office building had been taken care of properly. Van Koert, however, visited the post office building, where he found the damage had not been taken care of. However, the local contractor agreed to repair the dent on the door jamb as well as to take care of the small patches on the moldings plaster that were scraped while the panel was being put into position.

MORE ABOUT THE ARTIST AND THE MURAL

John Van Koert was a resident of Madison when he was commissioned for the mural painting at Neillsville. At the time he painted the mural, he also worked at the University of Wisconsin, Madison, as an instructor in the Department of Art Education.

The Section invited him to submit his designs for the mural decoration for the post office in Neillsville based on the designs he had submitted in the Wausau, Wisconsin, mural competition. Not long after he received the invitation to work on the mural, he said he had pored over the records of the town and also interviewed long-time residents, and through these interactions, he found various themes the most picturesque and traditional of which recalled the process of choosing Neillsville as the county seat.

His classes in the summer were on a light schedule, which gave him enough time to work, and he moved into a studio which he felt was an ideal place to work. He submitted two preliminary sketches he had designed for the mural. He also attached a quotation from one of the town's newspapers which explained the actual incident (or at the very

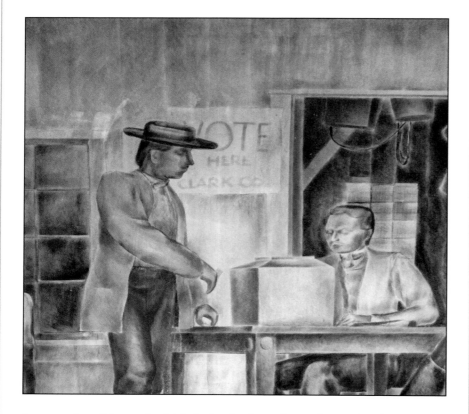

least, a plausible one) which he had selected as a theme for the designs. The theme was representative of the most colorful period in the history of the town, and most of the people who lived in the county were

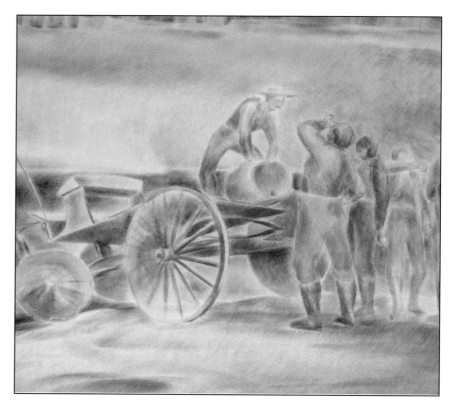

familiar with the episode. The time that was agreed upon for completion and installation was extended based on some delays he experienced. One of the suspected reasons for the delays was that he was also engaged in his metalwork, as he had made mention of it in several of his letters to the Section.

History of Neillsville

The history of Neillsville dates back in the history of the Church of Jesus Christ of Latter-day Saints in Nauvoo.[68] The construction of this church required more lumber than could be found locally, so the Latter-day Saint loggers set out to look for more timber in the pine forests of Wisconsin located 400 miles north. Between 1841 and 1845, they settled in Clark and Jackson counties and started cutting logs and

floating the logs in the Black River to mills located at Black River Falls. Neillsville was one of the areas where logging settlements were established and which supplied the logs to the mills. This was the main economic activity in the area. The Mormon loggers were thus the first non-native people to develop and establish Neillsville.

The Mormons left the area in 1845, and James O'Neill accompanied by his party settled there.[69] The town was named after him, as well as the stream that passes through the town to the Black River, called O'Neill Creek. O'Neill was looking for land along the Black River to construct a sawmill. In 1854, the town was selected as Clark's county seat. On April 4 of the following year, it was platted, and in 1882, it was incorporated.

One notable resident of Neillsville was architect William Steele, known for his important contribution to the design of the Prairie School in the early 20th century[70]

The Neillsville Post Office

619 Hewitt St., Neillsville, Wisconsin 54456

The Neillsville, Wisconsin, post office was built by Ebbe Construction Company of Trenton, Missouri. The cost of the building when new was about $40,200.

The Neillsville Post Office was completed in 1937 as indicated on the cornerstone on the lower right corner of the building. It reads, *Henry Morgenthau Jr—Secretary of the Treasury. James A Farley—Postmaster General. Louis A Simon—Supervising Architect. Neal A Melick—Supervising Engineer.*

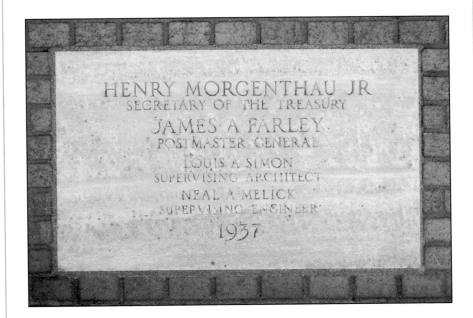

***Winter Sports and Rabbit Hunters,* by Edward Morton**

The mural *Winter Sports and Rabbit Hunters* is oil on canvas, measures 14 feet by 5 feet, and was installed on July 18, 1938.

OCONOMOWOC

History of the Mural

The commission of $710 was awarded to Edward Morton of Milwaukee, Wisconsin.

The Section invited Morton to submit his designs for the mural based on the works he had done for the Treasury Department Art Projects. The invitation was not competitive, and after the Director of Procurement approved his new designs, a contract was prepared for his signature concerning the execution of the mural painting.

The mural was allocated the space above the door of the postmaster that was located at one end of the public lobby as indicated in the blueprints forwarded to Morton by the Section. They authorized the artist to make any slight change he considered necessary in the size of the proposed panel to make it more suitable for the allocated wall space. The Section advised him to pay a visit to the post office and call on the postmaster so as to determine a subject matter suitable for the mural.

Morton's design was considered mostly satisfactory except for the color red, which was probably emphasized on too large a scale, and a balance of both cold and warm tones was suggested as better for the mural.

Morton forwarded the photograph of his cartoon for Oconomowoc to the Section and asked for permission to change from water adhesive to white lead adhesive since the latter was simpler and more effective for installing the mural.

In accordance with the request the Section had made to be contacted when he was done with painting the mural, he sent a letter to them informing that he was done, and he had decided that the first of July was the day he would like to install it, if he was authorized to. He had the mural photographed in his studio since there was a light fixture in the lobby of the post office which made a useful photograph impossible.

The Section told Morton to file a lighting report, which they sent to him, so that proper steps would be taken to have the lighting situation taken care of. Another photograph was sent to the Section of the completed and installed mural. Based on the lighting, the Section requested that he return the lighting form and that he also forward the snapshots of the already-installed mural.

MORE ABOUT THE ARTIST AND THE MURAL

Edward Morton was a resident of Milwaukee, Wisconsin, at the time he was commissioned to paint the mural in Oconomowoc. Morton accepted the invitation to work on the mural painting in a letter he sent on May 23, 1937.

History of Oconomowoc

Oconomowoc is located between Fowler Lake, the Oconomowoc River, and Lac La Belle. In Potawatomi, this name simply means "where the waters meet" or "rivers of lakes."[71] The area where the town is located has abundant resources that attracted settlers and members of the Winnebago and Potawatomi tribes.[72] The clear lakes and woodlands provided the tribes with an abundance of natural resources to sustain themselves.

The first post was established in 1827, but it was not until 1837 when the first settler came into the area, namely, Charles Sheldon, accompanied by Phil Brewer.[73] They constructed log cabins to store timber extracted from the deep woodland. Charles and Phil were later joined by other settlers who were lured by stories that the area was full of beauty and resources. One of the settlers who came after Sheldon and Brewer was John S. Rockwell, who is recognized for having established a strong foundation for the growth of the town. He constructed a gristmill and the first store, fire department, library, and hotel. He

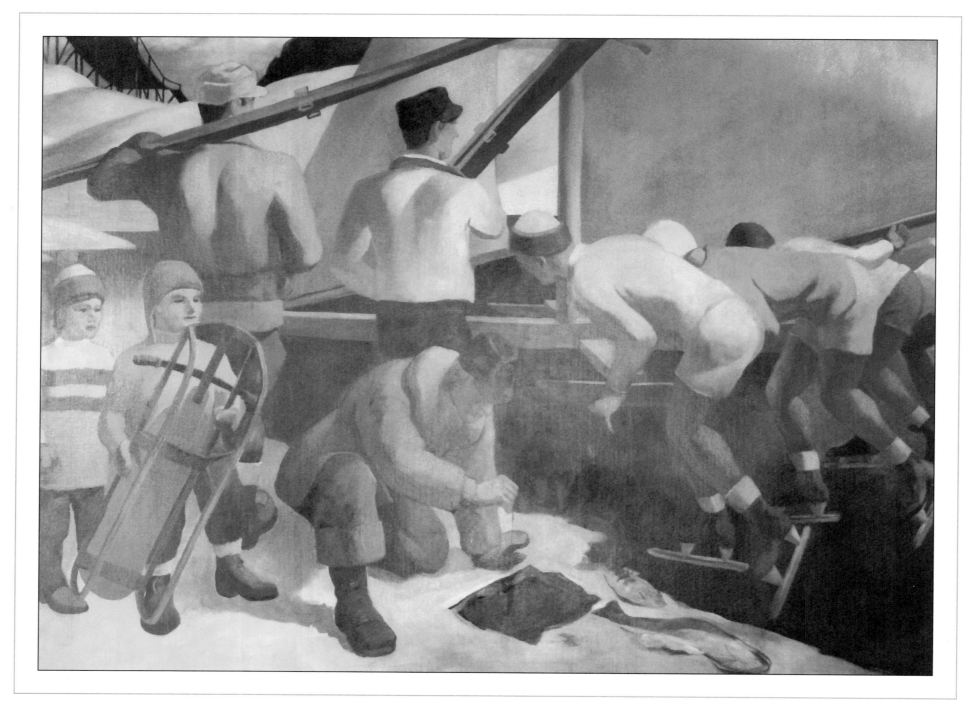

Edward Morton, *Winter Sports and Rabbit Hunters*

also donated land to churches and a women's seminary. He is known as the "Father of Oconomowoc."

In 1875, Oconomowoc was incorporated as a city. More immigrants continued to stream in, and by 1875, the population was about 3,000. The laying of the railroad further opened up the city as a trade hub and made it a favorite destination for tourists in the summer and wealthy vacationers from St. Louis, Milwaukee, Chicago, and Midwestern cities.[74] Some wealthy families constructed their homes along the lake. By the 1880s, there were six resorts in the town. The town was referred to as the "Newport of the West" until the Great Depression affected its economic base.

Notable people who visited are U.S. presidents Harrison, Grant, McKinley, Cleveland, and Theodore Roosevelt. The visit of these recognized personalities caused Main Street to be nicknamed the "Avenue of Presidents."[75] The town had other businesses such as the Oconomowoc Canning Company, Brownberry Ovens, Carnation Company, and the Pabst Farms that became an internationally recognized supplier of purebred livestock.

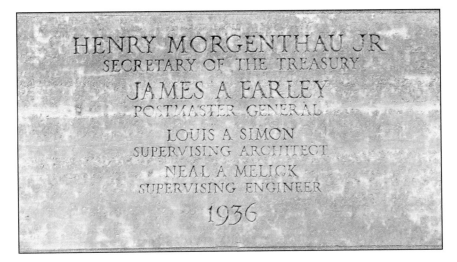

The Oconomowoc Post Office

38 S. Main St., Oconomowoc, Wisconsin 53066

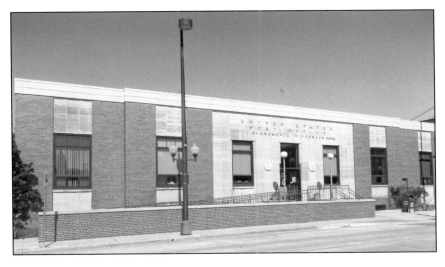

The Oconomowoc, Wisconsin, post office was built by Maas Brothers of Watertown, Wisconsin. The cost of the building when new was about $44,844.

The Oconomowoc Post Office was completed in 1936 as indicated on the cornerstone on the lower left corner of the building. It reads, *Henry Morgenthau Jr—Secretary of the Treasury. James A Farley—Postmaster General. Louis A Simon—Supervising Architect. Neal A Melick—Supervising Engineer.*

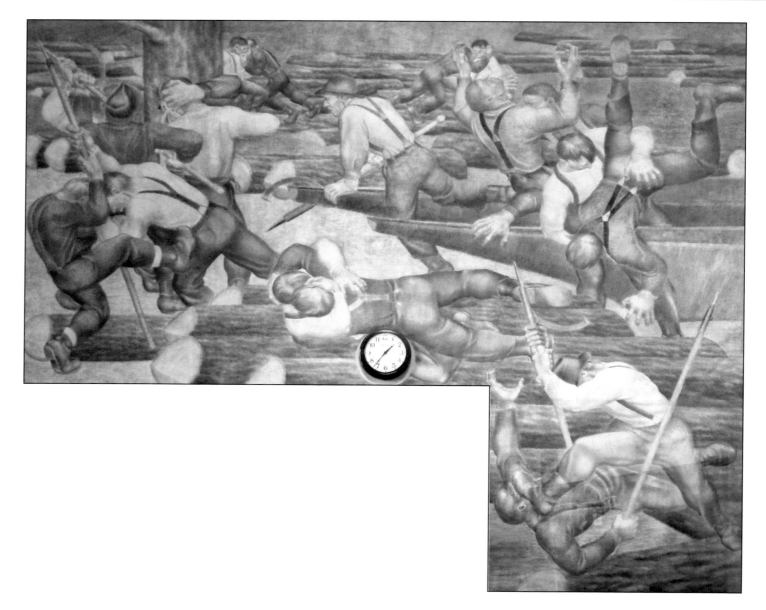

Lumberjack Fight on the Flambeau River, by James S. Waltrous

The mural _Lumberjack Fight on the Flambeau River_ measures 15 feet by 11 feet and was installed on May 29, 1938.

PARK FALLS

History of the Mural

The commission of $1,600 was awarded to James S. Waltrous of Madison, Wisconsin.

A letter was sent to the Section informing that the post office was going to occupy a new and beautiful three-story building. It stated the importance of having beautiful murals painted and installed in new Federal buildings. The letter also requested that the Section collaborate with the proper departments so that the new post office building would have its own share of some of the beautiful mural paintings that had been painted in government buildings.

In view of this, the Director of Procurement authorized the reservation for a mural decoration of the building. It was, however, going to take time before the building would be available for use.

The two-inch color sketch for the mural painting of Park Falls was forwarded to the Section for consideration. The postmaster of Park Falls had also corroborated the fact that the space to the right of the door was also available for design, and it was included in the plans. Attempts were made to integrate the design into the architectural setting as much as possible. The color of the woodwork around the door and that of the door were the same—dark reddish-brown—and it was believed that the color would fit in with the ones meant for the painting. There was also a large bulletin board which was painted dark gold with an oxidized effect at the left of the door, and surrounding it was a band of white plaster wall. Some of those colors were repeated in parts of the mural painting, which was placed immediately to the right side of the door.

A photograph of the mural painting was sent to the Section, and even though the lighting of the photograph was not even, it was however enough to convey the idea of just how far the work had progressed.

The painting of the mural decoration progressed at a very steady rate. During the course of painting the mural, Waltrous had planned to travel to Italy to observe the country's murals, and this prompted him to borrow some money which he had planned to settle with funds from the final payment for his post office mural.

The "handsome machismo" of the figures in the drawing was commended after the photograph of the painting was considered by the Section. But in the central area, it was not certain if the men were on a raft or were midair preparing to plunge into the water. There was also a vertical element on the left side which was not explained: It could be either a tree or a log or maybe something else. Also, an account was requested for the unusual position of the vertical element. He was then authorized to go ahead with the painting of the work and to continue keeping the Section up to date with its progress.

Though the artist was certain that the different elements in the painting were self-explanatory, he nonetheless offered some description. The action being described in the mural painting was actually taking place on the river which cuts through a point of land. A part of this river was used as the background on which the logs—which had small figures perched on them—floated. The central point of the mural was the land; the vertical element on the left and behind the figures was intended as a tree. On the right were two boats which had been drawn out of the river and onto the land.

Apart from the groups which were right above the clock and the figures which were at the extreme lower right side, all the men were fighting on the land. The men who were right above the clock were wrestling each other on a pile of logs which were stacked on each other and on the land down into the water at the point. The figures which were at the extreme lower right side were being forced into the water; this action was in itself an indication that there was a river at the left side of the point.

Those explanations appeared to be logical to the members of the Section: If the vertical element that was on the left side was a tree, then a great deal of the confusion caused by the design had been cleared up.

The figures on the center ground were dropped, just as was advised by the Section. There were other shifts (although small) in the position of the figures, which also seemed to simplify the arrangement and the action of the figures, such as the groups in the right corner. Some of the groups were also made slightly larger, and this helped to avoid the "chain-like" feeling the Section had questioned in the color study.

In order to get the details in the cartoon painting right, Waltrous had made use of real tools like pike poles and peaveys which he had gotten from the State Historical Museum as models. The small portion of water that was introduced at the bottom of the boat was done so that the idea of having water on both sides of the land, and also around the strip of land, would be clarified better.

The Section stated that the work had been carried out very satisfactorily, and the installation was also authorized. And they informed him that just in case he went through Washington on his way to Europe that he should visit the Section as it would be nice meeting the man behind the excellent mural decoration.

During the installation, residents of the town noticed that the figure that was climbing off the bateau was quite familiar, reminding them of a character known in that region as Fighting Finn.

The postmaster wrote to the Section, telling them that the mural was regarded as far-fetched even though it was enjoyed by a large number of the people who came to look at it. The town of Park Falls was located in the middle of a large resort area, and it was believed that a few woodland scenes should be placed on the walls of the post office, which would earn praise for the Section. The request for more mural decorations that would use the other landscapes of the region as subject matter was noted, and the issue was put under advisement.

MORE ABOUT THE ARTIST AND THE MURAL

James S. Waltrous was a resident of Madison, Wisconsin, when he was commissioned for the Park Falls mural.

He was invited by the Section of Painting and Sculpture to submit his designs for the mural painting based on the designs he had submitted for previous competitions.

Since Park Falls was right in the middle of Flambeau County, Waltrous thought that the locale offered some fine subject matter.

History of Park Falls

Park Falls is located in the northern-central part of Wisconsin along the Flambeau River. The area was first mapped in 1865 by government surveyors.[76] The Ojibwe or Anishinabe were the original residents of the area, and they practiced hunting and trapping. The Frenchmen Frederic Neadeu and Albert Lacqueoix settled here in 1876 and constructed their homestead on the northern branch of Flambeau River. Their area of residence would later be named Muskellunge Falls. The Flambeau River provided a means of transport of pine logs to the mills and fur traders taking their fur to the north.[77]

The railroad was laid in the area during the summer of 1877. It connected Park Falls with Ashland and Milwaukee and opened up the area for more people to settle. More immigrants streamed into the area, and its growing population required additional amenities. An area at the southern side of the town was set for constructing a school. In 1885, Henry Sherry erected the first band-saw mill, further encouraging the town's growth. In 1889, the first post office was opened. In

James Watrous 1938

the same year, the town acquired its name Park Falls, because the pines growing around the falls gave the area the look of a park.[78]

By 1890, the area had grown, with boarding houses, almost twenty houses, and a pulp manufacturing plant constructed by Henry Sherry.[79] New settlers were streaming in, and by 1900, a newspaper office, several stores, and a church were built. The pulp mill was expanded to Flambeau Paper Company and started producing paper by the late 1890s. By 1901, there were 750 residents who had been incorporated into a village. Despite most of the trees having been cut, the paper mill industry in the area continued to prosper, attracting more settlers. By 1912, the area had a population of roughly 2,000, and it became a city.

The fight on the Flambeau River is said to have really happened in 1888, between two rival logging crews.

HENRY MORGENTHAU JR
SECRETARY OF THE TREASURY

JAMES A FARLEY
POSTMASTER GENERAL

LOUIS A SIMON
SUPERVISING ARCHITECT

NEAL A MELICK
SUPERVISING ENGINEER

1936

The Park Falls Post Office

109 1st St. N., Park Falls, Wisconsin 54552

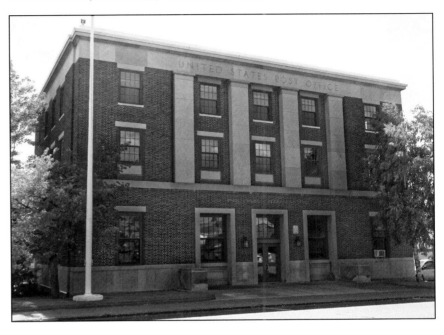

The Park Falls, Wisconsin, post office was built by Midwest Contracting Co., of Minneapolis, Minnesota. The cost of the building when new was about $93,452.

The Park Falls Post Office was completed in 1936 as indicated on the cornerstone on the lower left corner of the building. It reads, *Henry Morgenthau Jr—Secretary of the Treasury. James A Farley—Postmaster General. Louis A Simon—Supervising Architect. Neal A Melick—Supervising Engineer.*

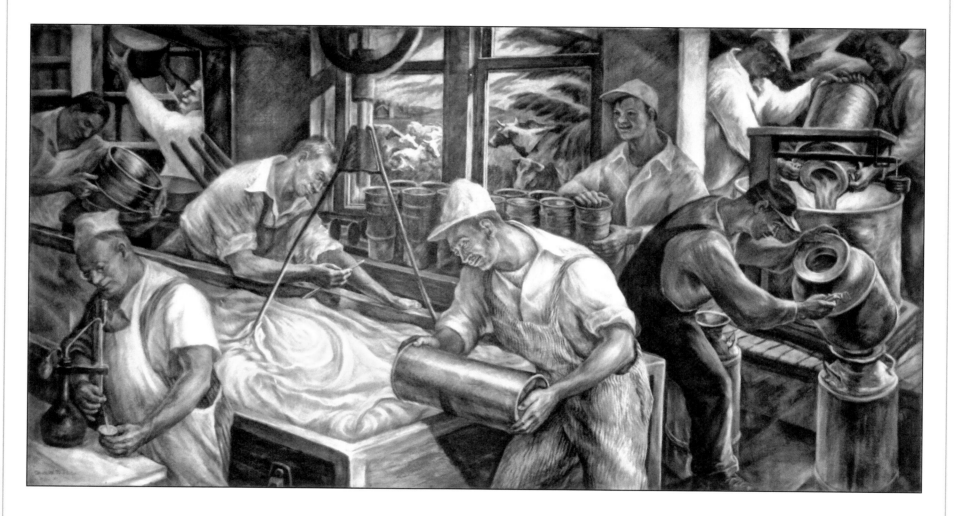

Making Cheese, by Charles W. Thwaites

The mural _Making Cheese_ is tempera on canvas, measures 6 feet 4 inches by 12 feet, and was installed on November 22, 1941.

PLYMOUTH

History of the Mural

The commission of $850 was awarded to Charles W. Thwaites of Milwaukee, Wisconsin.

Thwaites used cheesemaking as the subject matter since Plymouth was the cheese center of the United States. Thwaites also received an invitation to submit a design for the Windom, Minnesota, post office, which he accepted.

The mural decoration of Plymouth was finally completed and the photographs and negatives were forwarded to the Section of Fine Arts for consideration and approval. Thwaites's wife's health, however, made it imperative that they travel to Arizona during the winter, so he asked that the Section make their criticisms as soon as they could so he could finish installation of the mural and get on to Arizona as early as was possible.

After a photograph and a negative were received and approved by the Section, they authorized the installation of the mural. The mural decoration for Plymouth was finally installed on November 22, 1941. One of the most interesting things about the painting was the method the artist had suggested for cleaning the painting: He recommended using slightly moist bread crumbs, the way wallpaper was often cleaned.

MORE ABOUT THE ARTIST AND THE MURAL

[See the Chilton entry for more information.]

Thwaites was a resident of Milwaukee at the time he was commissioned to paint the Plymouth mural. He was invited to submit sketches based on the designs he had submitted for the Social Security Building Mural Competition.

The mural space was proposed to be 12 feet in width and 6 feet 9 inches in height and was located at one end of the lobby over the door of the postmaster. The length of time budgeted for the completion of the mural painting and its decoration was eight months, and Thwaites was advised to inform the Section if he could not undertake the mural painting as they would offer him another commission at a later date. The number of commissions available to grant artists was limited.

History of Plymouth

The land of Plymouth was surveyed by the government in 1835. The first settlers to make permanent settlements arrived on May 8, 1845: Ransellar Thorpe; and Isaac, John, and William Bowen, all from Tioga County in Pennsylvania.[80] They spent their first night at the cold springs near the area where the real Cold Springs was erected later, after they settled. After arrival, they cleared the land and constructed a log home. They also planted some crops for their food. Shortly after, they were joined by Henry Davidson and his son Thomas, who had migrated from Hartford, Connecticut. All of them were attracted by the beauty of the land. Henry Davidson had envisioned naming the area "Springfield." However, Thomas Davidson's wife passed away, and in honor of her he decided to name the area "Plymouth" after their previous home in Connecticut.[81]

Thorpe constructed the first house at the southeast part of town, completing it on May 12, 1845. During the fall, he cleared four acres of what later became Reuben Clark's farm, and sowed seeds for the wheat that would be the main food staple in the town. The early town of Plymouth included the Town of Rhine and was organized in 1849.[82] This was followed by the formation of Plymouth village after the combination of Plymouth and Quit-qui-oc villages. The central location of the town and its strategic location at the crossroad of Northwest Railroad and Milwaukee Road also made it a center of attraction for many immigrants. As a result, the village's population grew larger. In 1894, the telephone system was installed. A musical society was established in 1856.

A government was established on May 8, 1877, and Plymouth became a chartered city led by the first mayor, Otto Puhlmann. The area

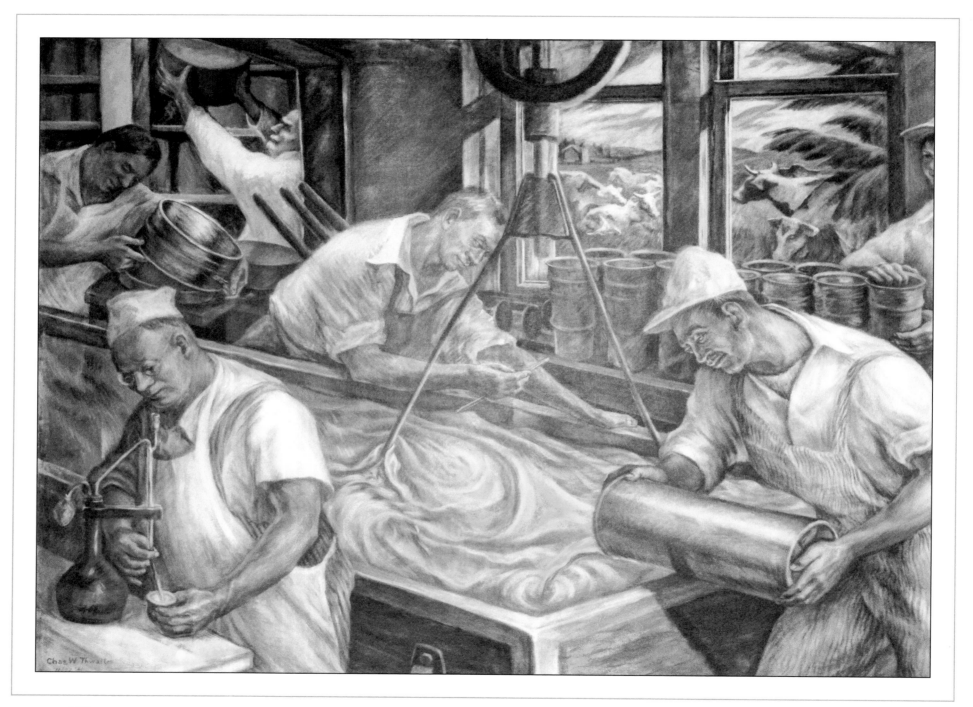

Charles W. Thwaites, *Making Cheese*

continued to produce grain until the Civil War disrupted agricultural activities. After the war, grain production was replaced by dairy farming as the major economic activity.[83] As a result, it became a cheese center, and in the 1950s, it was the leading center of cheese production in the United States, hosting the National Cheese Exchange. The first library was started in 1970 with 750 books. A half fire station was constructed in 1968, followed by the construction of a fire department in 1984.

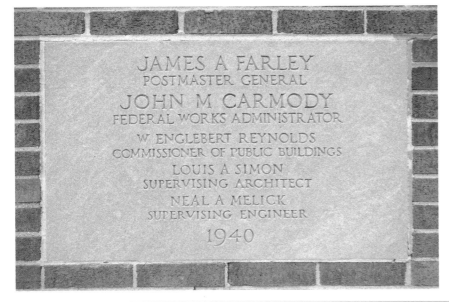

The Plymouth Post Office

302 E. Main St., Plymouth, Wisconsin 53073

The Plymouth Post Office was completed in 1940 as indicated on the cornerstone on the lower left corner of the building. It reads, *James A Farley—Postmaster General. John M Carmody—Federal Works Administrator. W Englebert Reynolds—Commissioner of Public Buildings. Louis A Simon—Supervising Architect. Neal A Melick—Supervising Engineer.*

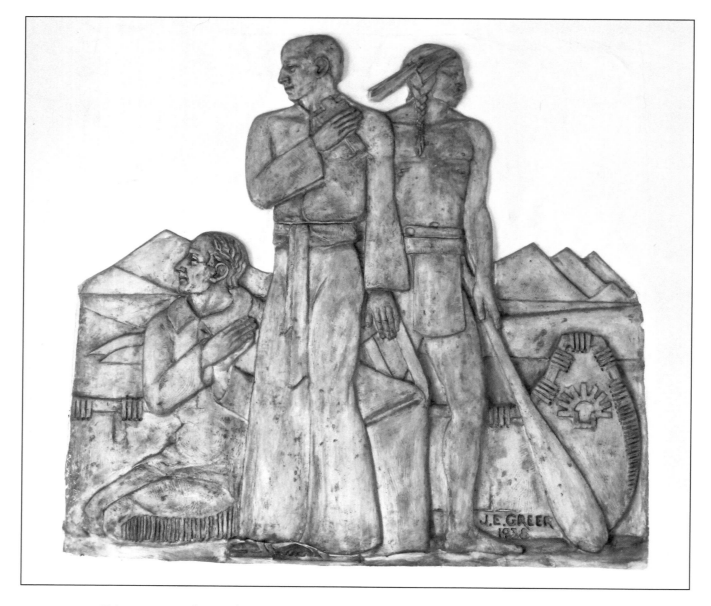

Discovery of Northern Waters of the Mississippi, by Jefferson E. Greer

The sculpture *Discovery of Northern Waters of the Mississippi* is plaster of Paris, measures 4 feet by 4 feet, and was installed on October 25, 1938.

Jefferson E. Greer, *Discovery of Northern Waters of the Mississippi*

PRAIRIE DU CHIEN

History of the Mural

The commission of $610 was awarded to Jefferson E. Greer.

The invitation letter sent from the Section to Greer had invited him to submit his own designs for a sculpture relief in Prairie du Chien based on the merit of the model he had submitted to them. The Section made several suggestions concerning the sculpture relief to Greer, some of which included submitting several pencil sketches of the design and incorporating a subject matter appropriate for the building or the locale of Prairie du Chien. The relief could be executed in plaster, wood, cast stone, terra cotta, or any other material that was considered appropriate for the building.

Upon receiving the sketches, the only suggestion offered by the Section was that the attenuation of the figures should not be pronounced in the finished work or possibly that the heads should be a bit larger in relation to the figures. The design presented to the Supervising Architect was approved. Greer was then authorized to go ahead with the full-size cartoon. After that met with the Section's approval, the artist was given permission to proceed modeling with clay.

Regarding the medium of the work (which had been agreed on to be plaster), Greer found when he visited the post office that the walls were unpainted. He then asked the Section what they intended to do with the walls and what tint would they like him to use in the relief. He also asked about the kind of tile that was used in the wall and the name of the local contractor they would like to employ to work on the installation.

Greer was also told to submit a working drawing that showed the method he was proposing for the installation, which was to be referred to their structural engineer for approval. The Section considered the method he had proposed would be best for installing the panel and advised that extreme care must be employed while cutting the terra cotta blocks so as to prevent breaking an entire block, which would necessitate repairs and probably refinishing the room when the decoration was done. A copy of the shop drawing he had sent to the Section earlier was forwarded to the postmaster as he was the one in charge of supervising the installation of the work.

Before Greer cast the work, the Section sent additional observations: The lower extremities of the figures that were kneeling seemed unduly shortened, and the hand of the Indian who was holding the paddle should be defined more than it was in the photograph. He decided that he would install the bas-relief on October 25, 1938.

In one of Greer's many letters, he stated just how excited and happy he was at the opportunity that was given him to work with the Section, and he hoped that the work he had done for them would justify their considering him for any future projects. He also invited them to his studio if they happened to find themselves on a visit to Wisconsin. He attached a copy of a panel he thought they should see. The panel showed Father Marquette at 36 as he stepped away from a canoe while looking towards the broad Mississippi. At his side stood an Indian who was not looking toward the west with its promise, but instead was fixated on the east.

MORE ABOUT THE ARTIST AND THE MURAL

Jefferson Elliot Greer was born in 1862. He was a resident of Milwaukee, Wisconsin, when he was commissioned to create the sculpture for Prairie du Chien.

The Section of Painting and Sculpture had invited the artist to submit his designs for the sculpture decoration of Prairie du Chien as a result of the excellent model he had submitted in the Federal Trade Commission Building Competition. He studied under Jonson in Chicago around 1920 and went on to the University of Wisconsin for about three years before he went to work on the Federal Building in

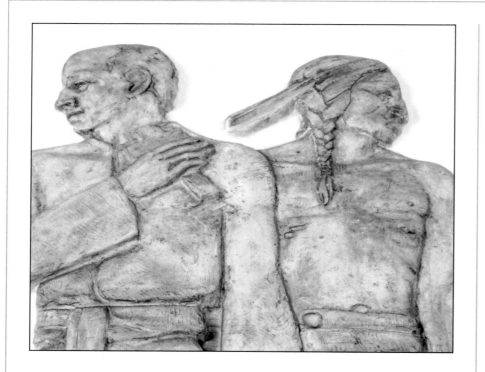

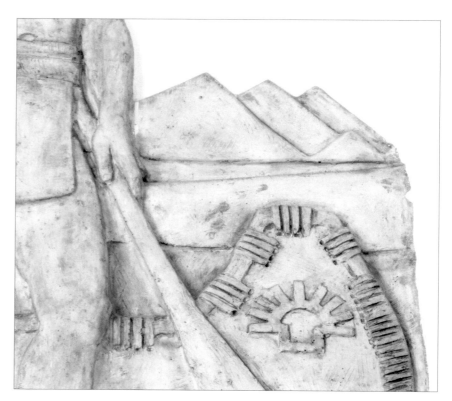

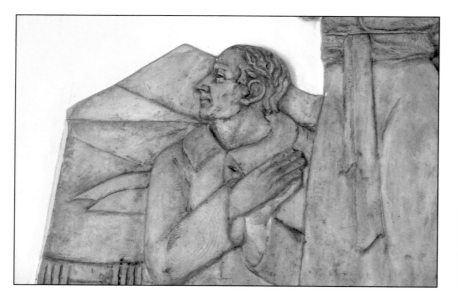

Jefferson E. Greer, *Discovery of Northern Waters of the Mississippi*

Texas where he remained under the supervision of Julian Garnsy. He was also an assistant to Gulzon Borglum for a year.

History of Prairie du Chien

Prairie du Chien, which is regarded as the second largest town in Wisconsin, was established in the 17th century by French Canadian travelers.[84] Prairie du Chien was the name first given to the area around the Mississippi River. Later on, the name was given to the city as well. The first people to arrive at Prairie du Chien were French explorers in the year 1673 using the Mississippi and Illinois River routes. The French constructed a trading center where the main item of trade was fur.[85]

After the French and Indian War of 1763, British took control of Prairie du Chien. The fur business continued flourishing until the mid-19th century when the business collapsed, and the people of Prairie du Chien changed to agriculture and railroads.[86]

The oldest school in the area was constructed in 1913 and was called St. Mary's Institute, which is today called Mount Mary University. The school was built on land donated by John Lawler. The oldest post office was constructed in 1824 with James Lockwood as postmaster.[87]

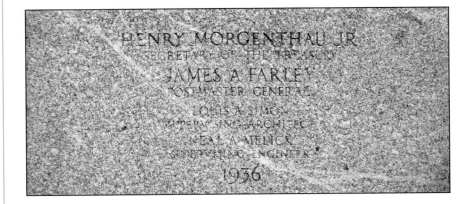

The Prairie du Chien Post Office

120 S. Beaumont Rd., Prairie du Chien, Wisconsin 53821

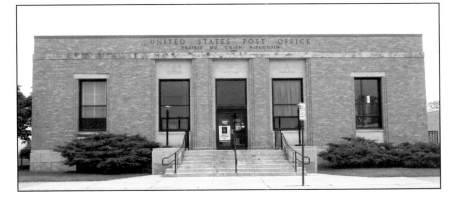

The Prairie du Chien Post Office was built by J. P. Cullen & Son, of Janesville, Wisconsin. The cost of the building when new was about $54,701.

The Prairie du Chien Post Office was completed in 1936 as indicated on the cornerstone on the lower left corner of the building. It reads, *Henry Morgenthau Jr—Secretary of the Treasury. James A Farley—Postmaster General. Louis A Simon—Supervising Architect. Neal A Melick—Supervising Engineer.*

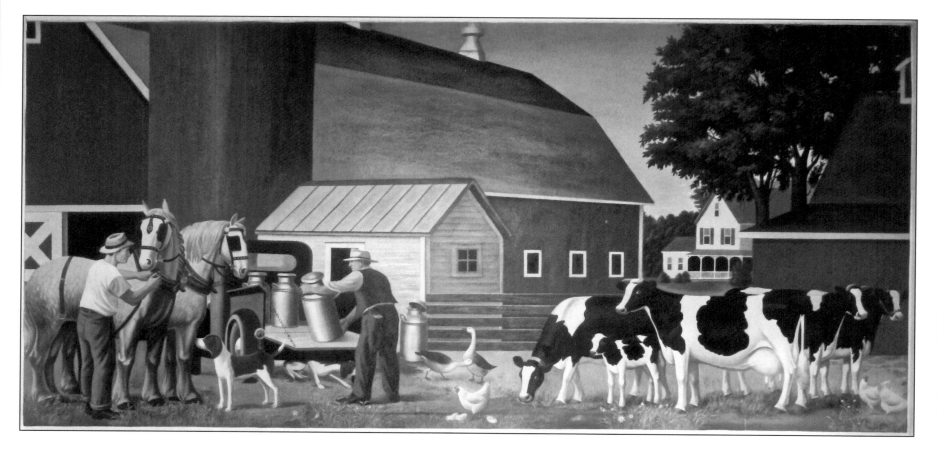

Dairy Farming, by Richard Jansen

The mural *Dairy Farming* is oil on canvas, measures 12 feet by 5 feet 6 inches, and was installed on March 16, 1940.

REEDSBURG

History of the Mural

The commission of $750 was awarded to Richard Jansen of Milwaukee, Wisconsin.

A mural competition was proposed that would be conducted locally for several new buildings being constructed in the area. However, a regional chairman was appointed to take control of the competition, while representatives from multiple surrounding towns would be invited for consulting in relation to the work.

One suggestion made to Jansen concerned the truck and the head of the second horse that was on the left in the painting: either the truck could be shifted very slightly, or the head of the horse could be shifted so that the vertical edge of the truck would not fully overlap with the mouth of the horse.

Jansen sent a photograph of the completed cartoon for the Section to consider. He also inserted a line drawing of the segment of the mural, which had changes made to it based on suggestions of the Section. These corrections involved moving the truck very slightly, opening the back of the truck, and shifting slightly the figures which were loading the milk cans. The roosters and the other chickens that were in the original design did not seem to work for the refurbished one, so he substituted a dog.

The mural for Reedsburg was finally installed on a Saturday, and the postmaster was reported to be very pleased with both the subject matter of the mural and the manner with which it was executed. When Jansen first visited Reedsburg before he started working on the sketch, he did not measure the dimensions of the wall; he merely followed the measurements that were on the blueprints (and they were not exact). The length of the mural space on the blueprint measured 12 feet and that size was used in his correspondence. The width was 5 feet and a half on the blueprints, ranging from the top of the postmaster's door to the molding board, but it was actually 5 feet and 9 inches on the wall.

Of course, there was nothing that could be done (apart from starting the mural painting all over), other than to cut the painting at the ends on both sides for the length. But then, in the case of the width, the mural was run against the molding that was on the top and three inches above the door that led to the office of the postmaster. There was about three inches of free space over the door, which was regarded as a benefit because it allowed everything that was at the bottom of the mural to be seen easily at a distance.

The Section expressed their regret over the mistake Jansen had made, as they believed that he should have known to use the measurement taken in the building and not the ones that were present on the blueprint which were apt to be wrong in certain situations, although they were pleased that the postmaster was delighted with the mural decoration. The Section then sent a letter to the postmaster requesting that he send a statement on the satisfactoriness of the installation.

The reply of the postmaster was based, however, on a recent inspection tour during which he concluded that the rectangular panels in the buildings are not always harmonious with the architectural features of the mural wall, like the door and bulletin boards. He suggested that the situation could be helped only if an appropriate color was taken from the mural painting and applied around it, as well as to the bulletin boards and door.

MORE ABOUT THE ARTIST AND THE MURAL

Richard Jansen was born in Milwaukee, Wisconsin, in 1909. He was a resident of Milwaukee when he was commissioned to paint the mural in Reedsburg.

Jansen studied in Milwaukee and also at the Art Students League in New York. His works were exhibited regularly at the International Water Color Show, at the one-man shows in both Milwaukee and Chicago, and extensively throughout the Middle West.

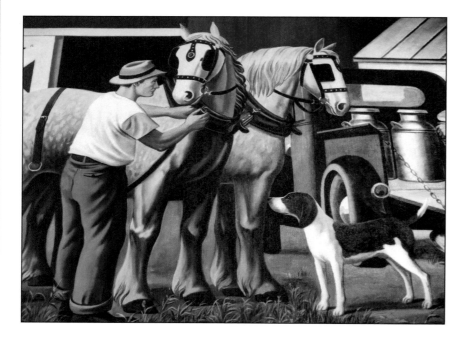

In 1935, his works were shown at the Marie Harriman Galleries and in private collections in Milwaukee, Chicago, Washington, and New York. He was also an instructor at the Layton Art School in Milwaukee from 1932 to 1934. He was an Associate with the Key West Group from 1934 to 1935.

He was employed with the Special Skills Division of the Resettlement Administration, Washington, D.C., from 1935 to 1936.

History of Reedsburg

Reedsburg is located around the Baraboo River in Sauk County. The city was established in 1887 as a result of the construction of many buildings around the village by explorers who had settled in the area. James W. Babb and his wife had come to Reedsburg in the 1840s, followed by other explorers who established a sawmill in the area.[88] David C. Reed is known to have come to the area following James W. Babb after hearing there were copper and iron. Reed is believed to be the founder of the town; hence the town was named Reedsburg.

By 1856, the community had grown to 50 houses of 20 families. In 1872, the railway reached Reedsburg, which led to the construction of a brewing company in 1880.[89]

The main economic activity in Reedsburg in the 19th century was cloth-making. Reedsburg Woolen Mill was constructed in 1882, and later started making clothes. The main market for the clothes was in Chicago.[90]

Reedsburg is known for its black squirrels which are often seen in the area by the Reedsburg residents. Two Black Sox players, banned from professional baseball, built a playing field in Reedsburg where they could play baseball. Reedsburg was the first town in Wisconsin to have a Ford dealership. There is also Webb Park, a historic site where German prisoners of war were held.[91]

The Reedsburg Post Office

215 N. Walnut St., Reedsburg, Wisconsin 53959

The Reedsburg Post Office was built by Deans Construction Co., of Minneapolis, Minnesota. The cost of the building when new was about $50,779.

The Reedsburg Post Office was completed in 1937 as indicated on the cornerstone on the lower left corner of the building. It reads, *Henry Morgenthau Jr—Secretary of the Treasury. James A Farley—Postmaster General. Louis A Simon—Supervising Architect. Neal A Melick—Supervising Engineer.*

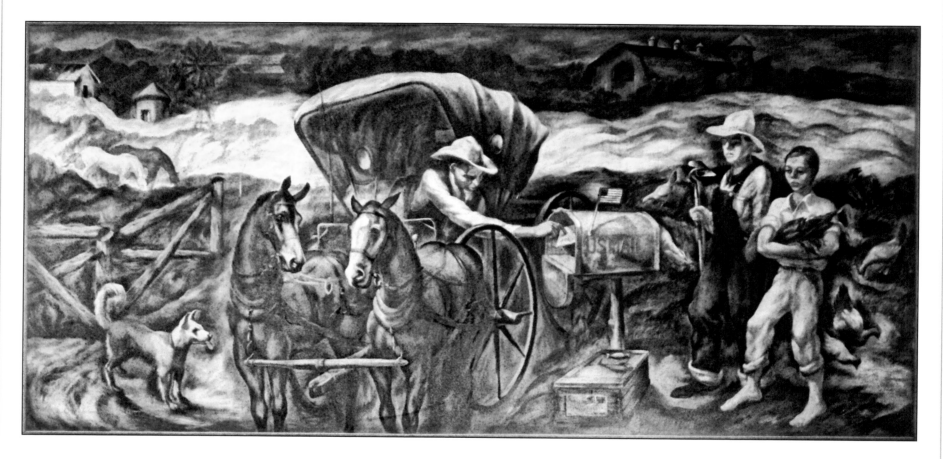

Rural Delivery, by Forrest Flower

The mural _Rural Delivery_ is oil on canvas, measures 12 feet by 5 ½ feet, and was installed on July 9, 1938.

History of the Mural

The commission of $660 was awarded to Forrest Flower of Wauwatosa, Wisconsin.

The Section invited Flower to submit his designs for a mural painting for Rice Lake based on work that he executed for Treasury Department art projects. He was asked to pay a visit to the post office in order to determine the exact measurements of the space meant for the mural, as well as to research what might be a good subject matter. He was given one year to complete the mural.

Based on his initial sketch, the Section recommended that Flower make "the form less nervously broken and also try to not make the color too dark." Flower intended to do the oil painting on canvas first and then cement the painting to the wall, with a subtle molding around its edges.

Flower eventually sent a two-inch color sketch of the mural, which was received positively by the Section. However, they considered the mailbox in the design as too large and requested that it should be reduced in size and moved forward on a diagonal to the left, as they believed that would make the gesture of the mailman much less strained than it seemed to be in the sketch and that it would take care of the placement of the figure on the right. They also suggested strengthening the horses and the back of the buggy. They again mentioned the dark tone of the painting.

Eventually, Flower started work on the full-size cartoon for Rice Lake, and, in less than two weeks, he had completed it and also had it photographed and forwarded to the Section. He agreed that the tone of the sketch was dark, after doing an analysis. He found that doing a darker drawing and adding more value contrast was going to achieve the desired effect, thereby making the color more intense.

The photograph of the completed mural decoration when it was considered by the Section indicated that the work had progressed satisfactorily. There were some reservations about the mural: for example, the scale of the fence in the upper right-hand section of the mural decoration was not convincing; therefore, a proposal was made that the artist eliminate it completely from the painting. It was also proposed that the barn, which was in the back and above the buggy, be moved to another area.

Flower was authorized to carry on with further painting of the work and also advised to keep on informing the Section about the progress he had made. Flower decided on July 9 for the mural installation. He had improved the color and also made changes in the drawing's proportions. He returned the color sketch and sent the negative photograph just after the mural was installed.

After over two months since the Section requested the postmaster's opinion on the mural, the postmaster replied that he considered the mural satisfactory. He added that the mural was admired by a lot of people, especially by those with knowledge of art.

MORE ABOUT THE ARTIST AND THE MURAL

Forrest Flower was born in April, 1912, in Portage. He was a resident of Wauwatosa at the time he was commissioned to paint the mural for Rice Lake.

He graduated from Portage High School in 1930, and he contributed his works to the school between 1929 and 1930. He then attended Layton School of Art between September 1930 and June 1934, after which he undertook a painting course and studied under Charlotte Partridge, Miriam Frink, Gerrit Sinclair, and Myron Nutting. He married Margo Miller—a fellow student at the Layton School of Art and also an artist—in January 1936.

History of Rice Lake

Rice Lake is located in North Woods Barron County in Wisconsin near Chippewa Falls. It was established in the years 1864–1867 after

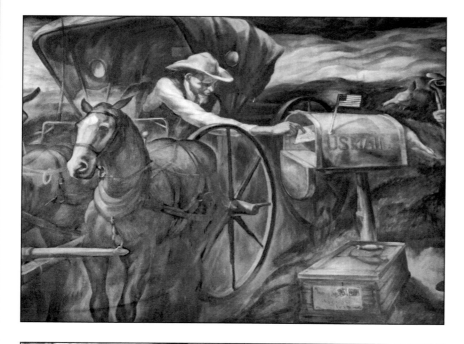

Forrest Flower, *Rural Delivery*

John Knapp had purchased land in the area and later formed a lumber company. Before Knapp bought the land, it was inhabited by Indians, including the Chippewa. The lumbering company was the largest in the world during that time.[92]

Knapp created an artificial lake to collect water for his company, which flooded the wild rice that had been gathered by Indian tribes.[93] These floods angered the Chippewa community, but the lumbering company brought them food. Today, Rice Lake is a tourist attraction and commercial city with many industries.

In 1904, a vocational school was constructed in the city which is now called Wisconsin Indianhead Technical College. The first post office in Rice Lake was constructed in 1937. The city itself derived its name from the wild rice around the lake.[94]

The Rice Lake Post Office

14 E. Eau Claire St., Rice Lake, Wisconsin 54868

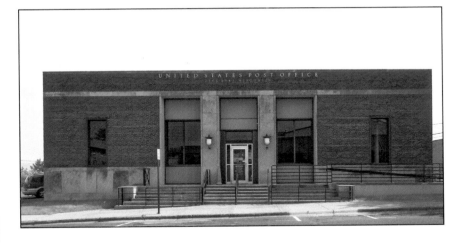

The Rice Lake, Wisconsin, post office was built by John Kratochvil of New Prague, Minnesota. The cost of the building when new was about $54,711.

The Rice Lake Post Office was completed in 1936 as indicated on the cornerstone on the lower right corner of the building. It reads, *Henry Morgenthau Jr—Secretary of the Treasury. James A Farley—Postmaster General. Louis A Simon—Supervising Architect. Neal A Melick—Supervising Engineer.*

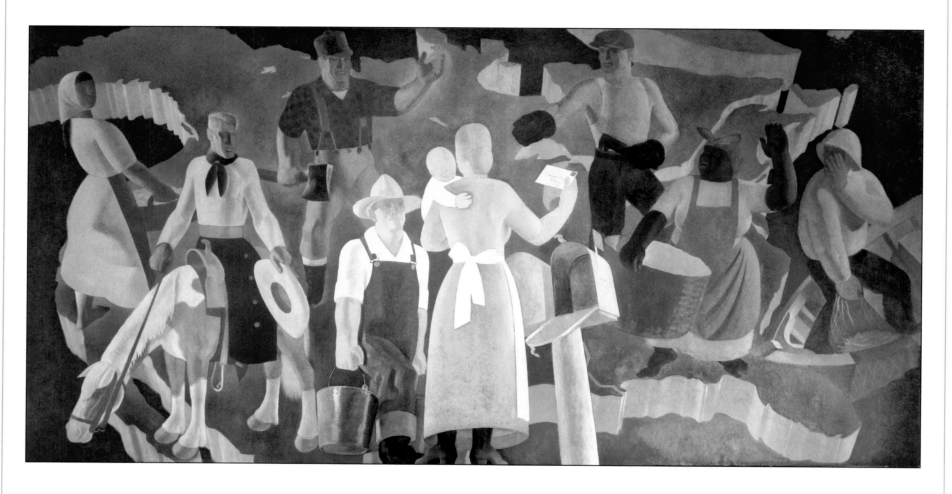

Decorative Interpretation of Unification of America Through the Post, by Ricard Brooks

The mural *Decorative Interpretation of Unification of America Through the Post* measures 10 feet 11 inches by 4 feet 7 inches and was installed on August 12, 1937.

RICHLAND CENTER

History of the Mural

The commission of $550 was awarded to Ricard Brooks of Madison, Wisconsin.

Brooks made two preliminary sketches, one larger than the other. The colors looked better in the larger sketch than they did in the smaller one. He asked for the Section's opinion on enlarging the two central figures in the smaller sketch. His central theme was that the post office makes all Americans neighbors.

The Section came to agree that the overall design in the larger sketch was possibly the best solution, but the postmaster of Richland Center did not seem to be enthusiastic about having a mural in the post office. The design would necessitate relocating two of the bulletin boards. This possibility made them consider using a single rectangular panel.

The Section approved Brooks's main theme, but the Supervising Architect felt that the man at the desk was not consistent with the outdoors figures. Brooks was asked to reconsider the motif in this respect and to introduce New York or New England style outdoor figures.

The Section felt that the scale of the figures was perfect. The pink dress worn by the central figure in the overall design was thought to be more pleasing than the rose-colored one which was worn in the smaller panel.

After being delayed in returning from Los Angeles for about two weeks, Brooks eventually went to Richland Center to look at the site of the proposed mural and to also get an interview with the postmaster. The interview, however, was less than satisfactory as the man appeared to resent the fact that he was not notified beforehand of the possible mural and also that the money paid for the mural could have been used for other purposes such as landscaping. The postmaster also would not allow any of the bulletin boards to be moved to make space for the mural.

Brooks found various problems with the actual space, including a vestibule and hanging light fixture that would block a full view. He felt that it would be better to install the mural in another public building in the district, but continued with the project, requesting that blueprints be forwarded to him, after which he made sketches for Richland Center. The eventual full-size cartoon presented some problems, including its use of light as well as an object that turned out to be a monkey wrench. But the Section ultimately approved the design, and the mural was finished and then installed by August 12, after which the artist left for Massachusetts, leaving an order with the local photographer to take some photographs of the mural. When the photographs arrived, one word was used to describe them: miserable. The color elements in the design were entirely washed out.

Brooks later had adequate photographs made and sent them to the Section, but before then, he sent the substandard photographs as proof that the mural had been installed. A large photograph was also added to show the situation of the lighting fixture that needed to be removed. Another lighting fixture could be put on the top of the vestibule, possibly a small flood.

The mural generated positive responses, even from the postmaster who had been hostile at the very beginning. He wrote that the installation of the mural by Brooks was satisfactory as well as attractive, and that comments from the public were favorable.

The Section also asked Brooks to forward to them a clear account of the story and the characters of the mural since they were considering preparing folders or booklets which would make the story of the different murals clear to the public, helping to spread recognition of the artists' work and that of the Section.

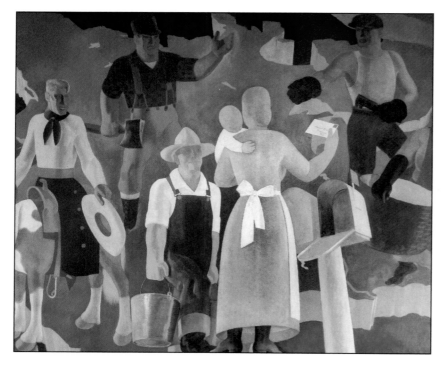

More about the Artist and the Mural

Brooks was a resident of Madison when he was commissioned to paint the mural in Richland Center.

It was customary for each post office to have three bulletin boards. Brooks was advised to call on the postmaster and see if there was any other place in the lobby he could suggest as suitable for the bulletin boards to be moved to.

History of Richland Center

Richland Center acts as the county seat for Richland County. The city was founded by Ira Sherwin Hazeltine in 1851. Hazeltine was a native of Andover, Vermont. The political entity of Richland County was itself established in 1842 with a population of about nine hundred

people. The land Richland Center sits on has huge, fertile prairies and abundant supplies of water, aspects which drew Hazeltine in 1850.[95]

After Richland Center was declared the county seat in 1852, it would later witness the expansion of railroad and associated transport activities in 1876. This ensured business and transportation between Richland Center and Chicago. Lumbering along the Pine River, agricultural support, and retail trade were the main economic activities that led to the growth of Richland Center into a city.[96] The first hospital, Kermott Hospital, was established in 1906 by Dr. Edward Kermott. Richland Center High School and Training School, which is one of the nation's oldest high schools, was established in 1902 and produced the first high school band in the U.S. in 1909. The first post office was established in the 1850s.[97]

One of the important facts about Richland Center is that the Women's Suffrage movement was started by the Richland Women's Club

formed by Julia Bowen and Laura Briggs James in 1882. The Women's Suffrage group was actively involved in advocacy after turning into a political party in 1909. Also, Frank Lloyd Wright, who designed the German Warehouse, was born in Richland in 1867. The German Warehouse, among other historical buildings, acts as a tourist attraction in the city of Richland Center.[98]

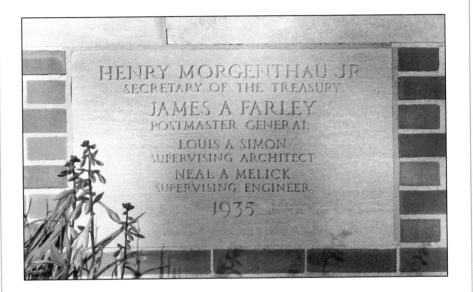

The Richland Center Post Office

213 N. Central Ave., Richland Center, Wisconsin 53581

The Richland Center Post Office was built by Maas Brothers, of Watertown, Wisconsin. The cost of the building when new was about $37,658.

The Richland Center Post Office was completed in 1935 as indicated on the cornerstone on the lower right corner of the building. It reads, *Henry Morgenthau Jr—Secretary of the Treasury. James A Farley—Postmaster General. Louis A Simon—Supervising Architect. Neal A Melick—Supervising Engineer.*

The First Settlers, by Eugene Higgins

The mural titled _The First Settlers_ is tempera wash with oil on canvas and measures 12 feet 6 inches by 4 feet.

SHAWANO

History of the Mural

The commission of $800 was awarded to Eugene Higgins of New York City, New York.

Higgins wrote to the postmaster of Shawano to see if he could get any assistance regarding the locale and the history of the town as well as the dimension of the mural space. He also wrote to the Section about his plan to divide the rectangle into two vertical panels on both ends and a longer horizontal panel between them.

Higgins forwarded two preliminary designs, writing of his understanding of the county's dairy farming, logging, fur trading, and pioneers. The Section preferred the design that showed a woodsman and his family watching a covered wagon train and a logger.

The colors the artist had proposed to use were regarded as satisfactory by the Section, but then the canvas which he had submitted did not appear to be pure linen or anything close to it. In order to get the greatest permanence, only pure linen canvas should be considered, and samples of the pure linen canvas were enclosed. He was asked to procure the canvas that was similar in quality and weight to the ones they had sent him, which he then procured.

Higgins eventually sent a photograph of the post office mural. He had wrapped the mural in a homemade wood frame because he wanted to use it, before installing it in the post office, for exhibition purposes. The exhibition stayed on display at the Grand Central Galleries New York City Terminal building. The Section was pleased that the work was exhibited at the Grand Central Galleries and that it was going to be shown also at the Salamagundi Club. The Section suggested that while Higgins was installing the mural he should include a simple molding around it.

After the mural decoration was installed, it was loved by everyone except for one person claiming to have once been a logger, who complained that the mural did not represent the county, that the final settlers had not arrived in covered wagons, but by boats which arrived up the river. Higgins asked the man if what he meant to say was that covered wagons did not travel through the country at all, and the man yelled, "No, Sir! The first time the covered wagons were seen in the locale was in 1850." In order to quiet the man down, he suggested that the name of the mural be changed from *Final Settlers* to *First Settlers*.

The mural is a representation of a woodsman resting with his axe stuck in a tree and looking on at a passing covered wagon train. His wife and child are near him, and a logger is going down the river; a dairy farm is in the distance.

More about the Artist and the Mural

Higgins was a resident of New York when he was commissioned for the Shawano mural.

History of Shawano

Shawano was first founded as a town in the 1850s until it later changed to a city in 1874. The city is found in Shawano County. It is on the Wolf River around the area of Green Bay. Shawano, the name given to the city, is borrowed from Menominee chief Sawanoh.[99] St. Mark was the first mission established by Jesuit missionaries in 1672 in the junction between Shawano Creek and the Wolf River. In 1843, Samuel Farnsworth explored the upper side of Wolf River where he was impressed by the trees. Farnsworth returned to his country and advised Charles Westcott to build a sawmill in Shawano as Farnsworth had seen a lumbering opportunity.[100]

The city's growth was based on the lumbering industry. A military road came along in 1866 that linked Shawano to Green Bay, which eased the transport of goods. Most of the inhabitants of the town were Yankees and the English until the Civil War when Germans began to enter the city.[101] In the next decade, Europeans and Scandinavians

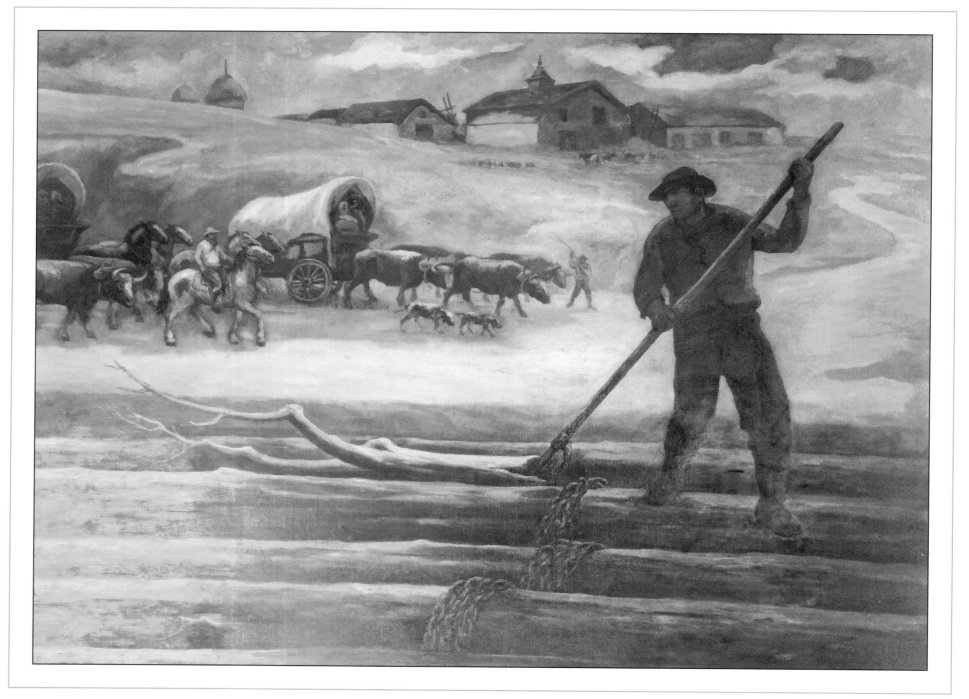

Eugene Higgins, *The First Settlers*

came in, and they began to cultivate the land left by loggers after trees were cut down. There was a catastrophic flood in the 1880s that damaged dams along the river and also bridges, leading to economic problems. After the flood, there were differences between farmers and loggers that led to the mobilization of troops to counter any feuds. The lumbering industry began to decline. Lake Shawano's good summer climate transformed the town into a tourist and service economy.[102]

The Shawano Post Office

235 S. Main St., Shawano, Wisconsin 54166

The Shawano, Wisconsin, post office was built by Mads Madsen Company, of Minneapolis, Minnesota. The cost of the building when new was about $50,962.

The Shawano Post Office was completed in 193? (the date on the cornerstone was covered up when the Postal Service installed the disability ramp). The cornerstone on the left corner of the building reads, *Henry Morgenthau Jr—Secretary of the Treasury. James A Farley—Postmaster General. Louis A Simon—Supervising Architect. Neal A Melick—Supervising Engineer.*

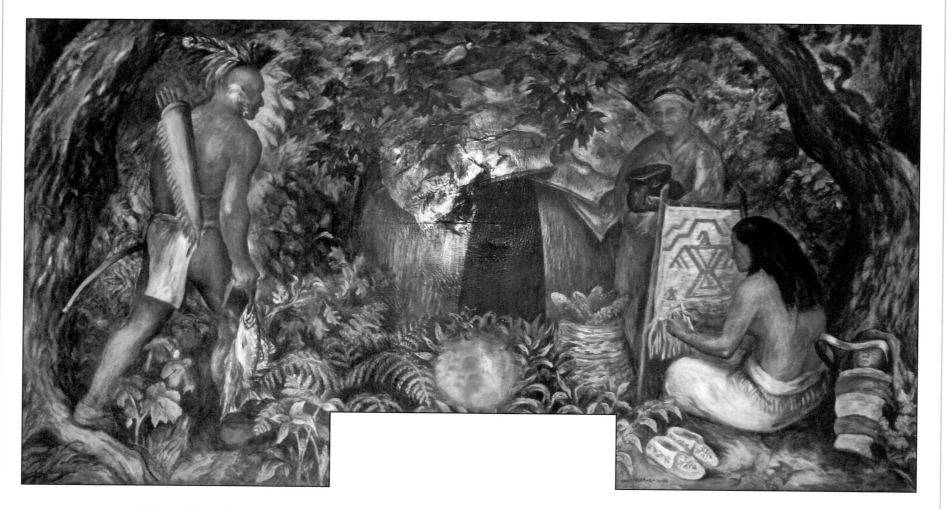

***The Lake, The Pioneer, Present City, Indian Life,* and *Agriculture,* by Schomer Lichtner**

One panel on the north wall measures 14 feet 6 inches by 7 feet 6 inches, another panel on the south measures 14 feet 6 inches by 7 feet 6 inches, the two panels on the east wall each measure 10 feet by 7 feet 6 inches, while the last panel on the east wall is 5 feet by 7 feet 6 inches.

SHEBOYGAN

History of the Mural

A letter dated February 11, 1941 was sent from the postmaster, advising that the mural already installed in the post office in Sheboygan had already come loose from the wall and was beginning to curl like wallpaper, and also that there has never been a mural on the south wall of the lobby.

It was shocking at first when the news about the condition of the murals in the post office reached the Section. The murals were put up with a water adhesive that was furnished by the project and by a crew of skilled installers. If the adhesive was to be blamed for the fault, then the damage should have been the same with the mural decorations in other post offices. The mural for the wall at the south end and the panels which were at the entrance were scheduled to be done that year.

Before the cost for repairing the murals at Sheboygan was estimated, they had to know whether or not there had been any trouble with the other murals that had been installed with the same kind of adhesive at other sites.

Lichtner offered to clean and repaint and reinstall certain parts of the mural at no cost to the government.

More about the Artist and the Mural

Schomer Lichtner was born on March 18, 1905, in Peoria, Illinois. He moved to Milwaukee, Wisconsin in 1907. He was a resident of Milwaukee when he was commissioned for the Sheboygan mural.

His first art training was in the class of Gustave Moeller at the State Teachers College in Milwaukee. In 1924, he attended the Chicago Art Institute. He was a student of the National Academy of Design School and the Art Students League in 1925. He then studied art history with Oskar Hagen at the University of Wisconsin from 1927 to 1928.

His designs were exhibited locally at Carnegie International, the Chicago Art Institute, and the Art Center in New York. His murals were painted under the PWAP.

History of Sheboygan

Sheboygan is located in Sheboygan County near Lake Michigan and is located between Milwaukee and Green Bay. The Indian communities of Potawatomi, Ho-Chunk, Menominee and others used to frequent the area until fur traders arrived in the 18th century. William Farnsworth arrived in the town in 1814, left, and came back in 1818.[103] In 1822, Farnsworth together with Colonel Oliver Crocker constructed a sawmill and two log cabins. In 1834, the first hotel and post office were established in Sheboygan. The first trading post was established in 1795 by Jacques Vieau; his main aim was to explore Sheboygan River. Many settlers started arriving by the 1830s, hoping to make the town grow and become the biggest town around that area of Lake Michigan. The greatest challenge that hindered the growth of the town was dense forest, which was not easy to clear.[104]

By the 1840s many immigrants from different countries such as Germany, England, and Ireland started arriving, making the population of Sheboygan grow at a rapid rate. A map of Sheboygan village was made in 1848 and a few years later, the village was chartered to be a city. The town continued to grow in the 1870s, thanks to furniture and kitchenware industries.[105]

In 1899, the first high school was constructed in Sheboygan. Today, Sheboygan city is known to harbor many manufacturing industries which have led to the rapid growth of the city.[106]

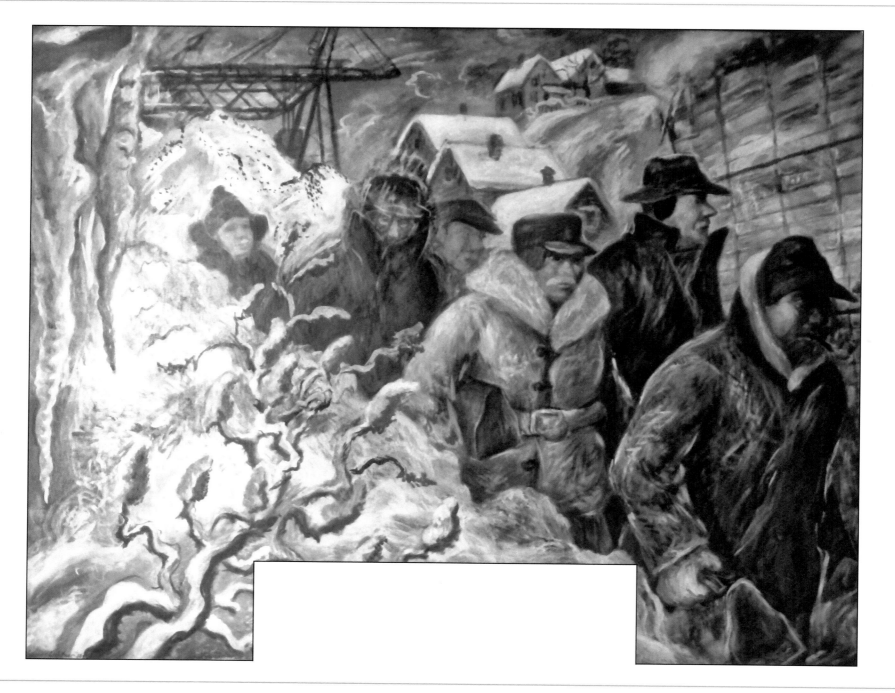

Schomer Lichtner, *Present City*

Schomer Lichtner, *Agriculture*

Schomer Lichtner, *The Pioneer*

The Sheboygan Post Office

522 N. 9th St., Sheboygan, Wisconsin 53081

The Sheboygan Post Office was completed in 1932 as indicated on the cornerstone on the lower left corner of the building. It reads, *Ogden L Mills—Secretary of the Treasury. Ferry K Heath—Assistant Secretary. James A Wetmore—Acting Supervising Architect. E A Stubenrauch—Architect.*

Schomer Lichtner, *The Lake*

Air Mail Service, by Edmund D. Lewandowski

The mural *Air Mail Service* is oil on canvas, measures 14 feet by 4 feet, and was installed on May 15, 1939.

STOUGHTON

History of the Mural

The commission of $760 was awarded to Edmund D. Lewandowski of Milwaukee, Wisconsin.

The Section invited him to submit his designs for a mural for Stoughton based on designs he had submitted in the Wausau mural competition.

The only suggestion the Section offered was that the direction of the blade attached to the propeller right behind the door to the cabin of the plane should be adjusted so that the relationship would be authentic. He was afterwards authorized to proceed with the full-size cartoon.

He sent another photograph of the mural decoration to the Section. This photograph had been taken while the mural was still being painted and so was not to be confused with the photograph of the completed painting. The final painting included more details such as the trees and buildings that were added to the landscape directly behind the hangars; the weather and wind indicators on the doors of the hangars; nuts, bolts, and the panels on the truck; and the rivets on the plane. Though the photograph was not correct in its color values, it gave an idea of the general design.

The mural was finally installed in Stoughton on December 9, 1939, nine days after the contract expired. Prior to its installation, questions were being asked by the Section as to why the installation was taking so long. Lewandowski replied that the reason the installation was so late was because the Section took a long time to approve the installation.

The mural decoration is a depiction of airmail service showing bags containing mail being transferred from a mail truck into a plane.

MORE ABOUT THE ARTIST AND THE MURAL

Edmund Lewandowski was born in Milwaukee, Wisconsin, in 1914. Lewandowski was a resident of Milwaukee at the time he painted the Stoughton mural.

The artist entered the Layton School of Art from 1931 and graduated in 1934.

Lewandowski became a public school teacher so that he could make a living while painting. He also sought out commissions in advertising and magazine illustration.

He was invited in 1936 by a prominent art dealer, Edith Halpert, to become a member of her Downtown Gallery where his works were exhibited alongside the works of other artists such as Charles Sheeler, Niles Spencer, Georgia O'Keeffe, Ralston Crawford, Charles Demuth, and George Ault.

He painted murals commissioned by the Treasury Section of Fine Arts of the Federal Art Project from 1939 to 1940. He also made maps and camouflage pattern designs for the United States Army and the United States Air Force from 1942 to 1946.

Lewandowski was appointed to the faculty of the Layton School of Art in 1947. The artist moved to Florida State University in 1949, where he stayed until 1954. After his time in Florida, he went back to the Layton School of Art, where he was Director until 1972. Finally, in 1973 he was made Professor and Chairman of the Art Department of Winthrop University in Rock Hill, South Carolina. He occupied this position till 1984. When he retired, he was named Emeritus Professor.

Lewandowski died in Rock Hill, South Carolina in 1998.

History of Stoughton

Stoughton is in Dane County, Wisconsin, and was founded in 1847 by Luke Stoughton from Vermont. Immigrants from Norway started arriving in the city from the 1860s up to early 1900.[107] The city is the second largest economy in Dane County after Madison. The city was first surveyed in 1833. The Yahara River, originally known as the Catfish River, provided a good source of water to run the sawmills. The river also offered good transportation as it ran through Stoughton

to Madison then to Mississippi.[108] Luke Stoughton built a sawmill in Stoughton then encouraged professionals such as teachers, doctors, and blacksmiths to settle in the area, as he wanted the town to grow.

Farmers in Stoughton mostly planted wheat which they would bring to Stoughton to be ground. This wheat farming encouraged T. G. Mandt to construct a wheat factory to serve the residents.[109] Later

in 1883, the factory was consumed by fire, wheat farming started to decline, and the farmers shifted to growing tobacco. Tobacco required a lot of labor and storage. This created jobs for the Norwegian immigrants.

Lake Kegonsa, north of the town, acted as a recreational area. Most tourists would frequent the lake during summer.[110] During the 1880s,

Edumund D. Lewandowski, *Air Mail Service*

the tobacco industry collapsed and was replaced by other industries as the town continued to grow. The first post office in Stoughton was constructed in 1818 at Wallace Capen Place. Most of the inhabitants are of Norwegian origin, and they annually celebrate their culture to mark when Norway achieved independence from Denmark.[111]

HENRY MORGENTHAU JR
SECRETARY OF THE TREASURY
JAMES A FARLEY
POSTMASTER GENERAL
LOUIS A SIMON
SUPERVISING ARCHITECT
NEAL A MELICK
SUPERVISING ENGINEER
1938

The Stoughton Post Office

246 E. Main St., Stoughton, Wisconsin 53589

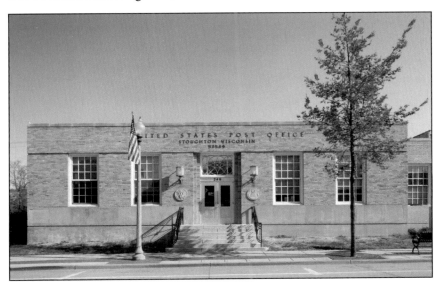

The Stoughton Post Office was built by Carl Westberg & Company Inc. of Chicago, Illinois. The cost of the building when new was about $41,887.

The Stoughton Post Office was completed in 1938 as indicated on the cornerstone on the left corner of the building. It reads, *Henry Morgenthau Jr—Secretary of the Treasury. James A Farley—Postmaster General. Louis A Simon—Supervising Architect. Neal A Melick—Supervising Engineer.*

Fruits of Sturgeon Bay, by Santos Zingale

The mural *Fruits of Sturgeon Bay* is tempera on canvas, measures 15 feet by 5 feet 3 inches, and was installed on May 17, 1940.

STURGEON BAY

History of the Mural

The commission of $1000 was awarded to Santos Zingale of Milwaukee, Wisconsin.

The community of Sturgeon Bay had been informed before the commission was awarded that there was the possibility of the Federal Relief Funds being used for murals in the Sturgeon Bay Post Office, which was new at the time.

The Sturgeon Bay Art Study Club suggested that V. W. Rousseff be considered for the work. Rousseff was a resident of Door County and at the time was making an extensive study of the County's history and tradition. He was already known for his dexterity at painting murals, including the work he had done for the Iron, Michigan, post office. Sturgeon Bay was one of the major tourist centers of the county, which meant that a mural being installed there would be viewed by people from all over the country.

Apparently, it was not possible after all to use the Federal Relief Funds for the Sturgeon Bay mural due to the fact that the chance of getting new funds for that kind of work was slim. However, the Section of Fine Arts had already set aside a small amount of money, which they had planned to use. Their intention was to make a mural painting which was going to be installed under the auspices of the Treasury Department Arts Project.

The Section made an announcement in the newspaper concerning a competition from which they were going to select their artist.

Zingale's designs initially did not seem to be related to Sturgeon Bay. The Section suggested that he try working with the fishing industry and he agreed. The new designs were reviewed by the Section, who considered them satisfactory and suggested ways he could make the mural look better: the slope nearest to the center and also the orchard-crowned hill were not deemed satisfactory enough from the viewpoint of the scale and distance relative to the elements in the foreground. The drawing and perspective of the boat also required more attention.

As soon as he was done with the color sketch and had incorporated the suggestions in it, he forwarded it to the Section, but the landscape at the upper center of the painting was still regarded as unsatisfactory. The cliffs rising from the water and the trees all seemed to be too near to the figures located in the foreground, and the solution which was suggested for this was that he shift the elements in the foreground into the background. On the left-hand side, the planks of the dock which were right behind the man carrying the box of fish were unrelated to the immediate foreground. Also, the planks didn't seem as though they were in a horizontal position; instead, they seemed as though they were raised to form a ramp.

The new color sketch still had problems: The transition of the water from the foreground to the distant bank; the relation between the boat on the left and the dock; the far end of the dock and the foreground where the men were working between the net and the flying gulls. In short, many of the elements in the design both front and back did not appear convincing in their locations. The Section thought that the fisherman used in the design was characteristic of the region, and that the figures could be further characterized by additional observation and study as the work progressed. The design was photographed and sent back to the artist and he was asked to move on with painting the full-size cartoon.

Zingale sent the photograph of the cartoon to the Section, after which he was told to proceed with the work.

The Section agreed that either the blue or green used in the mural should be carried around on the plaster strip on both sides of the bulletin boards as they would look much better than the existing buff color. Zingale thought that he should install the mural painting first

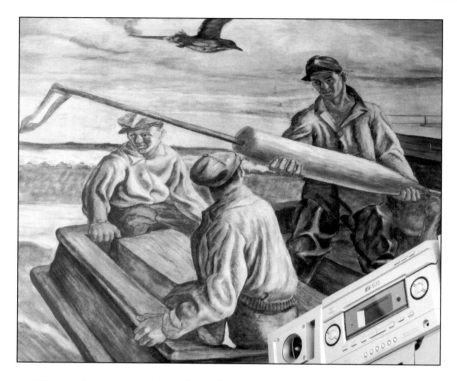

and then give his suggestions on the color. He eventually concluded that the Section was correct about the colors.

MORE ABOUT THE ARTIST AND THE MURAL

Santos Zingale was born in Milwaukee, Wisconsin, on April 17, 1908. At the time he was commissioned to paint the mural for Sturgeon Bay, he was a resident of Milwaukee.

He graduated with a B.S. degree as an art instructor from a four-year art course at the Milwaukee State Teachers College. He taught in a private primary school part-time for about three years after which he was unemployed until the Section of Fine Arts commissioned him for the mural.

He exhibited in every annual show of the Wisconsin Painters and Sculptors Society, a society which he was a member of from 1929.

His works were exhibited in the International Water Color Show, the American Water Color Show, the American Water Color Show of New York, and the Wisconsin Salon of Art.

He received his first award in Water Color at the Wisconsin Salon of Art. He also received an Honorable Mention in the same medium in the Wisconsin Painters and Sculptors Exhibit.

History of Sturgeon Bay

Sturgeon Bay is located in Door County.[112] The city was established in 1850 when the first house was constructed. After that, the town grew very quickly, and in 1862 three sawmills were established in the area. Oliver Perry Graham was the first man to arrive in Sturgeon Bay but the last one to construct a mill. The city grew and attracted many people who acted as workers in the timber industry.[113]

In the 19th century, the main economic activity was quarrying limestone. Later on, a canal connecting Sturgeon Bay and Lake Michigan was constructed. The construction of the canal was a great milestone for the town as it improved transport in the area and also led to the protection of ships that used dangerous routes previously.[114]

The first school in Sturgeon Bay was established in 1856 and was taught by Mrs. James McIntosh.[115] The Sturgeon Bay Moravian Church was the first in the city, constructed in 1864. In the 1880s, new churches were built by Germans. The first post office in the city was constructed in 1855.[116]

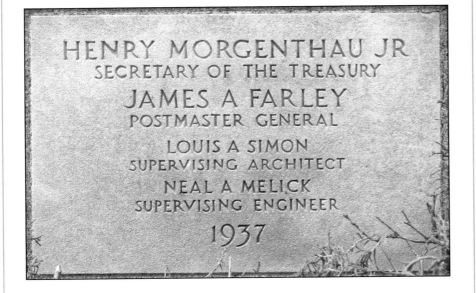

The Sturgeon Bay Post Office

359 Louisiana St., Sturgeon Bay, Wisconsin 54235

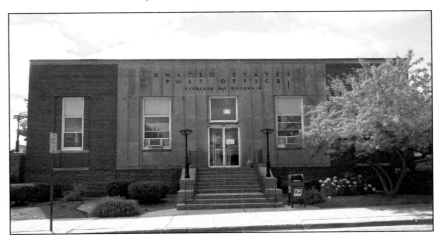

The Sturgeon Bay, Wisconsin, post office was built by Mads Madsen Company, of Minneapolis, Minnesota. The cost of the building when new was about $53,531.

The Sturgeon Bay Post Office was completed in 1937 as indicated on the cornerstone on the right corner of the building. It reads, *Henry Morgenthau Jr—Secretary of the Treasury. James A Farley—Postmaster General. Louis A Simon—Supervising Architect. Neal A Melick—Supervising Engineer.*

War Party, by Forrest Flower

The mural *War Party* is oil on canvas and measures 14 feet by 12 feet 3 inches.

VIROQUA

History of the Mural

The commission of $900 was awarded to Forrest Flower of Wauwatosa, Wisconsin.

The Section of Fine Arts invited him to submit based on designs he had submitted in the 48 States Competition. The postmaster had requested that a battle scene from the Black Hawk War which had taken place at Viroqua be depicted; it was, however, felt that depicting the actual fighting and dying white men would be grotesque rather than moving. It was then decided to portray Black Hawk's spirited war party in full battle regalia.

Upon reviewing the color sketch, the Section felt that the Indians and horses were drawn in an interesting manner but that the landscape and the ground on which they stood were not convincing enough. They then suggested that the Indian in the center of the group should be raised a little above the group.

The installed mural was regarded as an excellent addition to the decoration of the building. After installation, however, air bubbles were noticed in several places on the canvas. The Section contacted Flower and informed him about this; he promised to return and check the painting in summer, which he did. He then smoothed out the mural, which had not been pasted properly to the wall.

The mural illustrates Sac and Fox Indians who were engaged in stealing the horses of cavalrymen in the Black Hawk War. A print of the painting was requested in writing for use as the frontispiece of the forthcoming *Wisconsin Magazine of History*.

Flower was asked to recommend ways by which the mural could be cared for properly. His recommendation was the following:

The mural should be dusted at first with a soft cloth and then the crust of a loaf of fresh white bread should be torn off and the inside part of the loaf which is moist should be used to rub the painting until it is clean.

In 1831, the raiding by the Chief Black Hawk, leading a portion of the Sac and Fox Indians, became so horrendous that the United States Army pursued them effectively, defeating them close to Viroqua, Wisconsin. The intent of the mural was to show the spirited and recalcitrant behavior of the Sac and Fox as was manifested in the stealing of the horses of the cavalrymen.

MORE ABOUT THE ARTIST AND THE MURAL

[See the Rice Lake entry for more information.]

History of Viroqua

Viroqua is in Vernon County and was established in the 1840s. Viroqua is one of the smallest cities in Wisconsin but serves many purposes in the county.[117] It is the center of commerce and also harbors the government offices. The Ho-Chunk lived in the area until they were pushed westward in the 1850s. Moses Decker was one of the first visitors to have arrived in Viroqua about 1847.[118] He then established the village of Viroqua. Most of the early settlers started arriving around 1844 to build lumber mills. The mills were constructed around Kickapoo River. Originally the town was called Farwell, named after a governor of Wisconsin, but later, in 1854, was renamed Viroqua.[119]

Viroqua, being so fertile, supported farming and other agricultural activities. Most of the crops grown were wheat, oats, and corn. Viroqua hosted slaves after the Civil War, thus being regarded as a community of former slaves. The city once faced a catastrophic ordeal in 1865 when a tornado swept away many houses, killing some eight students with their teacher and also injuring scores of other people. The tornado was one of the deadliest in the history of Wisconsin.[120]

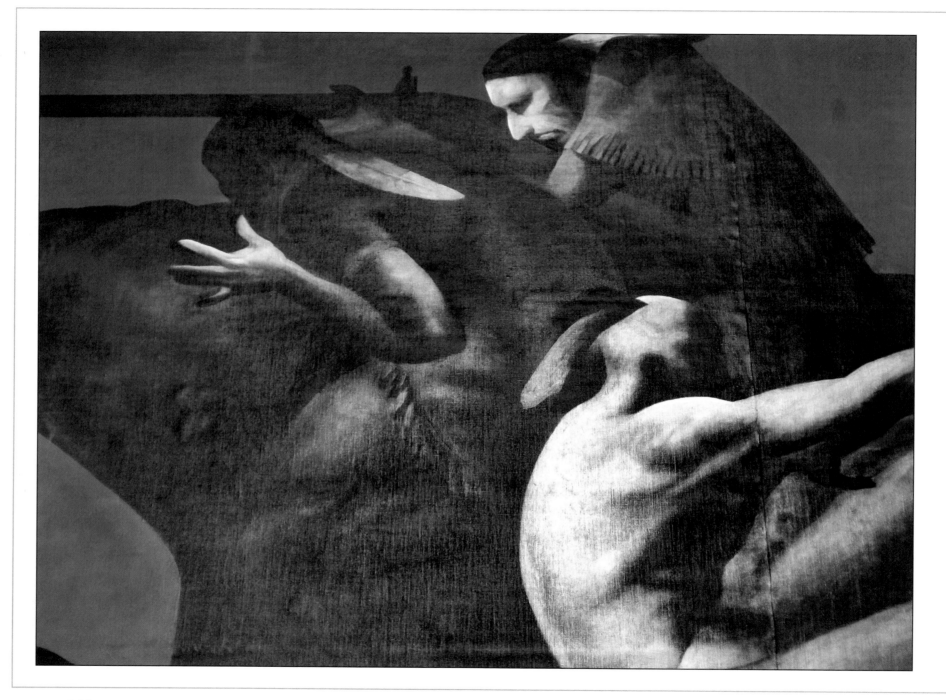

Forrest Flower, *War Party*

Viroqua is also known to have many communities of diverse origins, mostly from Norway. Foreaker School in Viroqua is one of the oldest schools in the city; the one-room school was active up to 1960.[121] The first post office in Viroqua was constructed in the 1850s. The town has grown as an industrial and commercial center, with great historical landmarks that attract many visitors.

The Viroqua Post Office

119 E. Jefferson St., Viroqua, Wisconsin 54665

The Viroqua Post Office was built by Johnson & Kramer, of St. Charles, Minnesota. The cost of the building when new was about $62,619.

The Viroqua Post Office was completed in 1939 as indicated on the cornerstone on the left corner of the building. It reads, *James A Farley—Postmaster General. John M Carmody—Federal Works Administrator. W Englebert Reynolds—Commissioner of Public Buildings. Louis A Simon—Supervising Architect. Neal A Melick—Supervising Engine*er.

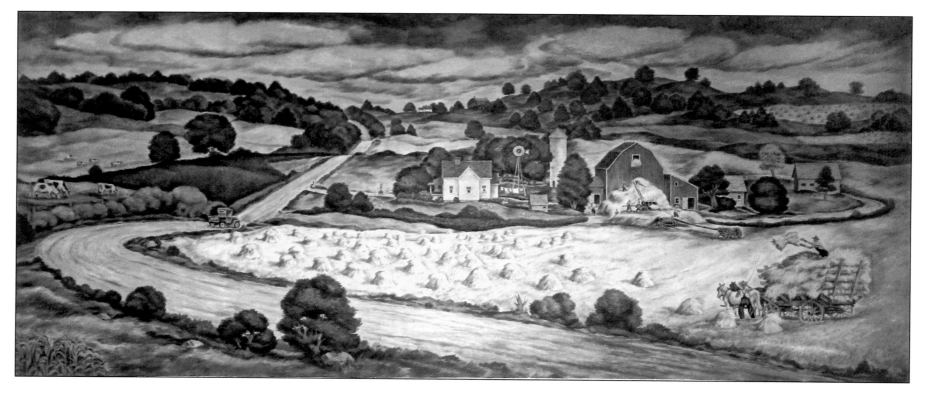

***Wisconsin Countryside*, by Raymond Redell**

The mural is oil on canvas, measures 12 feet by 5 feet, and was installed on August 11, 1940.

WAUPACA

History of the Mural

The commission of $800 was awarded to Raymond Redell of Wauwatosa, Wisconsin.

While reviewing a number of murals done under the Treasury Department Mural Program on an inspection trip he took, Redell arrived at the conclusion that the rectangular panels usually used were sometimes difficult to relate to the other features of the wall architecturally, including the door and the bulletin boards. It was, however, suggested that a color tone be taken from the mural and harmonized by carrying it around the door and bulletin boards. This would make one complete architectural unit of the wall on which the mural was to be hung.

Redell visited Waupaca in June of that year so as to arrange for the installation of the mural with the postmaster. He noted the color that the walls and woodwork were painted, so as to prepare a color which would be used to surround the mural. The walls of the Waupaca Post Office were painted white; he wrote that he preferred this over the dark buff color used in many post offices.

Redell installed the mural, after which he sent photographs of the installed mural to the Section. The mural was said to be a real addition to the beauty and decoration of the building. The color reproduction of the Waupaca mural that appeared in the *Milwaukee Journal* was considered excellent and regarded as a "swell job" by the Section. The report the postmaster sent to the Section stated that the mural was satisfactory and that they were proud to have it in their building. He also stated that it was the best mural painting he had ever seen and that it was very appropriate for any small city post office since the scene in the mural could be visualized at nearly every community in Wisconsin.

More about the Artist and the Mural

[See the Berlin entry for more information.]

Redell also did murals for the post office buildings in Berlin, Wisconsin; and Middlebury, Indiana.

History of Waupaca

Waupaca city is in Waupaca County in an area with many lakes.[122] This area was first occupied by Native American mound builders before the Europeans came and made their settlement in the region, later exploring the region and building sawmills and gristmills. The milling industry led to the early growth of the city.

Captain Augustus Hill and his sons settled on the Waupaca River near a waterfall in 1849, forming the city of Waupaca. In 1857, Waupaca was recognized as a village after a law passed by the Wisconsin legislature. Waupaca, borrowed from the Indian word "Waubuck Seba," means "clear water."[123] There had been two local Indian clans, Chippewa and Menominee. The clans had formed camps over the entire area and had practiced farming, as the region had fertile soil. Later, farming was done on the areas left by loggers, and the main crop planted was potatoes.[124]

The first post office was built in 1852, and the region was officially named Waupaca. In 1871, the first train arrived, which gave farmers a good mode of transport to ferry their potato crops. By 1875, Waupaca was fully organized. In comparison with other towns dominated by German populations, Waupaca was comprised of a huge number of Scandinavians.[125] In the 1900s, tourism began to take shape, leading to the construction of lounges and hotels to accommodate tourists.

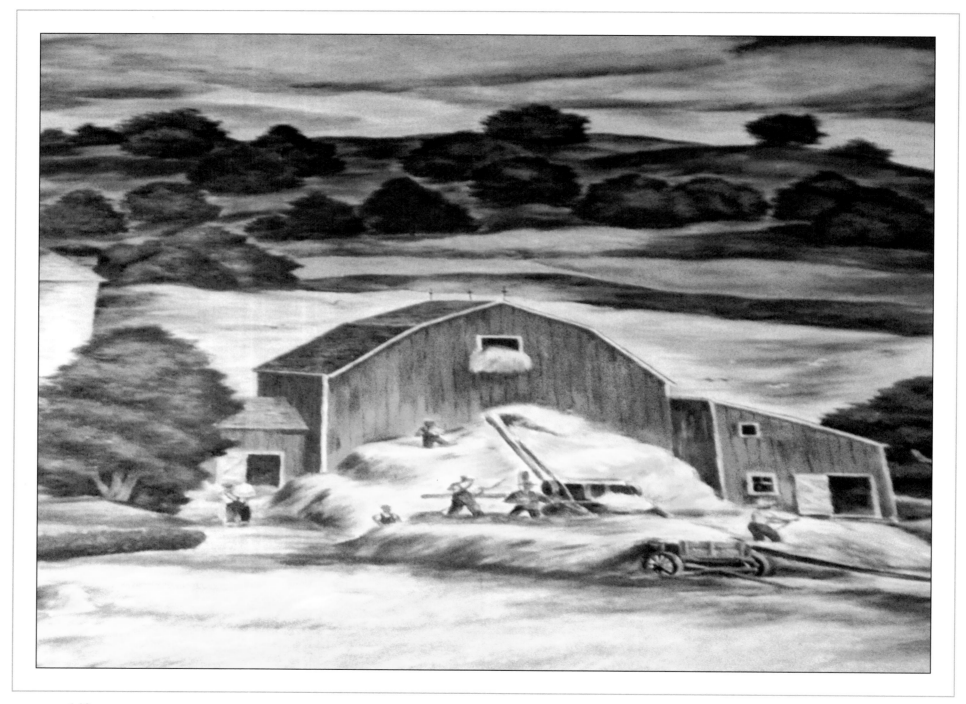

Raymond Redell, *Wisconsin Countryside*

The Waupaca Post Office

306 S. Main St., Waupaca, Wisconsin 54981

The Waupaca, Wisconsin, post office was built by Ring Construction Company of Minneapolis, Minnesota. The cost of the building when new was about $51,400.

The Waupaca Post Office was completed in 1938 as indicated on the cornerstone on the right corner of the building. It reads, *Henry Morgenthau Jr—Secretary of the Treasury. James A Farley—Postmaster General. Louis A Simon—Supervising Architect. Neal A Melick—Supervising Engineer.*

HENRY MORGENTHAU JR
SECRETARY OF THE TREASURY
JAMES A FARLEY
POSTMASTER GENERAL
LOUIS A SIMON
SUPERVISING ARCHITECT
NEAL A MELICK
SUPERVISING ENGINEER
1938

Raymond Redell, *Wisconsin Countryside*

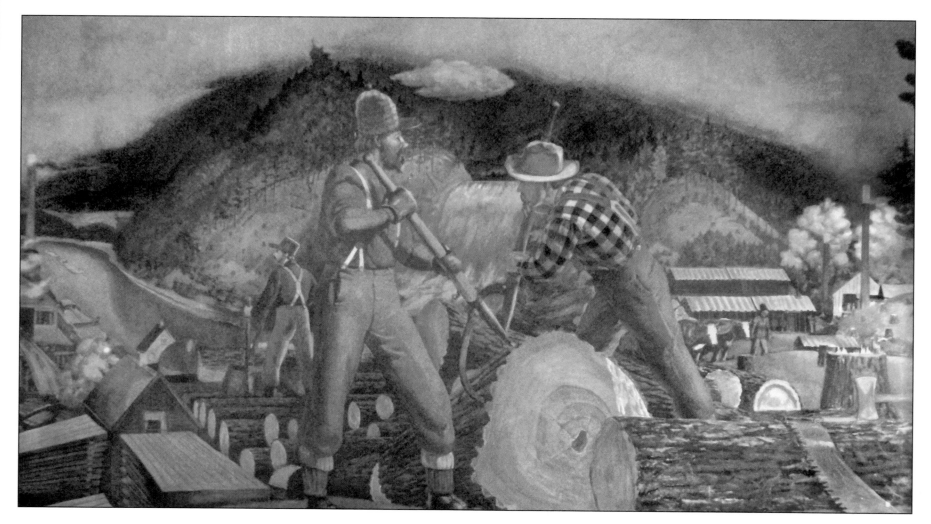

Lumbering and _Rural Mail_, by Gerrit Sinclair

The mural _Lumbering_ is tempera on canvas and measures 14 feet 6 inches by 8 feet 2 inches. The mural _Rural Mail_ is tempera on canvas and measures 11 feet 10 inches by 7 feet 3 inches. The murals were installed on May 12, 1940.

WAUSAU

History of the Mural

The commission of $1,600 was awarded to Gerrit Sinclair of Milwaukee, Wisconsin.

Sinclair was prompted to enter into the competition because Wausau was his hometown, and it was believed that Wausau was going to benefit from whatever Sinclair had to offer in the painting.

After Sinclair made some changes to the *Lumbering* mural, he felt relieved, as he had always felt uncomfortable with the position of the two central figures in the painting. The Section had suggested changes in *Rural Mail* concerning the children—the changes he made shifted the children and made them smaller.

The Section later made several other suggestions: the drawing of the legs of the horse should be studied further; the foreground was not convincing enough when considering the way the children were placed relative to the way the horse was placed; and the lower extremities of the figures which were central on the right in the other panel were not realized convincingly.

Sinclair had exhibited the two panels at the Layton Art Gallery in Wisconsin, and many people showed interest in them. Art teachers brought their classes in and gave their fair share of the usual compliments, advice, and criticism. There was also a lumberman who was equally interested in the exhibits but had a problem with the size of the axe, which he criticized, as axe heads differ in size from about five or six inches to about twelve inches in length.

The installation of the mural decoration was delayed for about two weeks due to the need to make certain minor changes. The changes became necessary after the paintings were seen at the exhibit at the Layton Art Gallery, and when he viewed them again at the post office, the colors seemed to be scaled too low in tone.

The murals were eventually put up using white lead and varnish. Onlookers made comments concerning how it was possible to paint murals on the walls so quickly, as very few of them knew that they were done on canvases which were then fastened to the wall.

The two murals were very good, but the *Rural Mail* mural was as fine in color, in composition, and in drawing as any of the eighty post office murals the Section had seen.

MORE ABOUT THE ARTIST AND THE MURAL

Gerrit Sinclair was a resident of Milwaukee at the time he painted the murals for Wausau.

He sent photographs of the cartoons to the Section, but they were considerably distorted because of their large size and also because the studio was narrow. The cartoons had gone through a number of changes since the original sketches; however, he had new color sketches made and their photos were enclosed and sent to the Section just so they could have the old sketches to compare them with. The changes which were made included elimination of the bands of inscription at the bottom, the slope of the log in the foreground, and the lines of the leg on the right in the foreground.

He tried to correct details after he went to visit the building as he looked into history and the character of the Wausau area. In the *Lumbering* mural, he introduced a second log for the purpose of composition and to also give reason for the two men pushing against each other. He introduced a mill, a cook with a horn, tree stumps, and ramps on which the logs could be run up to the mill. The mural now contained lumbering as it was carried out at Wausau, from cutting the timber to the sawmill to shipping it by raft.

The first sketch he had made seemed bare to him when he finally saw the countryside, so he added more pine woods, and after looking at the photograph, the centered wheel seemed bothersome, so the RFD post was moved a few inches to the left to cut one side.

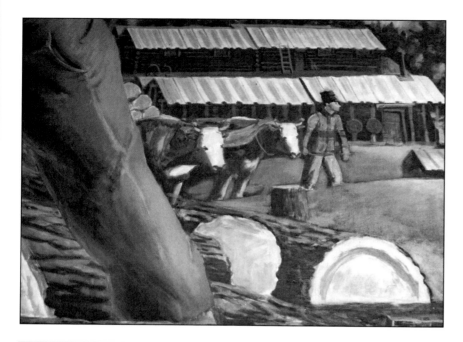

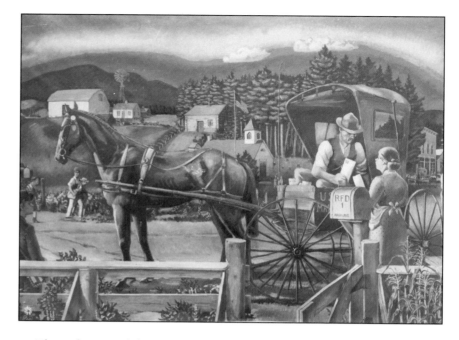

The coloring of the *Lumbering* mural was changed slightly by shifting some colors. The *Rural Mail* mural was made to match *Lumbering* more in color, as it had initially seemed too cold.

History of Wausau

Wausau city is the headquarters of Marathon County. The town was founded in 1840 when George Stevens established a sawmill along the Wisconsin River.[126] Other sawmills were later established in the area, and Walter McIndore came in 1846 to start a local business. The contributions of Walter McIndore led to the establishment of Marathon County in 1850. Before Wausau was founded, the area was initially

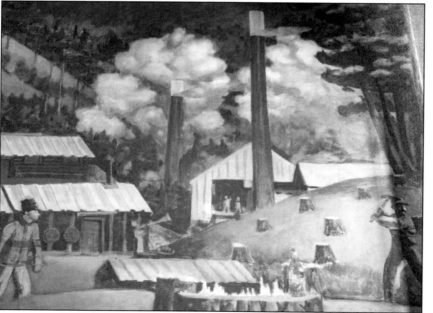

Gerrit Sinclair, *Lumbering* (above left) and *Rural Mail* (above right)

inhabited by the indigenous Ojibwa people, but later settlers were drawn into the area by the Wisconsin River.

Fur trading was the earliest economic activity. The entry of settlers and the arrival of Stevens made lumbering the main economic activity as pine forests were plentiful along the Wisconsin River.[127] The Big Bull Falls provided the best site for sawmills, as Stevens observed. Heavy immigration by Germans into the area in 1862 led to the establishment of social organizations, churches, and schools from 1852 to 1861. Wausau was granted a charter to graduate from a village to a city in 1872 by Wisconsin state authorities.[128]

Wausau was hard hit by the economic shocks of 1929, but the city was later rescued by the New Deal. The city has since witnessed the expansion of a western industrial park in its economic development.[129]

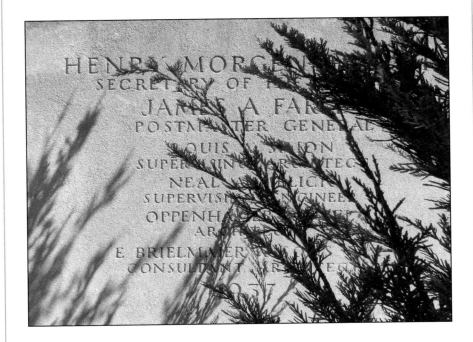

The Former Wausau Post Office

317 1st St., Wausau, Wisconsin 54403

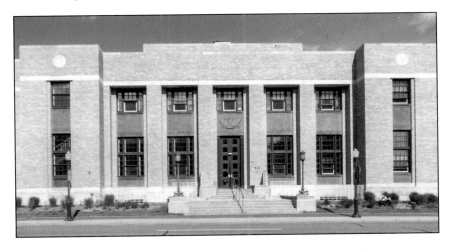

The Wausau Post Office was completed in 1937 as indicated on the cornerstone on the right corner of the building. It reads, *Henry Morganthau Jr—Secretary of the Treasury. James A Farley—Postmaster General. Louis A Simon—Supervising Architect. Neal A Melick—Supervising Engineer. Oppenhamer & Obel— Architects. E Brielmaier & Sons Co—Consultant Architects.*

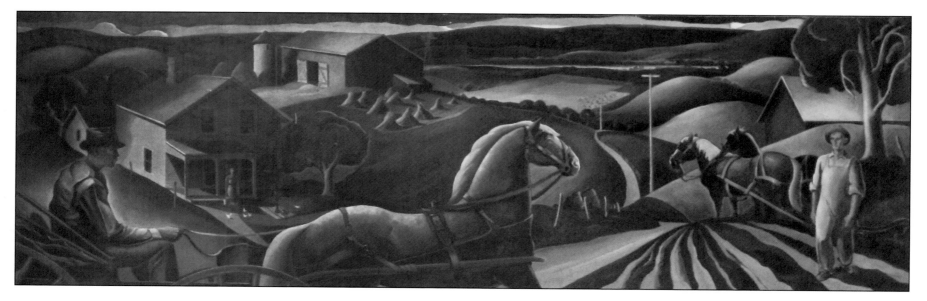

The Rural Mail Carrier, by Peter Rotier

The mural *The Rural Mail Carrier* is oil on canvas, measures 12 feet by 4 feet, and was installed on August 11, 1937.

WEST BEND

History of the Mural

The commission of $640 was awarded to Peter Rotier of Milwaukee, Wisconsin.

The Section invited Rotier to submit his designs for the West Bend mural. The proposed mural was to be situated above the door of the postmaster, which was on the east wall of the lobby as indicated on the blueprints sent to the artist. Rotier was to pay a visit to the post office and call on the postmaster. At the same time he was to obtain the specific dimensions of the wall space meant for the mural.

Rotier decided to visit the post office because he was already acquainted with West Bend as he had a country studio nearby. He and the postmaster decided that the subject matter should be the history of the post office. The research was to take about a month.

Rotier sent five sketches for the mural. The design number three was chosen as it was approved generally. The design was regarded as handsome in its horizontal flow. The horizon, which was located on the left side of the mural, was well treated, and the Section suggested that the whole horizon of the composition be treated the same way. It was also suggested that two mailboxes at the center of the composition be eliminated.

The Section also requested the title of the mural, the proposed medium, the specific dimensions of the space which was proposed to be decorated, and whether it was possible to complete the mural design in about a year's time.

Rotier decided to name the mural *Rural Mail Carrier*. He also planned to paint the mural using oil on canvas as he preferred that medium. The Section thought that the color Rotier had used in the sketch was too insistent on red-violet—a subtler use of the red-violet would be better. The other criticism offered concerned the approach he used: a combination of pure decoration and realism, whereas treating the scene in a more objective manner would be better as the elements of realism introduced in the mural were attractive.

After painting the full-size cartoon, Rotier sent the Section a photograph of it. He also offered to send an enlarged print or perhaps the actual cartoon if the photograph was not clear enough. But the photograph was enough, and it was regarded as satisfactory. They authorized him to proceed with the actual painting.

A lighting fixture which was suspended about ten feet from the ceiling was in front of the mural decoration and obstructed the view slightly, although the postmaster had assured the artist that the situation would be remedied by raising the light.

The postmaster wrote that the installation was satisfactory, although a lot of criticisms were voiced in the lobby by the patrons of the post office, especially by the people who were authorities themselves on art. The Section requested a clear account of the story and the characters in the mural since the Section was considering preparing folders or booklets that would make the stories of all the murals clear to the public.

MORE ABOUT THE ARTIST AND THE MURAL

[See the entry for Mayville for more information.]

Peter Rotier was a resident of Milwaukee, Wisconsin, when he was commissioned to paint the mural for the West Bend Post Office.

History of West Bend

Acting as the seat for Washington County, West Bend is located in the southeastern part of Wisconsin. West Bend came into existence in 1845 after an authorization by the territorial legislature of Wisconsin to build a road connecting Milwaukee and Fond du Lac. The surveyors were tasked with identifying halfway points for travelers, and one of the endpoints chosen is now the present-day West Bend.[130] The city is

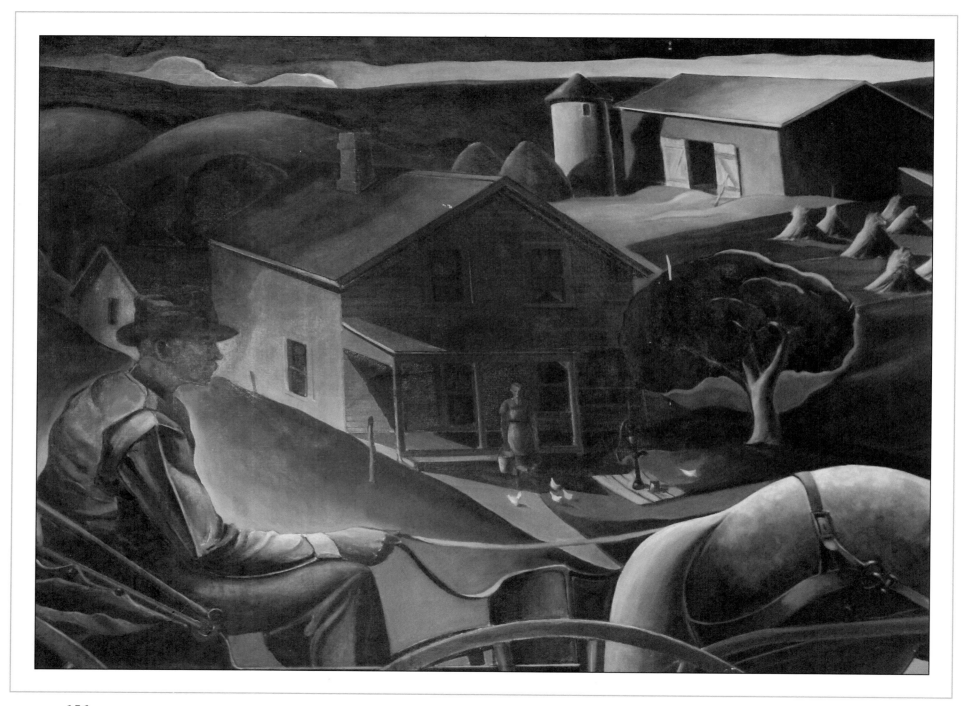

Peter Rotier, *The Rural Mail Carrier*

named after the bend to the western side of the Milwaukee River that runs through the town.[131]

The main economic activity at the time West Bend was being formed was sawmilling. The Milwaukee River provided energy to run sawmills and gristmills. The arrival of a railroad in 1873 contributed to more industrial activities in the town.[132] The Holy Angels Catholic church building, constructed in 1852, was converted to the first school in 1866.[133]

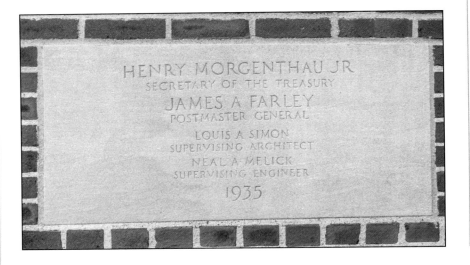

The West Bend Post Office

607 Elm St., West Bend, Wisconsin 53095

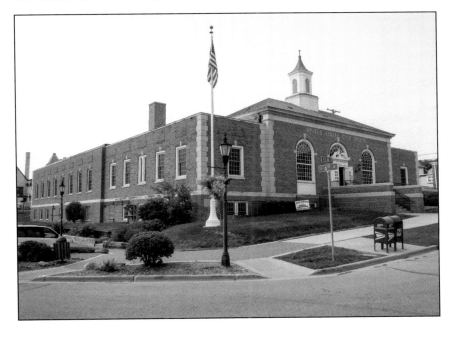

The West Bend Post Office was built by J. P. Cullen & Son, of Janesville, Wisconsin. The cost of the building when new was about $71,768.

The West Bend Post Office was completed in 1935 as indicated on the cornerstone on the left corner of the building. It reads, *Henry Morgenthau Jr—Secretary of the Treasury. James A Farley—Postmaster General. Louis A Simon—Supervising Architect. Neal A Melick—Supervising Engineer.*

WISCONSIN POST OFFICE MURAL LIST

Berlin: Raymond Redell, *Gathering Cranberries*

Black River Falls: Frank E. Buffmire, *Lumbering—Black River Mill*

Chilton: Charles W. Thwaites, *Threshing Barley*

Columbus: Arnold Blanch, *One Hundredth Anniversary*

De Pere: Lester W. Bentley, *The Red Pieta*, *Nicholas Perrot*, and *Give Us This Day*

Edgerton: Vladimir Rousseff, *Tobacco Harvest*

Elkhorn: Tom Rost, *Pioneer Postman*

Fond du Lac: Boris Gibertson, *Birds and Animals of the Northwest*

Hartford: Ethel Spears, *Autumn Wisconsin Landscape*

Hayward: Stella E. Harlos, *The Land of Woods and Lakes*

Hudson: Ruth Grotenrath, *Unloading a River Barge*

Janesville: Boris Gilbertson, *Wild Ducks*

Kaukauna: Vladimir Rousseff, *A. Grignon Trading with the Indians*

Kewaunee: Paul Faulkner, *Winter Sports*

Ladysmith: Elsa Jemne, *Development of the Land*

Lake Geneva: George A. Dietrich, *Winter Landscape*

Lancaster: Tom Rost, *Farm Yard*

Mayville: Peter Rotier, *Wisconsin Rural Scene*

Milwaukee, West Allis Branch: Frances Foy, *Wisconsin Wildflowers—Spring*, and *Wisconsin Wildflowers—Autumn*

Neillsville: John Van Koert, *The Choosing of the County Seat*

Oconomowoc: Edward Morton, *Winter Sports and Rabbit Hunters*

Park Falls: James S. Waltrous, *Lumberjack Fight on the Flambeau River*

Plymouth: Charles W. Thwaites, *Making Cheese*

Prairie du Chien: Jefferson E. Greer, *Discovery of Northern Waters of the Mississippi*

Reedsburg: Richard Jansen, *Dairy Farming*

Rice Lake: Forrest Flower, *Rural Delivery*

Richland Center: Ricard Brooks, *Decorative Interpretation of Unification of America Through the Post*

Shawano: Eugene Higgins, *The First Settlers*

Sheboygan: Schomer Lichtner, *The Lake*, *The Pioneer*, *Present City*, *Indian Life*, and *Agriculture*

Stoughton: Edmund D. Lewandowski, *Air Mail Service*

Sturgeon Bay: Santos Zingale, *Fruits of Sturgeon Bay*

Viroqua: Forrest Flower, *War Party*

Waupaca: Raymond Redell, *Wisconsin Countryside*

Wausau: Gerrit Sinclair, *Lumbering* and *Rural Mail*

West Bend: Peter Rotier, *The Rural Mail Carrier*

NOTES

1. Wikipedia.
2. Berlin Chamber of Commerce website.
3. Berlin Chamber of Commerce website.
4. Berlin Area Historical Society website
5. Wisconsin Historical Society website.
6. Wisconsin Historical Society website.
7. Black River County, Wisconsin website.
8. Wisconsin Historical Society website.
9. Wikipedia.
10. The Western Historical Company website.
11. Wikipedia.
12. Wikipedia.
13. Wikipedia.
14. World Maps Online website.
15. World Maps Online website.
16. Wikipedia.
17. Wisconsin Historical Society website.
18. Wisconsin Historical Society website.
19. Wisconsin Historical Society website.
20. Wikipedia.
21. Wikipedia.
22. Wikipedia.
23. Wikipedia.
24. Elkhorn Area Chamber of Commerce & Tourism Center, Inc., website.
25. Elkhorn Area Chamber of Commerce & Tourism Center, Inc., website.
26. Wikipedia.
27. Wisconsin Historical Society website.
28. Wisconsin Historical Society website.
29. Wikipedia.
30. Wikipedia.
31. Wisconsin Genealogy Trails website.
32. Wikipedia.
33. White Minor Resort website.
34. Wikipedia.
35. Hudson Connection website.
36. Hudson Connection website.
37. Wikipedia.
38. City of Janesville website.
39. Wikipedia.
40. City of Janesville website.
41. City of Janesville website.
42. City of Kaukauna website.
43. City of Kaukauna website.
44. Wikipedia.
45. Kewaunee, Wisconsin website.
46. Kewaunee Area Chamber of Commerce website.
47. Kewaunee Area Chamber of Commerce website.
48. Wikipedia.
49. Wisconsin Historical Society website.
50. Wisconsin Historical Society website.
51. Wikipedia.
52. City of Lake Geneva website.
53. City of Lake Geneva website.
54. City of Lake Geneva website.
55. Genealogy Trails website.
56. Lancaster, Wisconsin website.
57. Wikipedia.
58. Mayville Township, Clark County, Wisconsin website.
59. Mayville Township, Clark County, Wisconsin website.
60. Mayville Township, Clark County, Wisconsin website.
61. Wisconsin Historical Society website.
62. Wikipedia.
63. Milwaukee.gov.
64. Wisconsin Historical Society website.
65. Wisconsin Historical Society website.
66. Wisconsin Historical Society website.

67. Wisconsin Historical Society website.
68. Kenneth Mays, "Picturing history: Neillsville, Wisconsin," Deseret News (website), July 8, 2015.
69. Wikipedia.
70. Wikipedia.
71. Wisconsin Historical Society website.
72. Oconomowoc, Wisconsin website.
73. Oconomowoc, Wisconsin website.
74. Oconomowoc, Wisconsin website.
75. Oconomowoc, Wisconsin website.
76. RootsWeb.com.
77. City of Park Falls website.
78. RootsWeb.com.
79. RootsWeb.com.
80. RootsWeb.com.
81. Plymouth Historical Society website.
82. Sheboygan County, Wisconsin Genealogy & History, RootsWeb.com.
83. Town of Plymouth website. (townplymouth.com).
84. Wikipedia.
85. Wikipedia.
86. Prairie du Chien website. (prairieduchien.org).
87. Wikipedia.
88. Wikipedia.
89. Wikipedia.
90. Wikipedia.
91. Reedsburg, Wisconsin website.
92. Wikipedia.
93. Wikipedia.
94. Wisconsin Historical Society website.
95. Wikipedia.
96. Richland Center Tourism website.
97. Richland County Community Guide website.
98. Wikipedia.
99. Wikipedia.
100. Wikipedia.
101. Wisconsin Historical Society website.
102. Shawano County Historical Society website.
103. Wikipedia.
104. Wikipedia.
105. City of Sheboygan website.
106. City of Sheboygan website.
107. Wikipedia.
108. Wisconsin Historical Society website.
109. Wisconsin Historical Society website.
110. Wisconsin Historical Society website
111. Wisconsin Historical Society website
112. Wikipedia.
113. History of Sturgeon Bay, Door County, Wisconsin website.
114. History of Sturgeon Bay, Door County, Wisconsin website.
115. Town of Sturgeon Bay, RootsWeb.com.
116. Town of Sturgeon Bay, RootsWeb.com.
117. Wikipedia.
118. Wisconsin Historical Society website.
119. Wikipedia.
120. Wisconsin Historical Society website.
121. Driftless Wisconsin website.
122. Wisconsin Historical Society website.
123. City of Waupaca, Wisconsin website.
124. Wisconsin Historical Society website.
125. Wisconsin Historical Society website.
126. Wikipedia.
127. Wausau, Wisconsin website.
128. Wausau, Wisconsin website.
129. Wikipedia.
130. Wikipedia.
131. Wisconsin Historical Society website.
132. City of West Bend, Wisconsin website.
133. Wikipedia.

BIBLIOGRAPHY

Archival Sources

The bulk of research performed for this book was conducted at the National Archives and Records Administration in College Park, Maryland. The Section of Fine Arts kept records as they corresponded with the artists during the development of the work. These records are stored in Case Files Concerning Embellishments of Federal Buildings, record group 121 entry 133. The records are stored alphabetically in boxes, and each state has its own number. Each box contains individual folders for each town. The folders contain various handwritten letters, original black-and-white photographs, press releases, newspaper clippings from this period, and various other documents created while corresponding with the artists and other government agencies during the development and eventual installation of the mural. This material is the focus of the book and how it was developed.

The National Archives and Records Administration also houses building records for each town and building. These are stored in record group 121 Public Buildings Service, General Correspondence and related records. These are further broken down by years. For example, the records for the Chilton Post Office are in box 7664 which covers 1910–1939 and 1934–1939. The estimated cost of the building new and the contractor who won the bid was taken from these records. Sadly, not all the documents are complete; some of this is missing from a few of the towns. Since each building physically has a cornerstone, we are able to cross verify the year the building was constructed with the documents from the General Correspondence records.

As part of the contract with the artist, the government required the artist to send a photograph of the finished mural to the Section upon completion and installing the mural in the post office. The National Archives and Records Administration also houses these records. They are located in record group 121-CMS, Records of the Public Building Service, Completed Murals and Sculptures. These records are where the black-and-white photographs from the Ladysmith and Wausau chapters were pulled from.

The artists' biographies at the archives are limited, but some do exist. They are stored in record group 121 Records of the Public Buildings Service, entry 136—Biographical Data File Concerning Artists.

In addition to the scholarly research performed for this book, the author David W. Gates Jr. has personally visited each town and photographed each building and mural. During these visits, there are often times various documents, period photos, and descriptions regarding the murals and buildings in the encased bulletin boards. David has also consulted with numerous postal employees and postmasters regarding the buildings and art.

Sources Consulted

Beckham, Sue Bridwell. *Depression Post Office Murals and Southern Culture: A Gentle Reconstruction.* Baton Rouge: Louisiana State University Press, 1989.

Carlisle, John C. *A Simple and Vital Design: The Story of the Indiana Post Office Murals.* Indianapolis: Indiana Historical Society, 1995.

Davis, Anita Price. *New Deal Art in North Carolina: The Murals, Sculptures, Reliefs, Paintings, Oils and Frescos and Their Creators.* North Carolina: McFarland & Company, Inc., 2009.

Frist Center for the Visual Arts. *From Post Office to Art Center: A Nashville Landmark in Transition.* Nashville: First Center for the Visual Arts, 2001.

Hallsten, Susan McGarry. *The Art of Charles W. Thwaites: Freedom of Expression.* Albuquerque, New Mexico: Fresco Fine Art Publications LLC, 2008.

Hull, Howard. *Tennessee Post Office Murals.* Johnson City, Tennessee: The Overmountain Press, 1996.

"Speaking of Pictures... This is Mural America for Rural Americans," *Life Magazine,* December 4, 1939.

Marling, Karal Ann. *Wall-to-Wall America: A Cultural History of Post-Office Murals in the Great Depression.* Minneapolis: University of Minnesota Press, 1982.

Marling, Karal Ann. *Wall-to-Wall America: Post Office Murals in the Great Depression.* Minneapolis: University of Minnesota Press, fourth printing, 2000.

O'Connor, Francis V. *The New Deal Art Projects: An Anthology of Memoirs.* Washington, DC: Smithsonian Institution Press, 1972.

Parisi, Philip. *The Texas Post Office Murals: Art for the People.* Texas: Texas A&M University Press, College Station, 2004.

Park, Marlene, and Gerald E. Markowitz. *Democratic Vistas: Post Office Murals and Public Art in the New Deal.* Philadelphia: Temple University Press. 1984.

Puschendorf, Robert L. *Nebraska's Post Office Murals: Born of the Depression, Fostered by the New Deal.* Lincoln: Nebraska State Historical Society Books, 2012.

Michael Scragg's Postal Museum, Marshall, Michigan

Smithsonian Institution

Smithsonian American Art Institute

Thomas, Bernice L. *The Stamp of FDR: New Deal Post Offices in the Mid-Hudson Valley.* New York: Purple Mountain Press Ltd, 2002.

United States Postal Service

ABOUT THE AUTHOR

DAVID W. GATES JR. is a post office enthusiast who has traveled thousands of miles nationwide in search of historic post office buildings and art.

He blogs about his work at www.postofficefans.com

Although the murals have been around for more than 85 years, David discovered how often these are overlooked. Join David in his quest to visit them all.

He lives in Crystal Lake, Illinois with his wife, son, and two cats. When not photographing and documenting post offices, he can be found cooking, baking, hiking, or involved in do-it-yourself projects at home, not necessarily all at once and not necessarily in that order.

For more of David's work please visit www.davidwgatesjr.net.

WISCONSIN POST OFFICE MURAL GUIDEBOOK

Wisconsin Post Office Mural Guidebook is the companion to Wisconsin Post Office Murals

We hope you have enjoyed this book of **Wisconsin Post Office Murals**. If you are planning on visiting or traveling to view these magnificent works of art in person, you may find the **Wisconsin Post Office Mural Guidebook** a valuable addition.

While the book you are holding now contains the history and images, the guidebook provides the location and status of the artwork. In some cases, the mural could be hundreds of miles from the building where it was initially installed.

Wisconsin Post Office Mural Guidebook is available from your favorite retailer or can also be ordered directly from the publisher at www.postofficefans.com.

CPSIA information can be obtained at www.ICGtesting.com
Printed in the USA
LVIW011818060919
630128LV00002B/2